THE ART OF
WILLIAM S. PHILLIPS:
THE GLORY OF FLIGHT

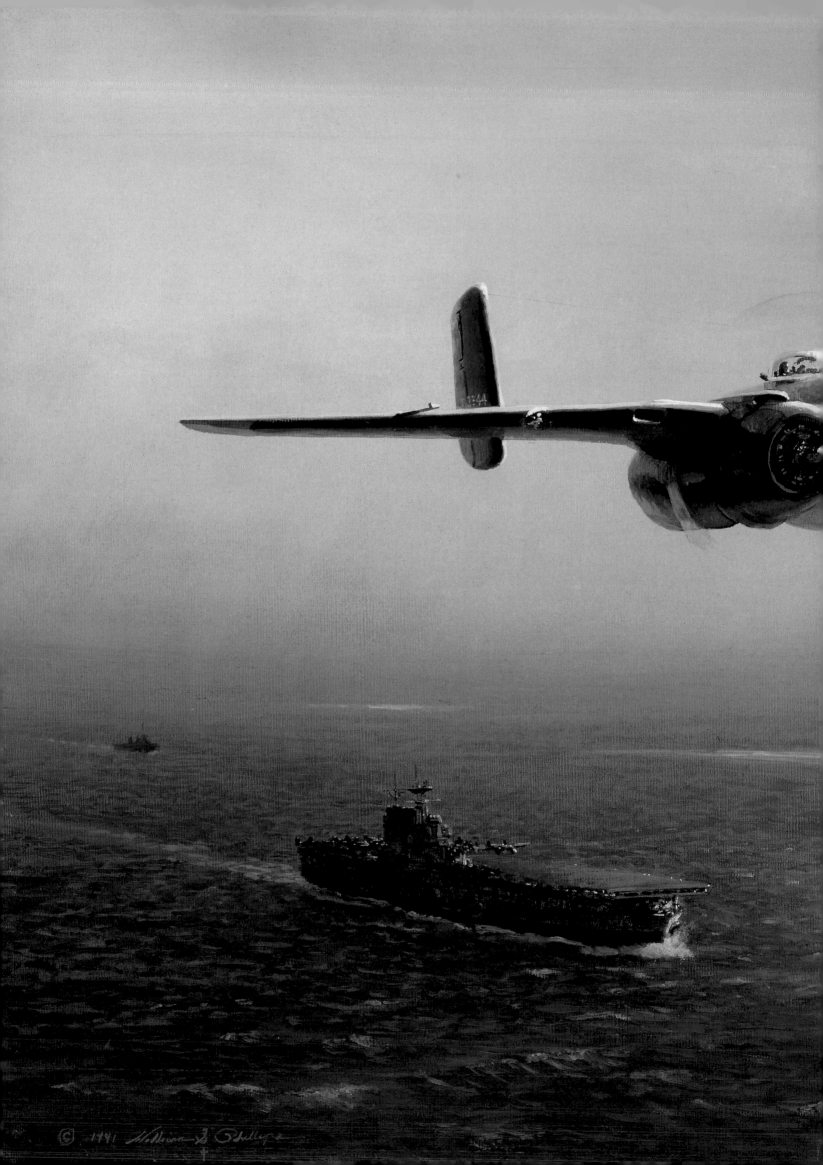

© 1941 William S. Phillips

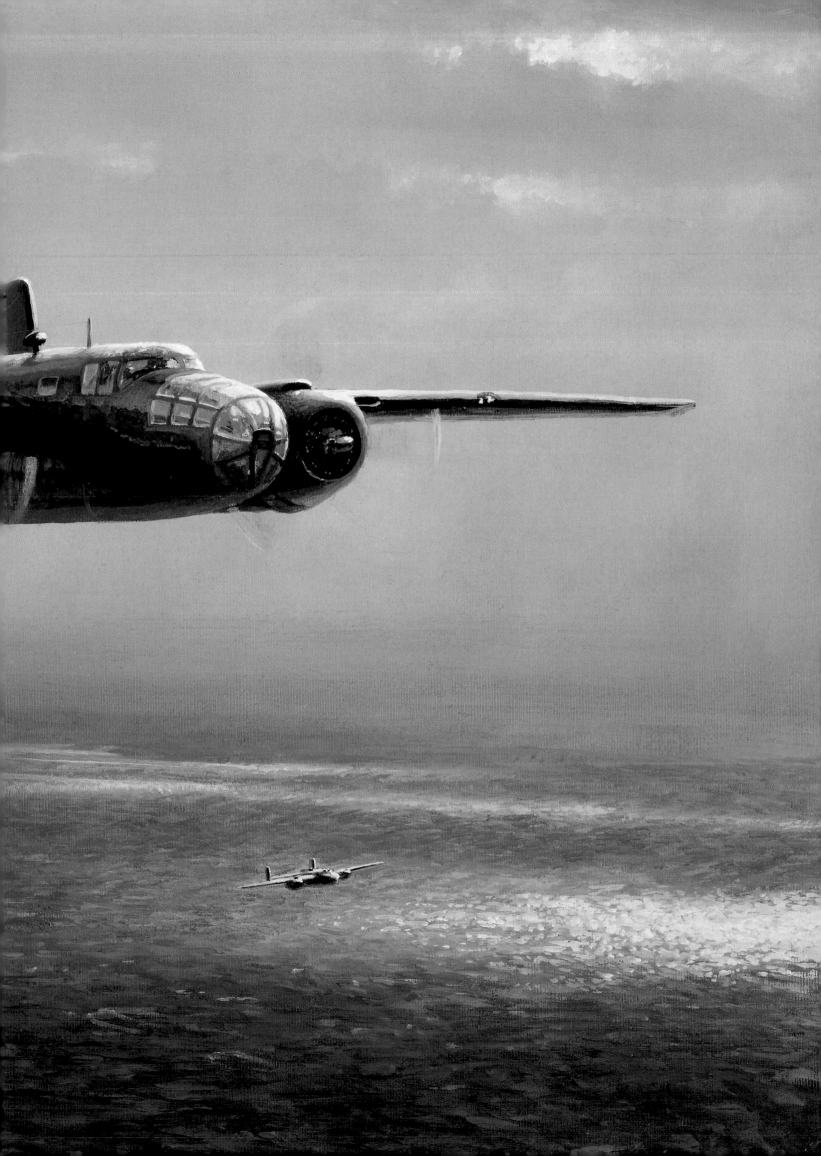

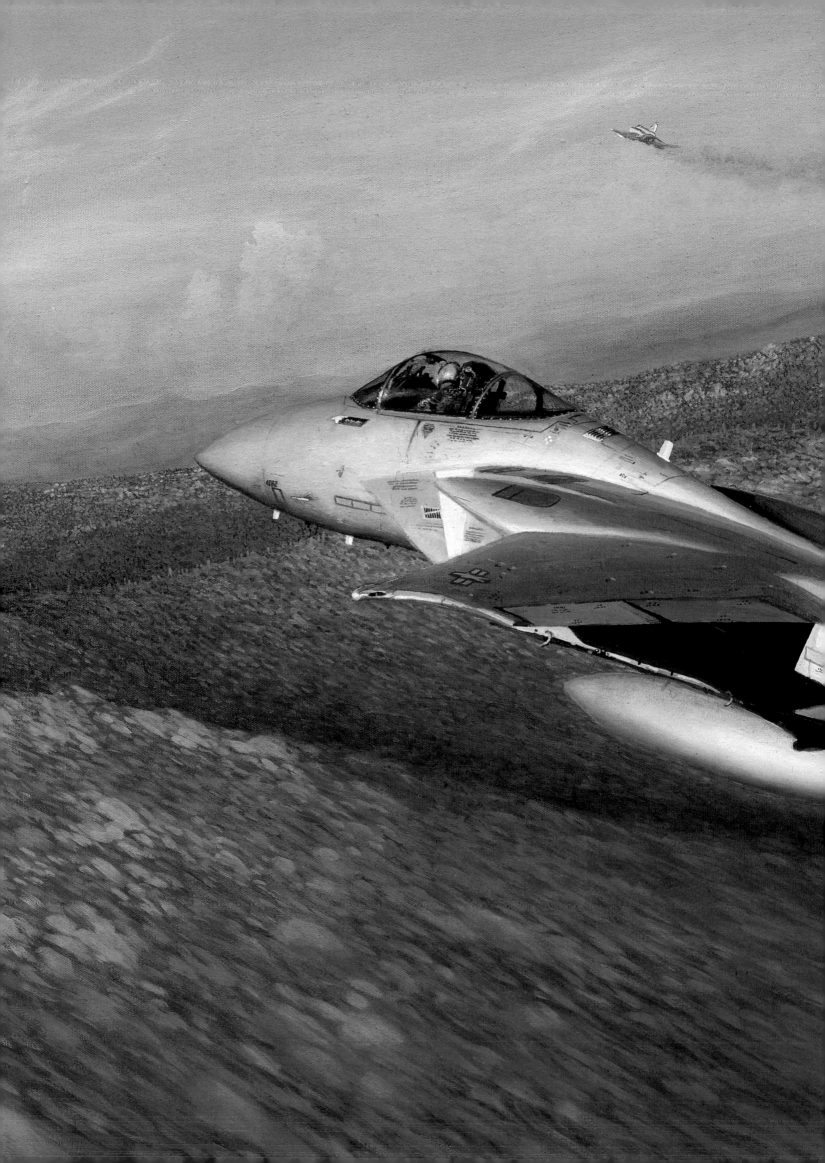

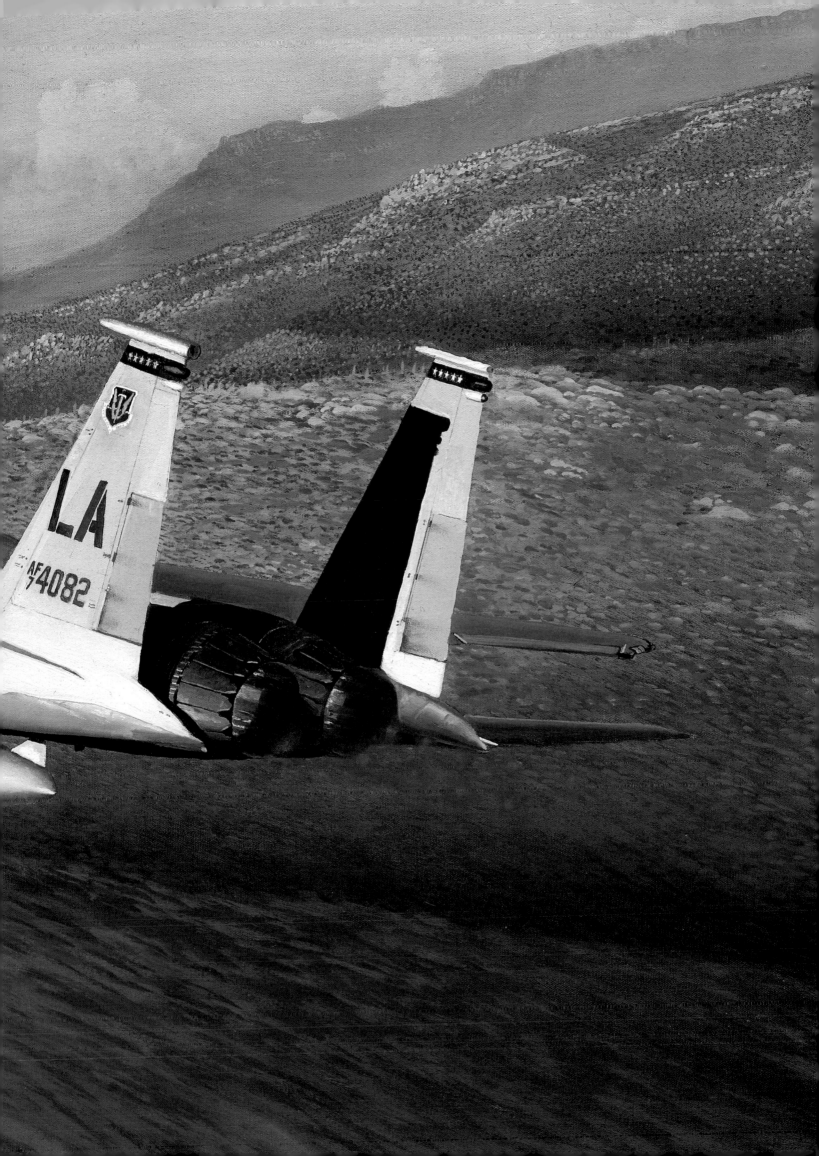

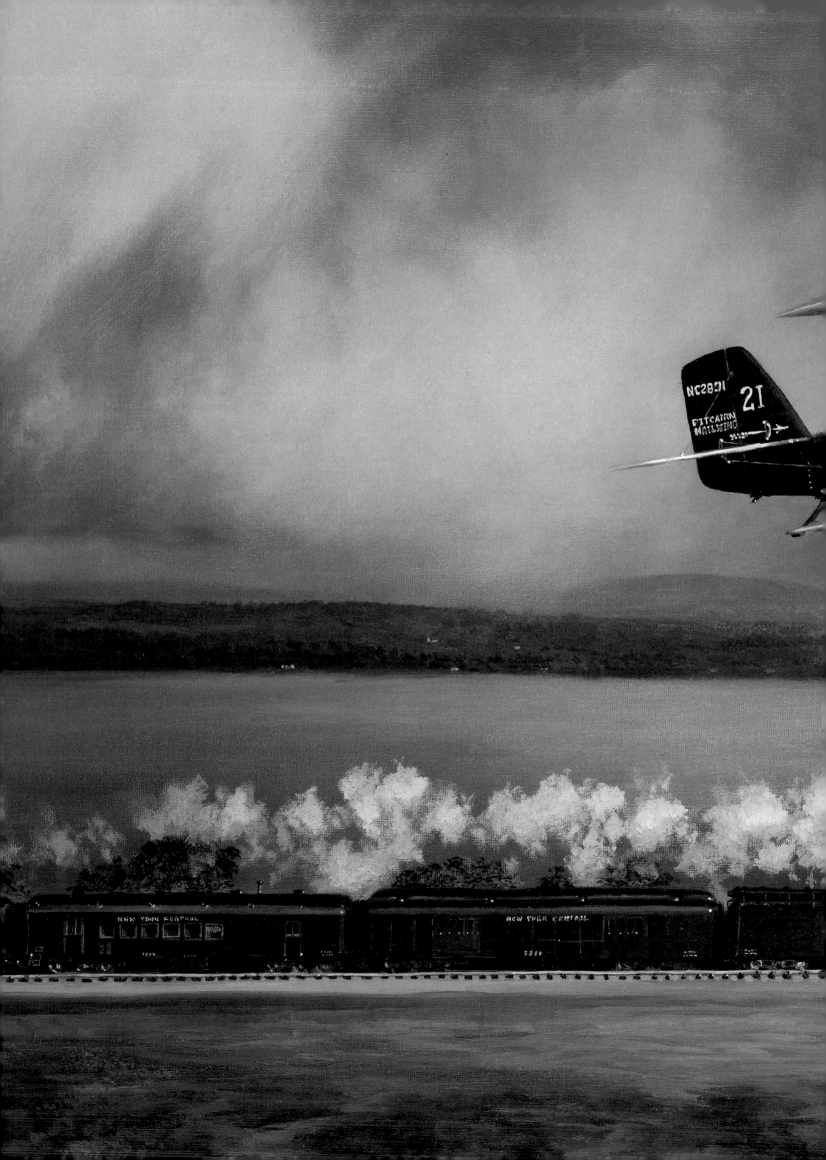

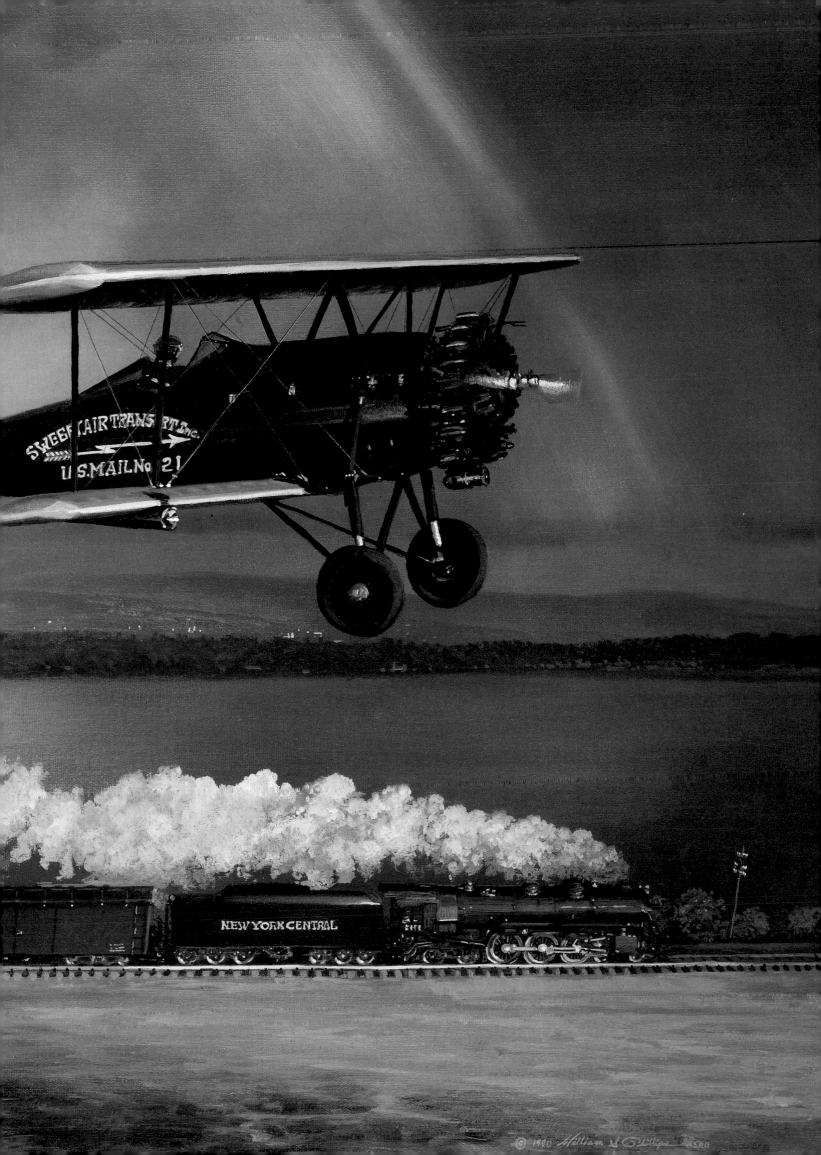

THE ART OF WILLIAM S. PHILLIPS: THE GLORY OF FLIGHT

TEXT BY EDWARDS PARK
INTRODUCTION BY STEPHEN COONTS
THE GREENWICH WORKSHOP INC.

TO GOD FOR PROVIDING MY TALENT AND
TO KRISTI FOR ALL OF HER LOVE AND SUPPORT

ACKNOWLEDGEMENTS

The author and publisher have made every effort to secure proper copyright information. In the case of inadvertent error, they will be happy to correct it in the next printing. The Greenwich Workshop extends grateful thanks for permission to reproduce the following: pp. 92-93 quotes from *Into the Teeth of the Tiger* by Donald Lopez, copyright 1986 by Donald Lopez, used by permission of Bantam Books, a division of Bantam Double-day Dell Publishing Group, Inc.; pp. 70-71 quotes from *To Fly and Fight* by Clarence E. "Bud" Anderson with Joseph P. Hamelin, copyright 1946, published by Henry Holt and Company.

P. 99 quotes by Joe Foss from *Hunters in the Sky: Fighter Aces of WWII* by James R. Whelan, published in the U.S. in 1991 by Regnery Gateway, copyright 1991 by Anthony Potter Productions, Inc.; p. 33 paraphrase from *At the Edge of Space* by Milt Thompson, copyright 1992, published by Smithsonian Institution Press; pp. 40-41, 157 paraphrases from *Nanette* by Edwards Park, published by Smithsonian Institution Press; p. 111 paraphrase from *Song of the Sky* by Guy Murchie, published 1979 by Ziff Davis.

Grateful thanks are also extended for permission to reproduce the following art: pp. 6-7 *Rainbow Chaser*, pp. 112-113 *Last of the Bush Pilots*, and p. 136 *Gee Bee* courtesy of Bantam Doubleday Dell Publishing Group, Inc.; p. 107 *Two Down to Glory* courtesy of National Guard Heritage Series, National Guard Bureau, Washington, D.C.; p.100 *Top Gun* courtesy United States Air Force Collection.

A GREENWICH WORKSHOP BOOK

Copyright © 1994 by The Greenwich Workshop, Inc.
Introduction © 1994 by Stephen Coonts
Biography on pp. 170-171 ©1987 by the Smithsonian Institution.

LIBRARY OF CONGRESS CATALOGING-IN-PUBLICATION DATA
Park, Edwards. The art of Williams S. Phillips : the glory of flight / text by Edwards Park ; with an introduction by Stephen Coonts. p. cm.
Includes index.
ISBN 0-86713-022-9
1. Phillips, William S., 1945- --Catalogs. 2. Airplanes in art--Catalogs. 3. Airplanes--Piloting. I. Phillips, William S., 1945-
II. Title. N6537.P445A4 1994 759. 13--dc20 94-15294CIP

FRONTIS ART
pp. 2-3 *I Could Never Be So Lucky Again*
pp. 4-5 *Advantage Eagle*
pp. 6-7 *Rainbow Chaser*

Book design by Peter Landa and Diane Kane
Display face, Rightstuff, designed by Philip Bouwsma
Printed in Italy by Amilcare Pizzi, S.P.A.
First Edition
94 95 96 0 9 8 7 6 5 4 3 2 1

CONTENTS

INTRODUCTION 12

OFF AT FIRST LIGHT 14

LATCHING ON 30

HIGH AND TERRIBLE 46

LOW AND MEAN 66

MIXING IT UP 88

CLIMBING THE CRAGS 108

PLEASING THE CROWD 122

HEADING FOR THE BARN 138

MOMENTS REMEMBERED 154

WILLIAM S. PHILLIPS, THE ARTIST 170

LIST OF PLATES 172

INTRODUCTION

Flyers are busy people. There is much to do in any cockpit, and those people who expect to arrive safely at their destination stay busy at it. Military aviators, especially those in single-piloted tactical machines, are even busier than their multi-crewed colleagues because there is no one to share the workload with. One must aviate, navigate, communicate, and monitor engine performance, fuel consumption, electronic warfare counter-measures. In today's high-tech machines, there are also computers, radars and inertial navigation systems that require careful attention and constant monitoring.

Combat multiplies the demands on the fliers. As always, you must fly your airplane, yet in combat you must keep track of your friends and find the enemy before he finds you. When the enemy is found, you must successfully attack him and safely make your way home.

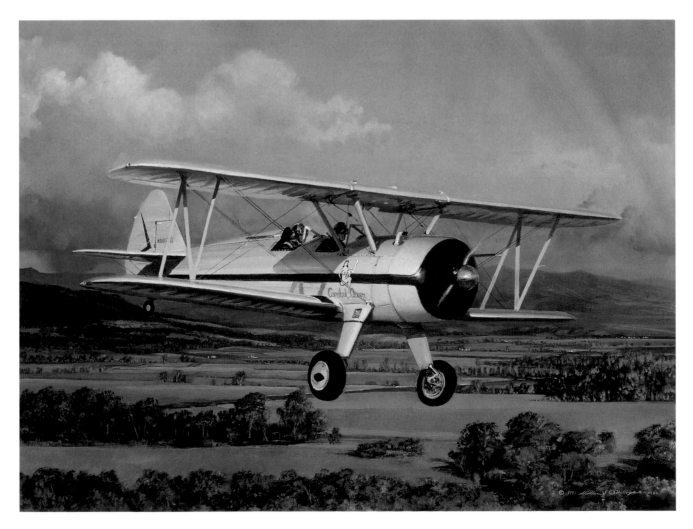

And yet, in spite of the workload, somehow every pilot manages to grab a second or two now and then to look outside, to see and marvel at the pristine wilderness of the sky through which he flies, to view with awe the extraordinary vistas of land and sea which lie below. It is these few precious moments sandwiched in between the chores that pilots remember long after the flight is over, long after the switches and gauges and cockpit procedures fade to insignificance. These rare, shining moments are the magic of flight that William S. Phillips captures with his art.

I had the privilege a few years ago of flying with Bill. On one of my vagabond aerial expeditions in my Stearman, I alighted in Ashland, Oregon, and called him on the phone.

It was a sunny July evening, the air like golden wine as it drifted in from the Pacific and wafted gently through the valleys and around the peaks of the coastal range.

Bill inspected the airplane carefully—not, I suspected, for mechanical condition, but to actually *see* it—the curve and shape of the wings, how the lines of the fuselage flowed and narrowed near the tail, how the ailerons were attached, how the struts and wires braced the structure...he wanted to know how this airplane *looked*.

Airborne with him in the front cockpit and me back aft in the captain's chair, his head never stopped moving. He examined the way the sunlight made the yellow wings glow against the deep blue of the sky, how it enriched the greens and yellows of the landscape below and deepened the lengthening shadows. His gaze returned repeatedly to Mt. McLoughlin, an extinct volcano rising from the mountain range to the east to stand like an ancient pyramid against the sky. And he watched how the entire perspective constantly changed as we flew along in our aerial chariot with the engine snoring and the wind swirling against our cheeks.

Our flight wasn't long, but it was long enough.

I saw the sky as a pilot
sees it—a medium in which
to fly—and the rugged terrain below
as obstacles to be avoided. Bill Phillips saw it
with artist's eyes.

In this book you will see what William S. Phillips has seen aloft, for he truly has a rare gift—he can distill his vision of the aviation experience to the pure, raw essence, and share it with us.

His painting of my yellow Stearman, *Cannibal Queen*, hangs over my desk as I write this. I glance at it many times a day, but every now and then, when the writing gets difficult or the paperwork oppressive, I pause and really look. The *Queen* is flying above a green valley with a range of hills or low mountains in the background. There are clouds over the mountains with tops illuminated by an evening sun, and at the very right of the picture, the slashing arc of a rainbow.

As I gaze at the painting, the magic seizes me. I can once again feel the *Queen* in my hand, hear the throb of her engine, see the timeless green landscape below and the warm puffy clouds floating along above.

Bill painted me looking out of the rear cockpit to the left at a row of trees alongside a stream. He put himself in the front cockpit. He is gazing ahead over the nose and slightly upward, looking at something out of the picture to the right, something beyond the range of my vision yet something that he can see quite clearly. Which is why his paintings captivate me.

Well, this essay is long enough. That painting of the yellow Stearman in flight can be ignored no longer. She is waiting, the sky is waiting, life is rushing on. When you finish this book, you'd better meet me at the airport. We'll go flying together.

—Stephen Coonts

Climbing you meet the sun.
However demanding your mission,

OFF AT

FIRST LIGHT

the adrenaline churns…
you cannot ignore the sudden radiance
of clouds bathed by sunrise.

OFF AT FIRST LIGHT

There must have been fifty ways, at least, for pilots to leave their beds at an ungodly hour and go to work. In the 1940s, one old fighter squadron in New Guinea was roused by the insistent clatter of a watchman's rattle. The Charge of Quarters would walk among the scattered tents, wheeling this device around his head and crying out "Early flights! Early flights!" as though he were hawking fresh crab-cakes on a Baltimore street. And you'd wrench yourself out of your uneasy sleep, where exhaustion from yesterday battled endlessly with worry over all the tomorrows to come. With a groan and a curse, you'd break out of your mosquito bar, bang your boots heel first on the ground, and then shake them so that you wouldn't share them with a scorpion.

A generation earlier, when you wore jodhpurs and riding boots, it could have been your batman who woke you with a tin cup of hot tea to help you face the bitter cold of a Nieuport's—or Fokker's—open cockpit at 12,000 feet. And in the jet age, electronics has most often done the job: "Good morning, Vietnam!"—and a blast of hard rock.

However you wake, you have always seemed to be creatures of the pre-dawn, fumbling for the zippers of flight suits, gulping coffee, gathering together your gear and yourselves, and heading into darkness.

Getting off at first light has always been a delicately timed operation. Crew chiefs generally beat pilots to the flight line. They drained condensation from the fuel, started the engines, idled them to warm the oil, ran them up for a check. So if you were on an island too close to the equator to merit twilight, you first glimpsed your plane only as a ripple of blue-flamed exhaust in the black night.

A generation earlier, in temperate Europe, you could just make her out against the eastern sky—the silhouette of her upper wing, its gentle dihedral, the outline of the struts, her tilted nose and elegantly curved propeller. And today you may only catch the gleam of the canopy, swung up and back. For a jet sits low to the ground, an unobtrusive bundle of power.

After briefing, still in relative darkness, you finally greet your steed, your Pegasus, and wherever you are—and of whatever generation of flyer—you touch her with a certain delight, perhaps a close concern, even a true affection. Preflight is well over, and she is dozing again. And as you prepare to mount her, you run your hand over her dew-drenched wing and feel the dead coldness of her smooth metal and wonder if she'll come alive for you. You snuggle into her, familiar straps snapping into place, leads and tubes secured with familiar clicks, helmets and masks greeting you with familiar smells—your own. Rubber, plastic, metal, and webbing lose their overnight chill and take on the warmth of your body.

As the engine takes hold, you muffle its thunder with earphones, hearing instead the squawk of radio voices asking for tests: "Mary from Beaver: How do you read me? Over," was the way you used to say it in World War II, and the answer would come in strong: "Beaver, you are R-5, S-5." And then your crew chief would pat your shoulder, jump from your wing, and in the blue light of your exhaust you'd see his perfunctory salute, a graceful tradition that reminds you how bound he is to your fate.

In the tropics, "first light" came abruptly. You left your revetment in utter blackness. But as you trundled to the end of your strip you began to see. Black became pale gray in only a matter of seconds as you checked your mags. Your wingman appeared beside you as though by a wave of a magician's wand. And when you flapped your ailerons at him to signal take-off, he saw, and flapped back.

In all the annals of flight there must be fifty ways to leave the ground. Two planes at a time, wings tucked together, rattling down a strip of steel matting in a jungle clearing; an air army of Fortresses rumbling off a dozen English fields in careful sequence; the crash of the catapult flinging an Intruder from a carrier deck into the uncertain air; the tight little snarl of a lone Piper, dew whipping from its windscreen as its airspeed creeps toward 60.

Wherever and whenever you make that dawn takeoff, the air is always cool and hard, quick to lift smoothly. Often contrails spring from every protuberance. Flaps, landing gear, wheel fairings, antenna, canopy latch, even rivet heads spew creamy ribbons of tortured air. Propellers sometimes carve wondrous white spirals, corkscrews of condensation, that hang over the strip after a plane is up and away.

Climbing, you meet the sun. However demanding your mission, however the adrenaline churns in your body, you cannot ignore the sudden radiance of clouds bathed by sunrise, of the brilliant sky above contrasted with the murky ground, still clinging to night, far below. In skies over England you climbed through cloud corridors to find the sunrise and be washed in pink light that danced off every surface of your Spitfire. In the Pacific, the sun was white gold, but as it thrust through distant ocean clouds its beams radiating into the high sky to form a gigantic Japanese battle flag. What an uneasy omen to fly under!

After that moment to savor the sunrise, it was business as usual. Procedures occupied you— holding position in your bomb group, or perhaps weaving in escort. In a fighter you probably had to switch to your auxiliary fuel tank, checking your wristwatch, drilling yourself to switch away from it before it ran dry and left you with the deafening silence of a dead engine.

The live one sang a cheerful baritone, and you listened to it critically, and to the chord struck by the air, rushing past the shape of your plane, giving her a special tune to sing. Even today's superb pilots know that song of an aircraft and realize that it gave their grandfathers understanding and rapport. When the tone faltered into what seemed a dissonance, you knew without a glance at the air speed indicator that you were moving slower or faster—climbing or diving or slipping or skidding. Though you checked the gauges on the dashboard periodically with a practiced sweep of your eyes, your plane's constant song was your first and handiest instrument.

Gaining altitude in the lightening sky gave you a few more stolen moments of carefree flight. "First Light" was usually too early to meet an enemy near your own base, so you had time to trim your plane, to itch around in your cockpit so you weren't sitting on sharp pleats of your folded rubber dinghy. It was even a time for a few unwarranted and illegal murmurs on the radio—a squadron catchword, a snatch of a song—all low and quiet as though somehow you could keep your conversation private. With the new sun in your eyes, your night fears wilted away, and you felt confident and proud of your part in this band of brothers.

But the day quickly became serious, and you settled into your vital and everlasting career of looking at the sky. Pilots who lacked today's detection devices learned to peer through the sky, not just at it. They covered it in every direction, quartering the horizon and patrolling 90 degrees at a time with their eyes. They searched the edges of every cloud for dark spots in silhouette, moving fast and furtively. They blocked the newborn sun with their thumbs, and then probed around it for a glint of polished metal, diving....

Below, the darkness dissipates; sunlight gradually washes into valleys revealing meadows and streams. Jungle chasms hide under veils of morning mist. But poplar-lined roads of France, rock walls of Yorkshire pastures, canal banks of Germany are etched in black shadows cast by the low sun. And the dark Pacific turns cobalt as the rays strike deeper.

Then the magic of dawn melts away. The sun beats hot on your canopy; warming air begins to bump and rock your aircraft; cumulous builds around you, and your heart beats faster at the thought that an enemy may lurk behind every humping shoulder of cloud. Your eyes burn as you search, your oxygen mask is slippery with sweat; your buttocks grow numb. The fun is over.

Welcome to the day's work.

DAUNTLESS AGAINST A RISING SUN

Bill Phillips likes symbolism, and this early morning scene is rich with it. It's June 4, 1942. Two U.S. Navy SBD dive-bombers—"Dauntlesses" from the carrier *Yorktown*—climb into the Pacific sunrise and head toward the island of Midway, now threatened by Japan.

Since the attack on Pearl Harbor, six months have passed in dark clouds of defeat. Japanese forces control the Pacific, their rising sun ignites the Orient. But today the tide will turn. The Dauntlesses will howl out of the dawn to smash a huge Japanese armada.

This Battle of Midway was history's first naval encounter fought entirely by aircraft. American losses were heavy: 132 planes down, and one carrier sunk—the *Yorktown*. But the SBDs sank four enemy carriers, and with them, 275 planes. Thanks to Dauntless planes and dauntless men, the darkness of defeat gave way to a dawning of hope for final victory.

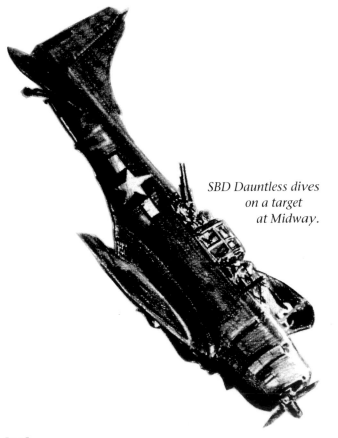

SBD Dauntless dives on a target at Midway.

[18]

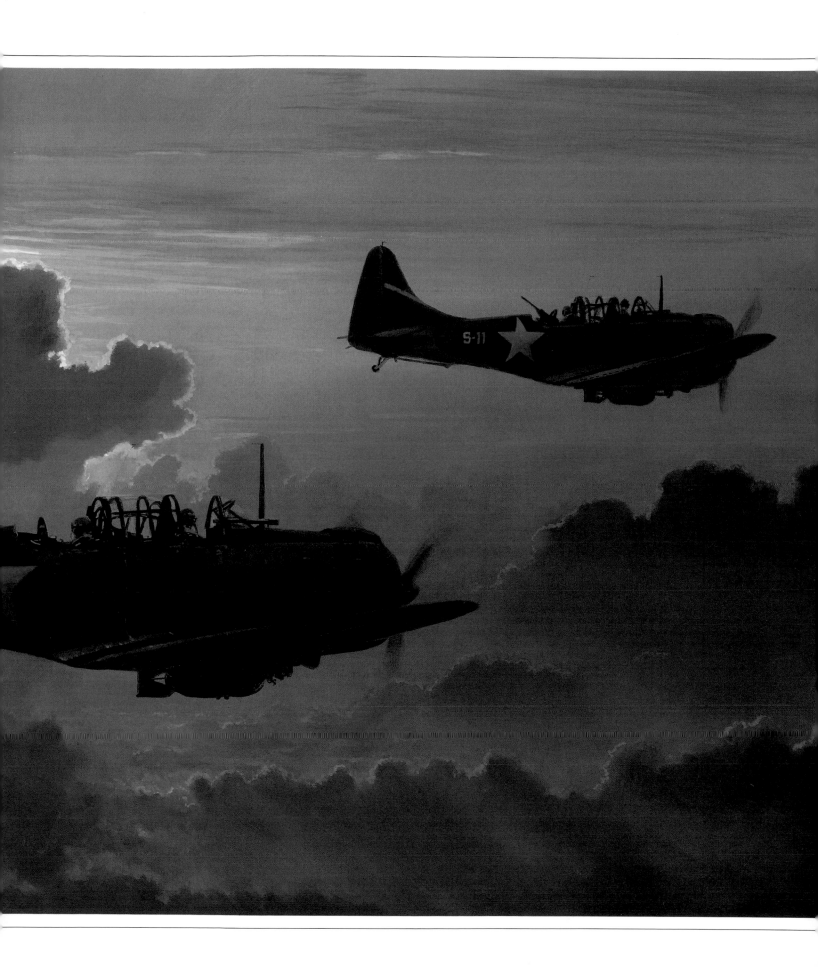

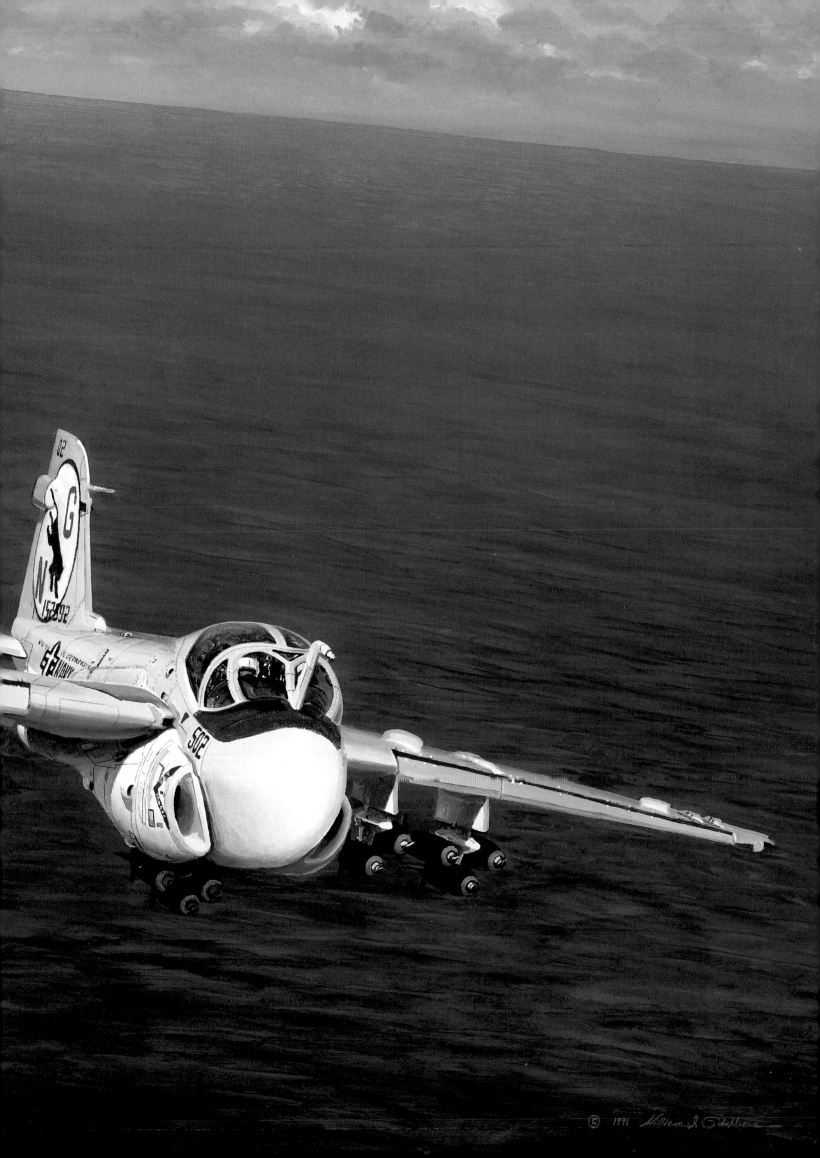

INTRUDER OUTBOUND

A clear morning in 1967: The carrier *Enterprise* swings into the wind in Vietnam's Gulf of Tonkin to hurl 27 planes into the dawn, among them this A-6 Intruder. Phillips calls it "an Alpha Strike" at a Hanoi depot.

The Grumman A-6, an all-weather attack plane, carries a pilot and weapons-system operator side by side. Their bulky aircraft packs more than seven tons of devastating weaponry to use on targets and ground-to-air missiles.

This particular Intruder, here taking off on its 81st mission, failed to return. Hit by a missile, it crashed, its pilot bailing out. Navy Captain Eugene "Red" McDaniel (above), was seized by the Vietcong and imprisoned for six long years. Despite brain-washing attempts and brutal physical torture, McDaniel managed to live through his ordeal and finally returned home, a lasting example of courage.

HEADING FOR TROUBLE

A pair of army Cobras follow a distant "Loach" as the gunships ride into action in Vietnam. Bill Phillips served there for a year, and came away deeply impressed by the steadfastness of army helicopter pilots, off every day on extremely dangerous missions, hammering over the enemy, fast and low, guns ablaze, taking it heavy from ground fire. Here they go into the sunrise, brave and cocky, to earn their day's pay.

Helicopters barely made it into World War II, but served in Korea, moving troops and wounded. By the time of Vietnam, the chopper had evolved into an impressive offensive weapon with heavy firepower for use against ground targets.

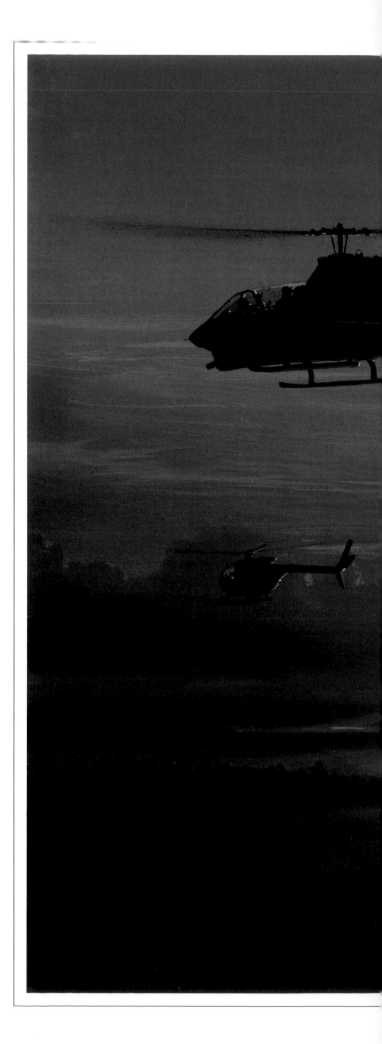

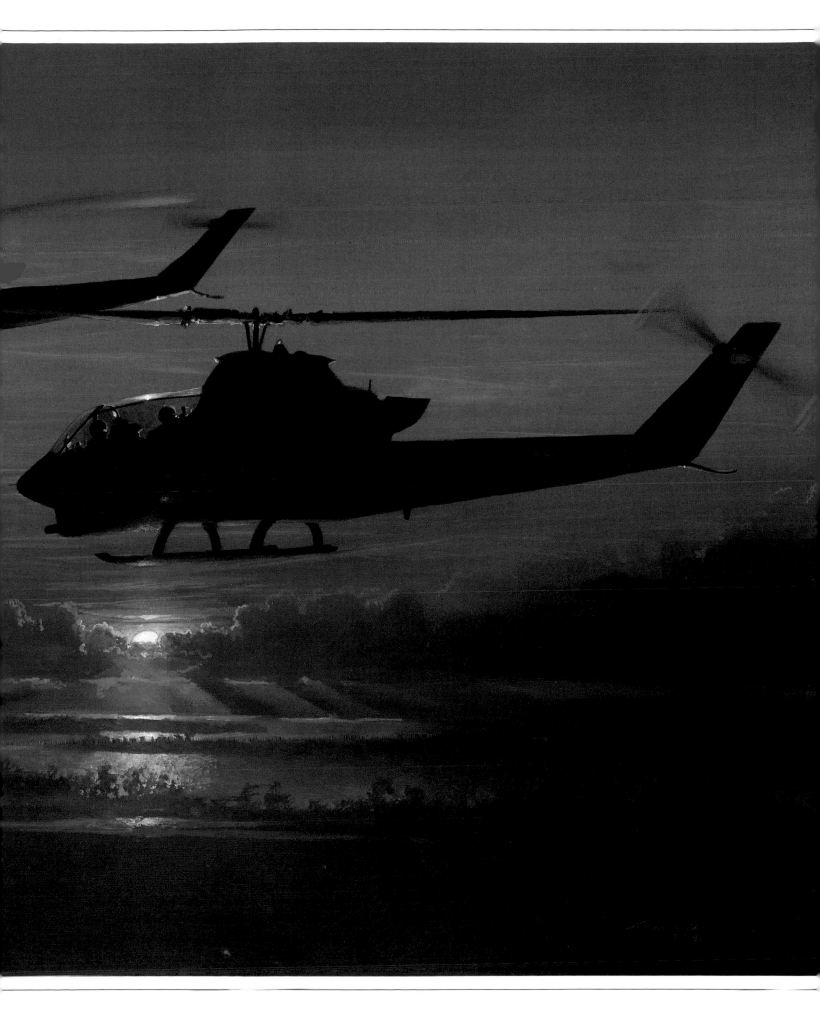

AMERICA ON THE MOVE

Blocking a Pacific sunrise, the massive USS *America* surges full ahead to launch at first light. The lead F-4 is barely in the air while the wingman rolls up into postion. With a blast of steam, the catapult whips a plane from zero to 150 knots faster than the pilot can react. He just sits there, crushed back against his seat until his brain catches up with his body.

Quick launches allow a carrier to shift course so she can avoid attack or hazard. Her deck roars and screeches with violent action and unbelievable power. "I wanted to catch that sense of might," says Bill, "so I painted the ship head-on, in the powerful colors that streak the dawn."

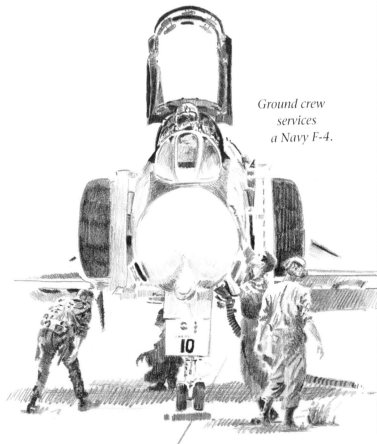

Ground crew services a Navy F-4.

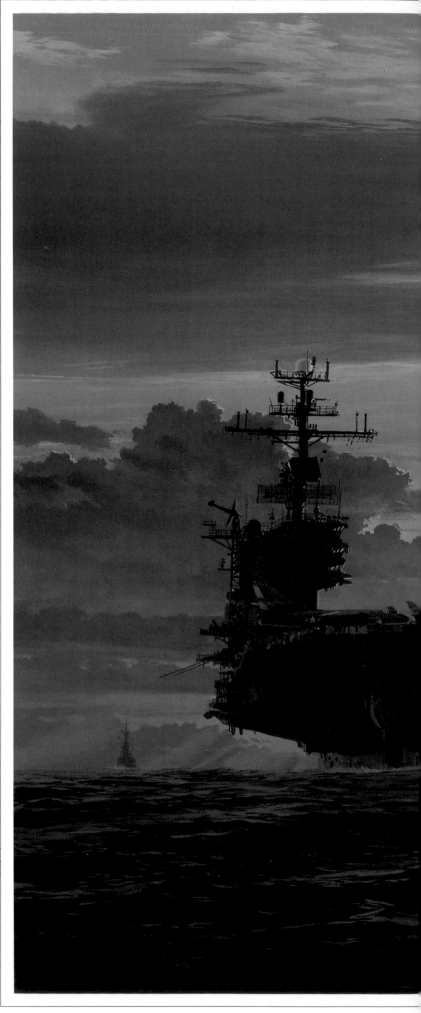

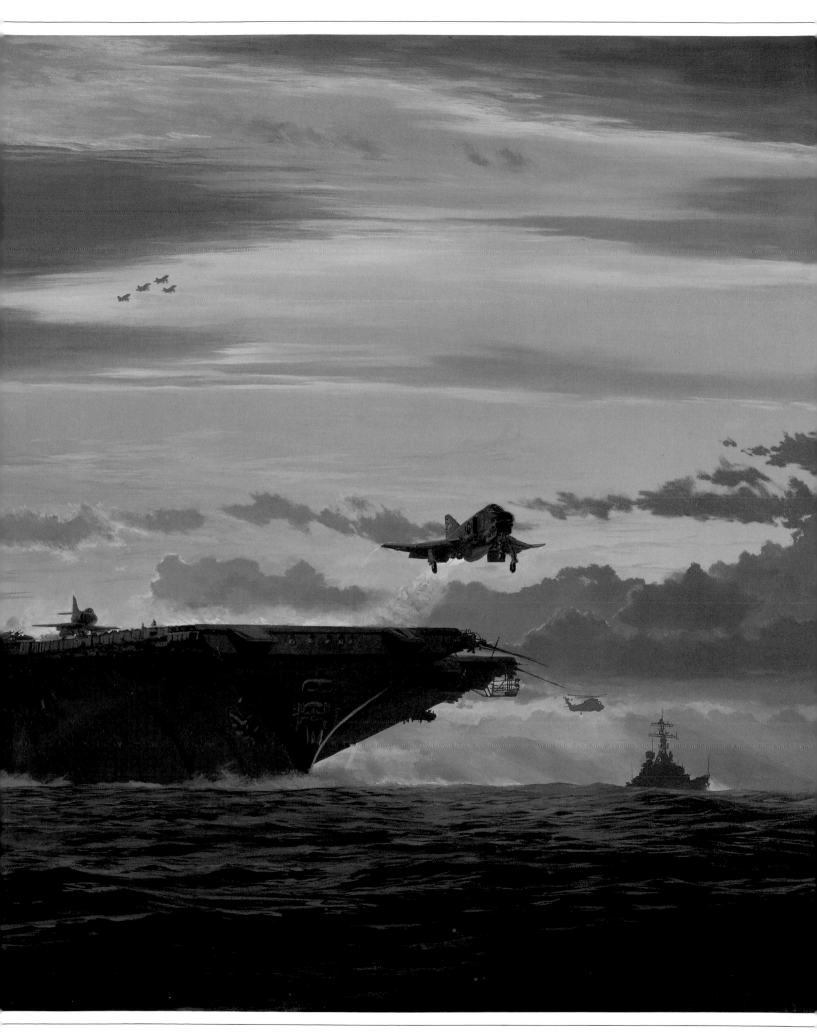

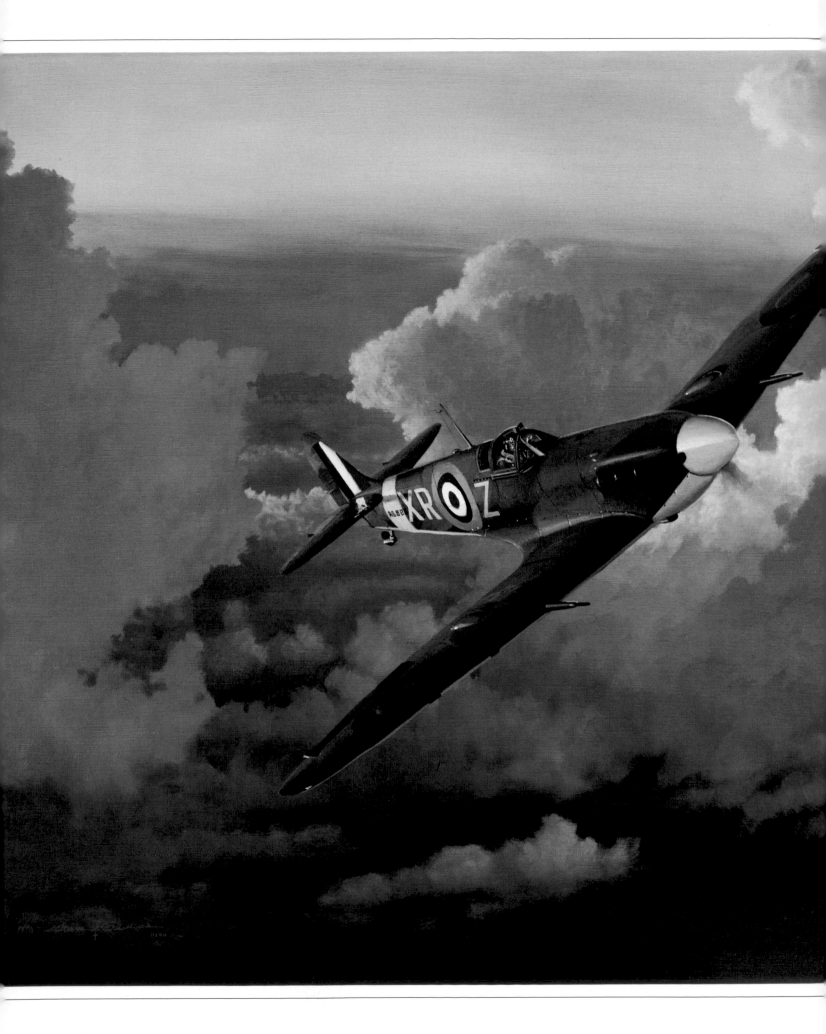

Oscar H. Coen

A TIME OF EAGLES

Clawing up past dawn-tinted clouds, an RAF Spitfire of 71 Eagle Squadron starts its day's work. Its pilot is an American, Oscar Coen, one of hundreds of Yanks who volunteered to fly for Britain in the dark days after the fall of France.

Bill spent several days with Oscar and Jenny Coen at their eastern Oregon ranch. He likes to touch base with the people who have flown the aircraft he paints—it gives him a feeling for the human being within the machine. "These pilots," he says, "are a delight. It's an honor to know them."

Oscar Coen joined 71 Squadron, clobbered six enemy planes, got hit and had to bail out himself. He says every American had his own reason for joining the RAF. "A lot of guys went because the British Spitfire was the hottest thing in the air and they wanted to fly it."

In 1942, after the U.S. entered the war, Eagle Squadron pilots transferred to the Army Air Forces and formed the 4th Fighter Group, relinquishing their dainty "Spits," for P-47s and P-51s.

Oscar Coen, former Eagle Squadron pilot, wears American gear in this 1945 photo.

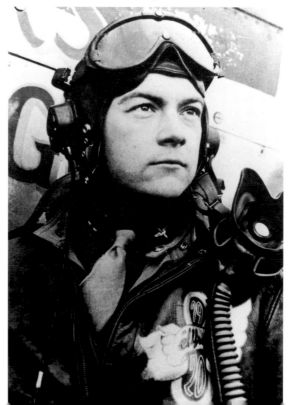

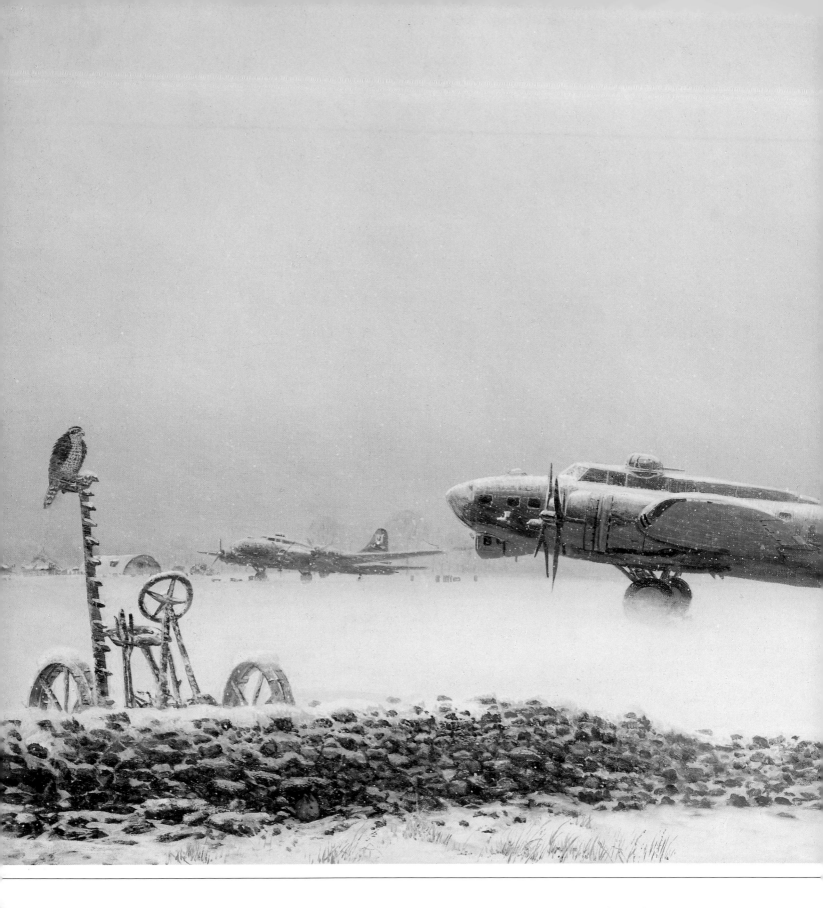

NO FLYING TODAY

The first light of dawn, here at Framlingham, England, is pale gray, hazed with snow. All northern Europe is swept by an Arctic air mass. All that meticulous planning for today's mission? All that urgency to show the effectiveness of strategic bombing? Forget it! Mother Nature couldn't care less. No one flies in this weather.

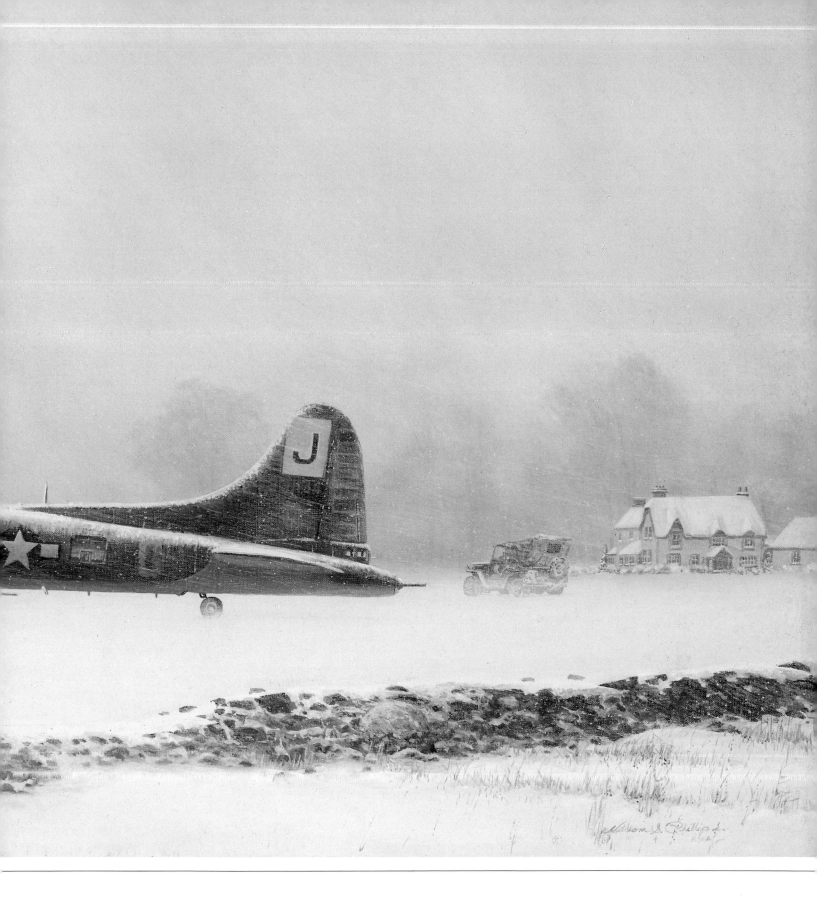

Air crews, keyed up for the mission, take a look at the snow-swept base and go back to sleep. For most, the unexpected break in daily tension is gloriously welcome. For some, it's a pesky delay in the long testing of skill and guts and luck that men must face before they rack up enough missions to get rotated home. For now, the clamor and fury of war are gone. The B-17s sit quietly in the snow; peace reigns over the silent base. A goshawk, feathers puffed against the cold, waits patiently for a glimpse of a rabbit, hiding in the stone wall. The whole war waits as well, ready to swoop and kill.

But not today. Tomorrow perhaps. Not today.

Illustrating with their hands,
instructors repeated their litany
of latching on like priests at communion:

LATCHING

ON

"take a position not too near...
not too far... right there.
Watch your leader carefully.
Stay with him."

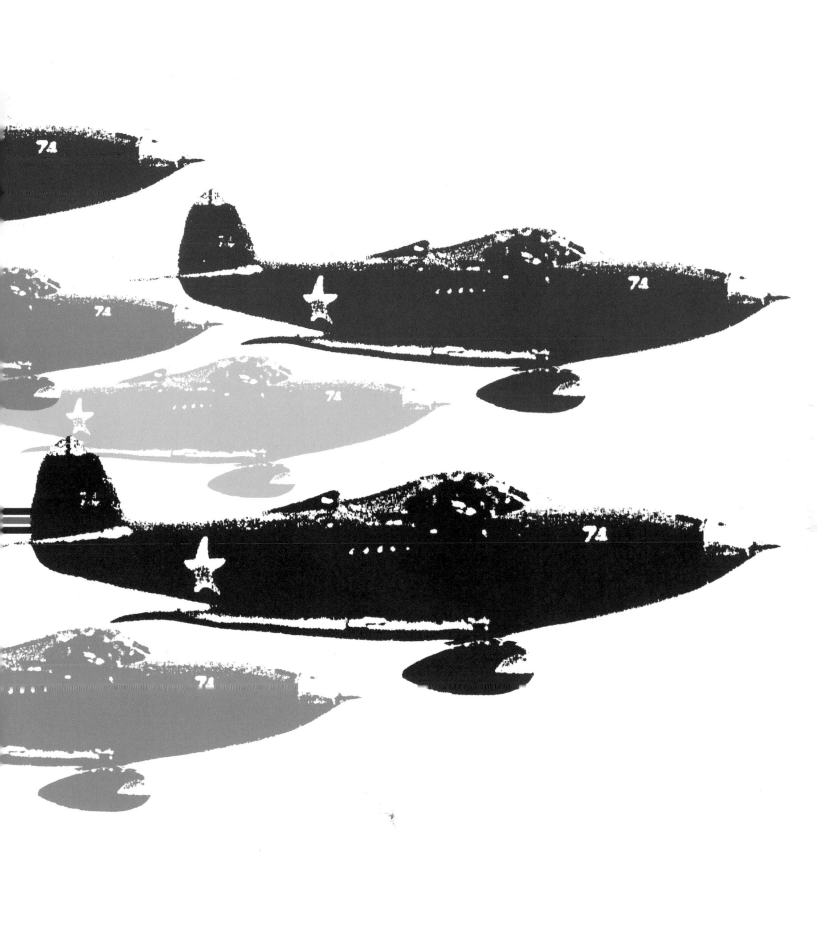

LATCHING ON

The fact that a human can leave the ground in a large, complex machine, hurtle through the air faster than sound, and return safely to earth is astonishing. The notion that two or more of these machines can do it at once, packed close together, in some cases even touching, seems appallingly difficult and dangerous. Civilian flyers are taught that formation flying is a no-no. Airline captains shudder at the possibility of it. But military pilots spend so much time in formation that they can hardly picture flying any other way.

Mass flights started in the Great War when gaggles of Camels, Spads, Albatroses, and Fokkers rambled over enemy lines, each side bringing many eyes to bear in seeking out the foe. Once seen, it was every man for himself and often *sauve qui peut*. Speeds were seldom more than 150 knots, and monoplanes, biplanes, and triplanes wheeled ponderously, trying to line up clear shots at one another. Wings whirled around the sky; bullets zipped in every direction. And almost always new pilots returned to report that they had been too busy avoiding each other to see a single enemy plane!

Two early German pilots, Max Immelmann and Oswald Boelcke, learned that flying as a pair increased effectiveness and safety. Their "buddy system" became the basis of all combat flying, and continues even today. But between wars, military pilots increased the pair to a trio and often snarled over fairgrounds in "vees" of de Havilands, Curtiss Hawks, Keystone bombers and other members of the Army Air Service. The Navy put on similar shows for the newsreels, with fleets of neat little Grumman biplanes, ancestors of the famed Wildcat, massed above a spanking new aircraft carrier—*Lexington* perhaps, or *Saratoga*.

World War II created the four-plane fighter flight, made up of two pairs, now called "elements." Trainees began learning it in Basic Flight School. Illustrating with their hands, instructors repeated their litany of latching on like priests at communion: "take a position not too near... not too far...right there. Watch your leader carefully.

Stay with him." By the time a cadet moved to Advanced School, he was comfortable with formation work. But there were always new things to learn....

I graduated with the Army Air Forces class of 42-H at Selma, Alabama. Next day my old instructor (now my fellow-officer) found that I "owed" a cross-country flight. Do it now, he suggested, and just for fun he'd come along on my wing.

The flight was no sweat—100 miles to a check point, then return. Clear sky. Bright sun. I worked out the dead reckoning problems, and in a celebratory mood my instructor flew first on one side, then on the other, closer and closer until the two AT-6s must have looked from the ground like one plane. I remember scrutinizing tiny scratches on his wingtip—so close to my canopy I could almost have touched it.

Tiring of this game, my friend pulled off to the right and flew wingtip to wingtip with me. As I was resetting my gryo compass, I felt the plane rock slightly. I glanced right and found my instructor beaming happily at me through his canopy. And as I smiled back, he raised his left wing, eased it over my right wingtip, then tapped it: the same little lurch.

"I didn't know planes could actually touch each other and get away with it," I said to him after we landed back at Craig Field.

"If you tell anyone else, we won't get away with it," he answered.

Ironically, close formation became so routine to military pilots that much of their later combat training was devoted to getting wingmen off and away so they could look around. "Spread out," flight leaders of my World War II fighter squadron would repeat to new men. "You're on patrol, not on parade."

And so we learned to fly in elements, wide apart, looking everywhere, each wingman learning to feel rather than see his leader's turns. The flight generally held the "finger formation"—the relative positions of the tips of four spread fingers. But its two elements wove back and forth like pairs of swallows searching for mayflies. Sometimes the second element trailed behind, sometimes the two pairs formed an echelon.

The process started at takeoff when each flight leader established a gentle turn and the following planes turned inside him. First came Number Two, usually newer and greener than the others, nuzzling close to the leader, like a foal finding its mother. Then Number Three, the element leader, slid into position, followed by Number Four—"Tail-ass Charlie."

By the end of a 180-degree turn, each flight was together, its pilots adjusting rpms so they could hold position without jazzing throttles and wasting fuel. In our prop-driven fighters, I learned to find the leader's rpms without breaking radio silence to ask him. I'd fall behind just enough to see the blur of his propeller through mine. That way, my spinning blades interrupted my vision of his, and I saw a "ghost" propeller, turning slowly left or right. A tweak or two of my pitch control held the ghost still, and meant my rpms exactly matched his. Now if I crept up on him, I could crack open cowl flaps, or maybe just open the oil cooler to slow down a hair. Falling back? I'd cut a corner to catch up. Prideful tricks, these.

Number Four had to watch his own rear as well as the whole flight's. When the flight wove, Tail-ass Charlie was always falling behind, then stumbling to catch up, like Dopey of the Seven Dwarfs. Inevitably, he burned more fuel than the other three. His was the worst position, the place, we used to say, for the flight's most expendable pilot. I often found myself posted to that slot.

Jets fly formation much the same way, but with wider separations—except for the demonstration teams. Yet the famed Air Force Thunderbirds and the Navy's Blue Angels latch on just as we did. Ready to go home after a sky-shattering performance, the leader starts that same gentle turn, and the rest of the flight turns inside, and cuddles up to him the same old way. And it's still Tail-ass Charlie who rushes to catch up, howling after the others, then slowing abruptly as he opens his massive air brakes and slips neatly into place.

Fast jets have always served as chase planes for experimental aircraft like the X-1 which broke the "sound barrier," and the X-15 which flew six times faster. One chase plane—usually an F-104—would supervise the X-15's launch from under a B-52, flying to one side of the giant bomber to watch the X-15's rockets fire up. Then the experimental plane would head upstairs and flash out of sight, and other chase planes would rendezvous with it on the way down, to see it home.

In his book about the X-15, "At the Edge of Space," test pilot Milt Thompson says the 104 burned a lot of fuel getting into position for the launch. To save enough for his landing, the pilot often rode the turbulent vortex off one of the B-52's wingtips—"almost like surfing"—using about half his normal power. Thompson notes that geese and ducks have been flying in each other's vortexes for millennia—nature's way of latching on.

The most literal way is apparent when planes refuel while in flight. Modern fighters burn fuel fast, so missions are based around refueling "cycles." Heavy with fuel, great tanker planes roar off at designated times to rendezvous with the fighters at high altitude where air is smooth. For this operation takes a surgeon's skill.

The tanker drops its hose ("boom") toward the thirsty fighters as they cluster under its belly. Often the boom has small, controllable wings, and a skilled operator in the tanker's stern "flies" it into the receiving plane's tank. Other times, the boom ends in a funnel-shaped basket, lit at night, and each fighter noses up to it, gently flies his jutting fuel pipe into it, and holds it absolutely steady, minutes at a time.

And so the fighters take turns to feed. We may marvel at the aerial meeting of the queen bee with the best of her drones. Now we ourselves have espoused the sky, and in the cold smoothness of its distant heights we perform our own marvels.

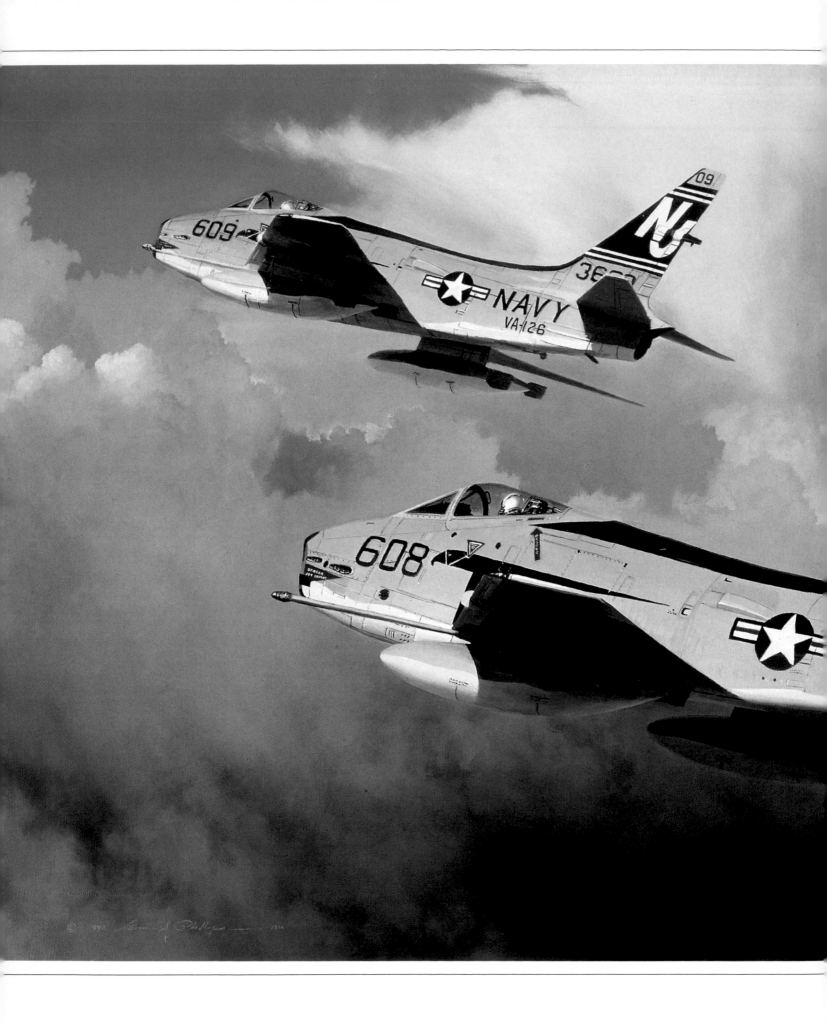

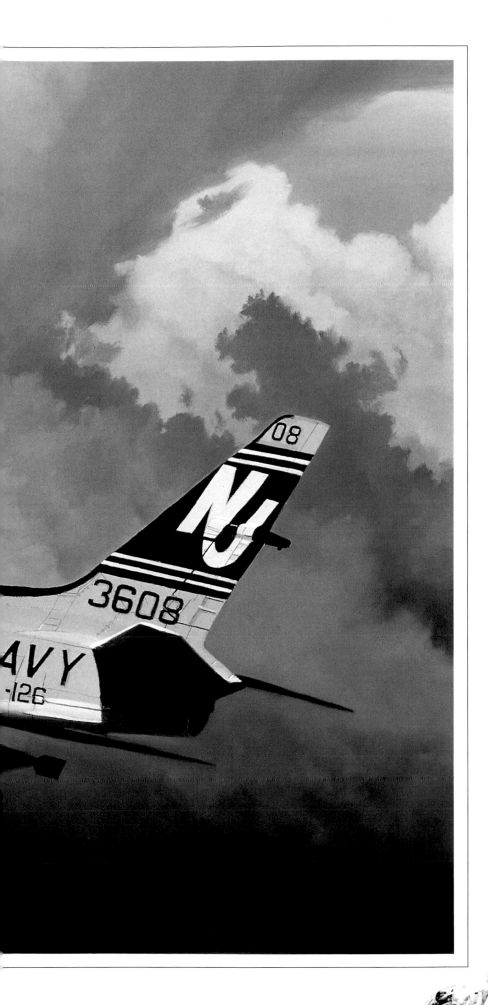

CLIMBING OUT

An element of Furies—FJ4-Bs—breaks out of the murk and turns toward the high cloud corridors that lead to clearer skies.

The Fury was a navy version of that old air force workhorse, the F-86, which cut its teeth in Korea. "A great little plane," says Bill, who catches leader and wingman here, swinging into a climbing turn, nice and tight.

Climbing out and whipping past domes of cumulus, they suddenly realize their speed. "At altitude," says Bill, "far above the earth and its weather, there's very little sensation of any motion at all."

Going through weather in formation puts the onus on leaders of flights or elements. They fly on instruments; wingmen get their heads out, cling close, and keep the faith.

*Navy Corsair heads for
"the weeds."*

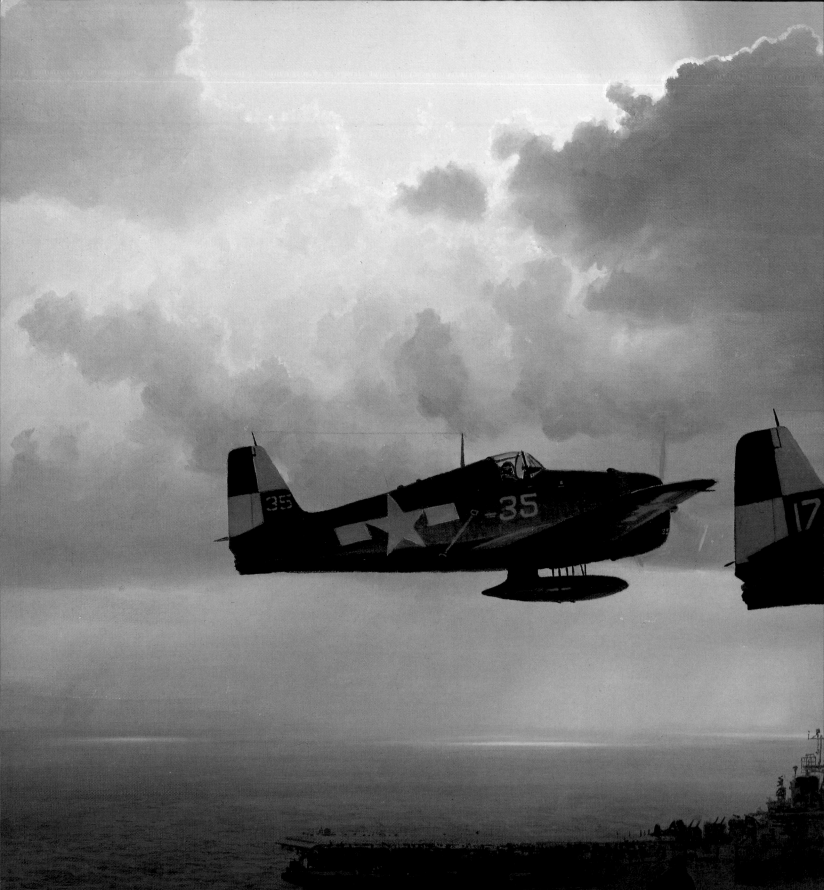

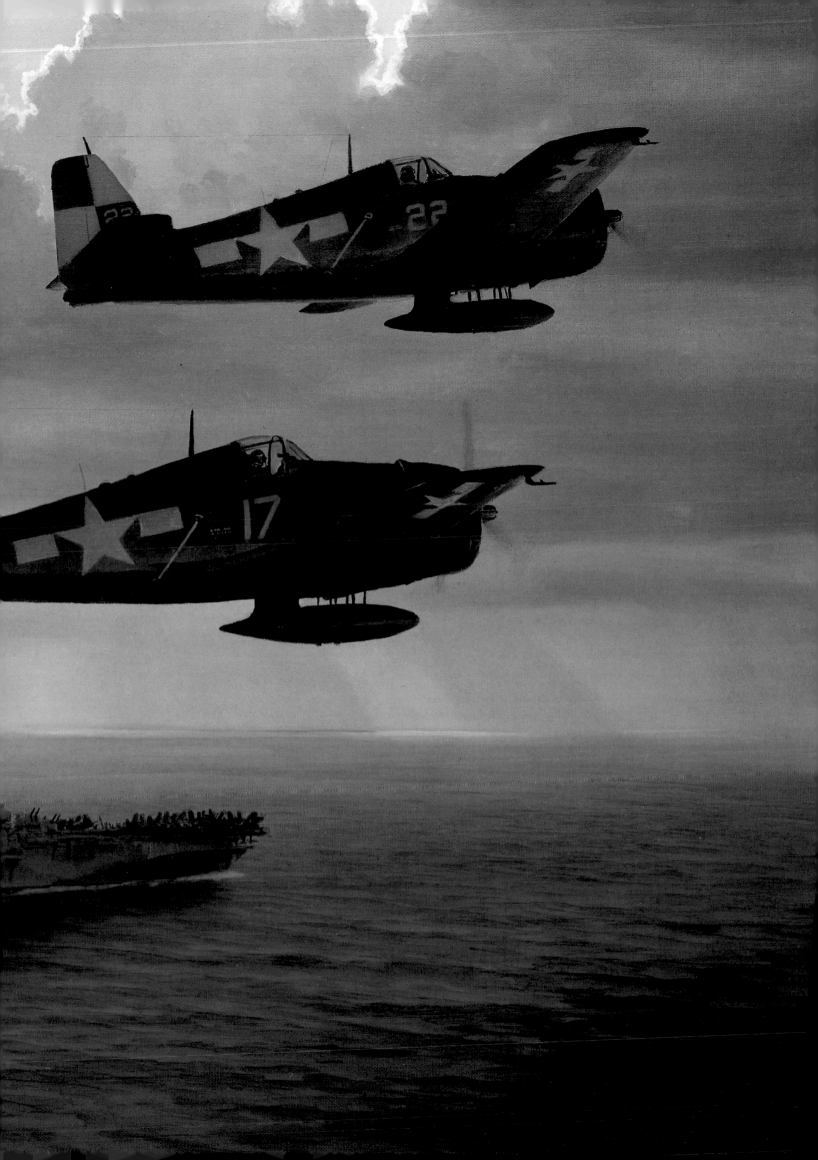

AND NOW THE TRAP

A trio of F6F Hellcats swing over the carrier *Hornet*, getting squared away to come in and be trapped by the arresting gear. These Grumman fighters have been on a boring patrol—no need to drop belly tanks. By now, the navy has the Pacific sewed up. Japan is spent, the old chant, "Home alive in 'fifty-five," is outdated: This is 'forty-five, and the huge trap that Americans have woven around the Japanese Empire is closing. Home looms large in everyone's mind.

Right at this moment, says Phillips, nothing looms before these pilots except the everlasting challenge of landing on a carrier. "This is when blood pressure rises and adrenaline pumps."

So much to remember; so tense the seconds. The landing signal officer takes charge, bringing the fighters in. They clump down, "hit the wire," the arresting gear cables, and are wrenched to a halt in a heartbeat. The trap is sprung.

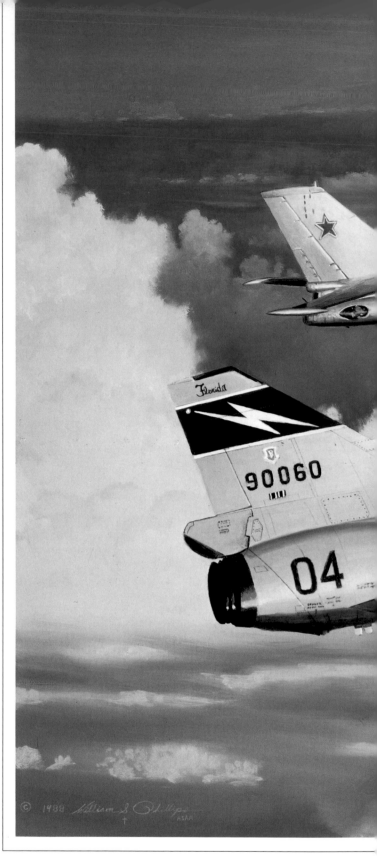

*Deck crewman brings F-4
up to catapult bridle.*

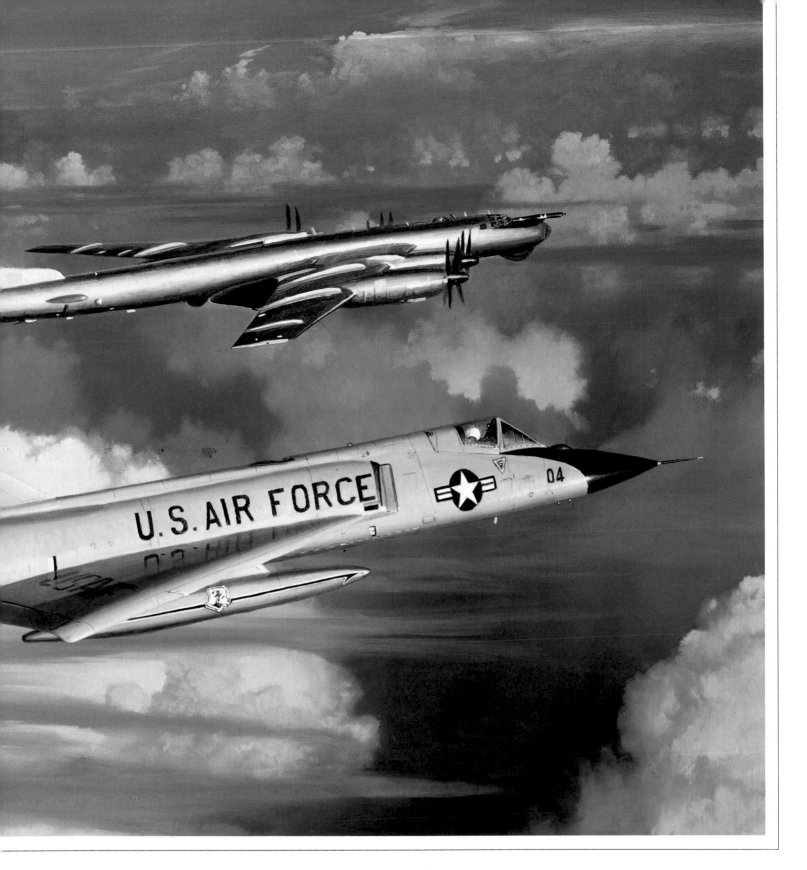

HUNTING FOR BEAR

A chill moment in the Cold War: An F-106 from Florida intercepts a Soviet Bear bomber on a "recce" flight near Cuba, and latches on. Enemies? Never quite. But they often played a little war game, hide and seek in the high sky. In close formation, cameras did the shooting, not guns or rockets. The tension was always high, but always under tight control.

"They'd be near enough to size each other up carefully," says Bill Phillips, "and to wave." So our F-106 was surely familiar to the Soviets—the swept-wing job with a tubular fuselage—and the Bear was old-hat to us—huge and sleek with counter-rotating turbo-props.

And the people inside? Each group would reply to that with a shrug: "Just like us."

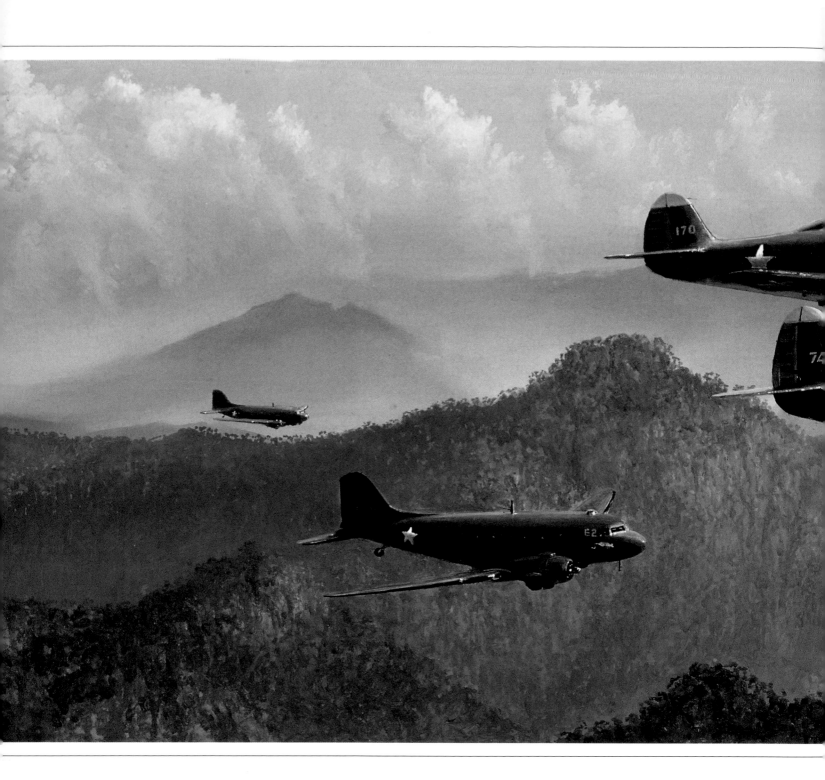

NANETTE

C-47 "biscuit bombers" clip over the foothills of New Guinea's Owen Stanleys with a close cover of P-39 Airacobras. Phillips painted this scene to illustrate a well-known flyer's book, *Nanette*. He didn't know that the painting would appear here, in a book of his art, written by *Nanette*'s author, the pilot who flew its title character—a sexy, dicey, ever-lovin' harlot of a plane—and carried on a most unlikely affair with her.

The Airacobra was one of Larry Bell's many innovative designs—the engine mounted behind the cockpit, drive shaft geared to the propeller, making room for a 37-mm cannon to protrude from the spinner. Originally, a supercharger was planned to make the little plane into an interceptor, but the army wanted that cannon for low-level work like tank-busting, so good-bye supercharger. The army was right. The Airacobra was a wonder at strafing—fast, quick, with great visibility and firepower. But in World War II's early, hungry days, it had to serve as an interceptor too, straining for enough altitude to fight Japan's fast and frisky Zekes and Oscars.

So here's lovely *Nanette*, (number 74) of the grand old 41st Fighter Squadron, on the daily milk-run to Wau, a gold-mining settlement in the Owen Stanley Mountains, beseiged by enemy infantry, that had inched over the hills from their base at Salamaua.

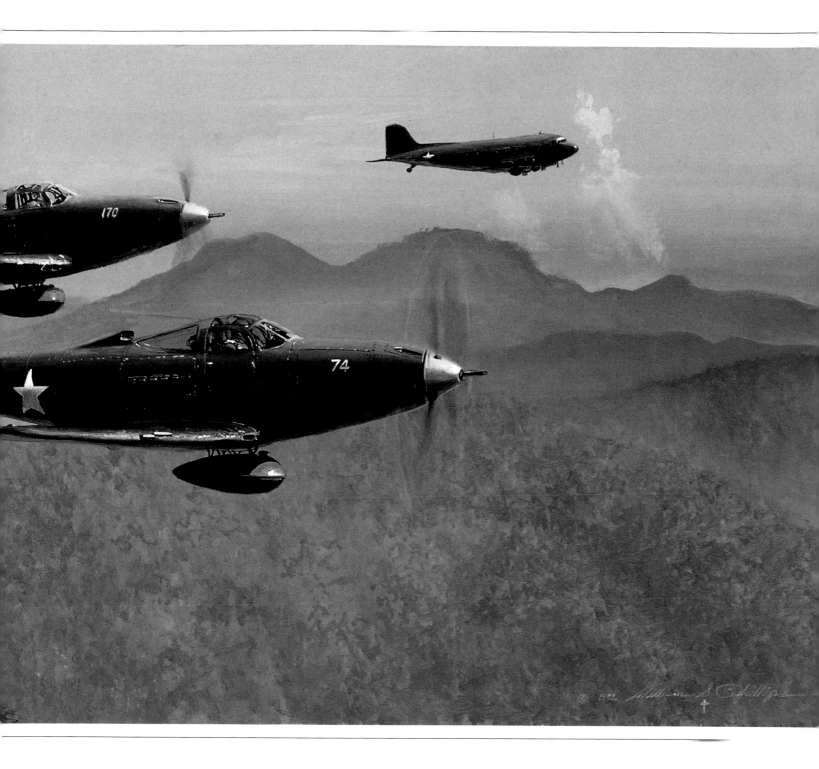

Edwards Park in his P-39 days in New Guinea.

C-47s will land uphill on Wau's tiny dirt strip (it's in a box canyon so no one can go around), disgorge tough Australian infantry ("Diggers"), who'll hit the dirt shooting. And *Nanette* and her sisters will stooge around above, their pilots drenched with sweat, fretting about fuel, endlessly squinting into the sun from whence cometh the Zero.

The cagey Zeros generally waited until the short-range '39s were committed for the homeward flight—too low on fuel to turn back. Then they bombed and strafed. But Japan never took Wau. The dainty, nearly useless P-39s finally gave way to P-47s. And *Nanette*'s skinny, raunchy pilot (left) lived to tell her story in his book. Now he tells it again on these pages.

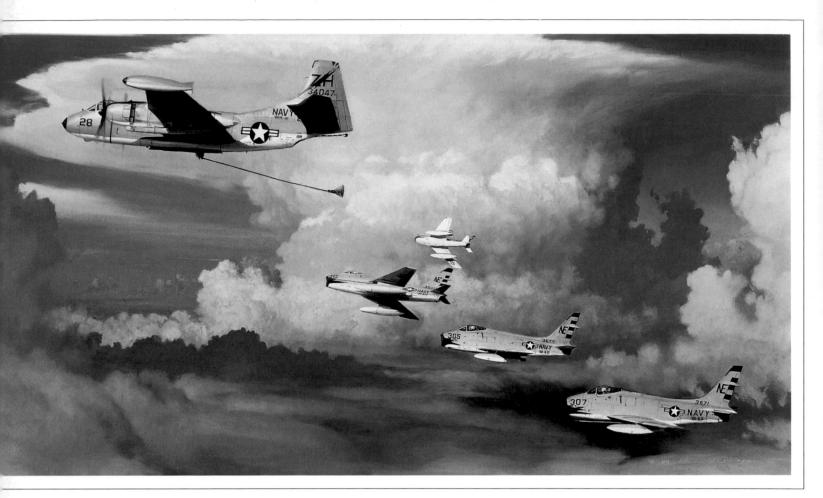

AMONG THE THUNDERSTORM'S SAVAGE FURIES

Bill Phillips loves to play on words. Here, in the '50s, a flight of four fuel-thirsty navy Furies sidles up to an AJ-1 Savage, a jet-assisted piston-engine attack plane, converted to a tanker. Dark clouds ripple with lightning as the fighters snuggle close to suckle, one after the other, at the pipe and drogue that the big plane trails.

Phillips finds a special pleasure in painting the planes of the '50s and '60s. "At that time," he says, "the drab colors of World War II gave way to bright, flamboyant squadron markings and designs on individual planes—to an artist a visual feast of warm colors against the cool, dark blue of the sky."

PEDAL TO THE METAL OVER SMITH RANCH

Latching on became unlatching when test pilots put the rocket-propelled X-15 through its paces in the 1960s. Flights started by "mating" the X-15 to a B-52 bomber which carried the rocket ship to 45,000 feet. An F-104 (at right) supervised the launch, ready to follow the X-15 down to a landing if something went wrong. Landing areas were a series of dry lake beds stretching from Smith Ranch, northwestern Nevada, to Edwards Air Force Base in southern California.

At release time, the X-15 pilot would drop away from the mother plane, light the fire, pour on the coal, and thunder almost straight up, sometimes hitting mach 6, six times the speed of sound, and reaching 250,000, even 300,000 feet—the beginning of space. Then came the long drop back to earth, powerless, flaring out at Edwards to touch down at 200 knots.

A ten-minute flight. First step toward the Earth orbits, toward the moon landings, toward the shuttle flights, surely toward Mars.

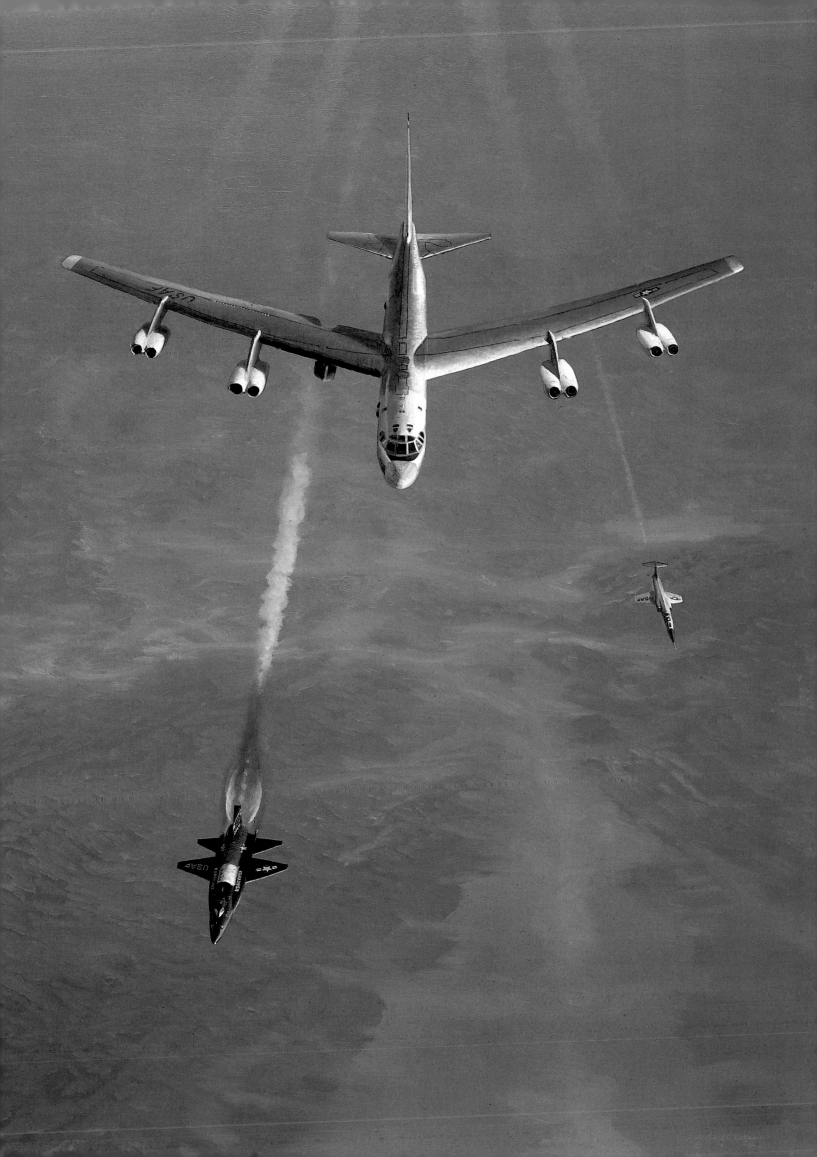

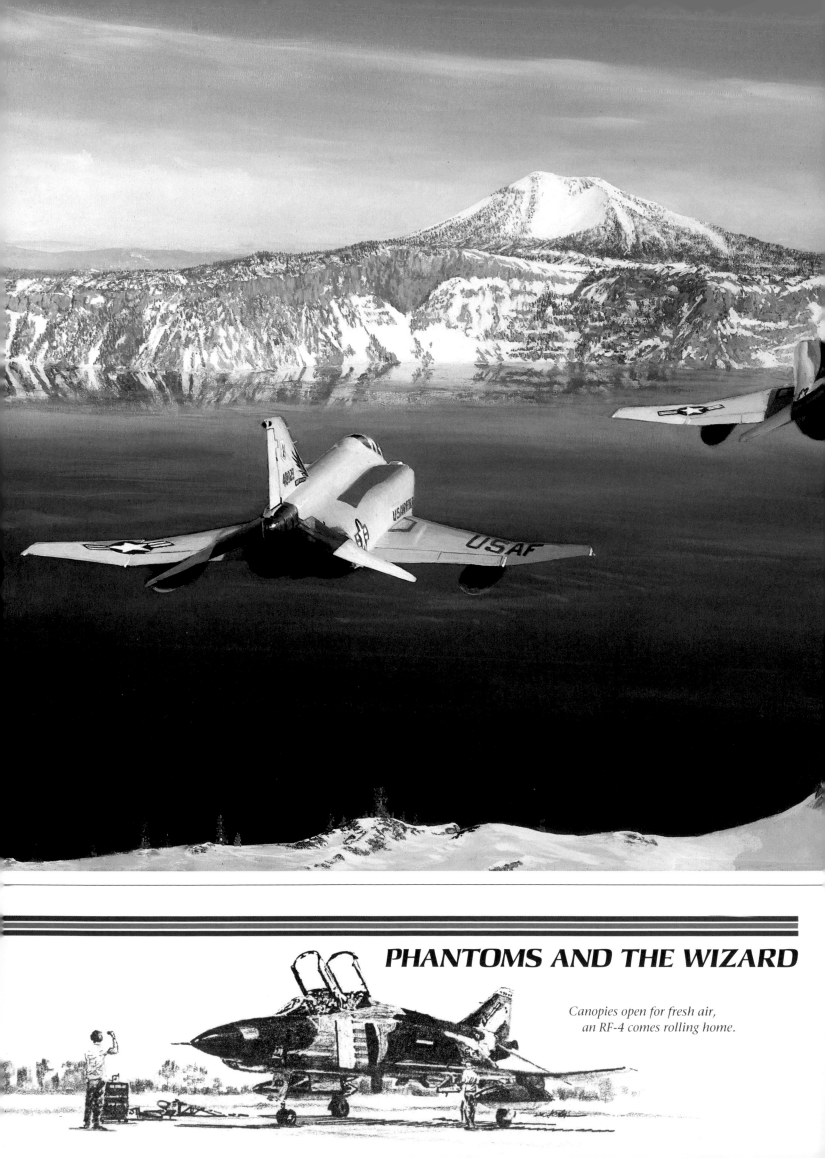

PHANTOMS AND THE WIZARD

*Canopies open for fresh air,
an RF-4 comes rolling home.*

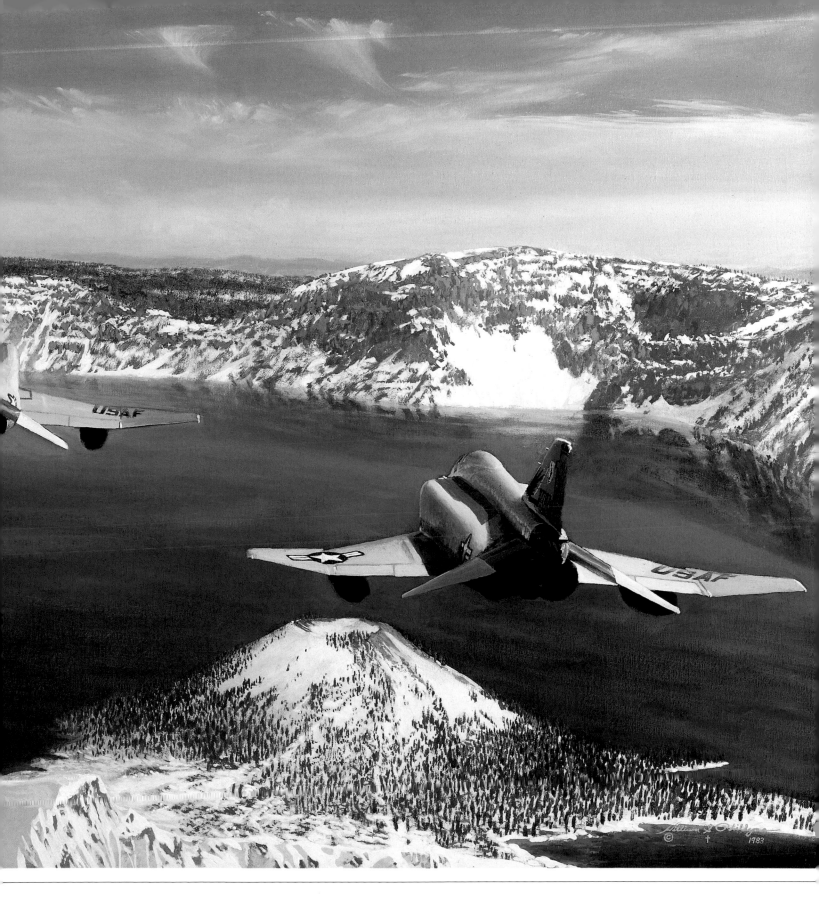

Three F-4 Phantoms, tucked in tight, howl over wintry Wizard Island in Crater Lake, Oregon. Since this is a national park, this unit of the Air National Guard needed official permission for a low flight—at Bill Phillips' prodding.

"This painting takes place in my own backyard," says Bill, who lives in southern Oregon. "The colors are so extreme—pure white and deep blue—that my aerial photos seemed like black-and-whites. I skied in later for more controlled photos and to sketch the area I'd be painting." He also painted the formation flying lower than Crater Lake National Park would ever allow. "Don't try this," he warns. "Only an artist can do it, and only on canvas."

Technically, that world is the high border of the troposphere

HIGH AND

TERRIBLE

abutting the stratosphere. But to much of the military, the high world is the office.

HIGH AND TERRIBLE

We hear it so often that we pay little attention—the faint grumble of a jet airliner passing overhead. It's simply one of the chords in the music of modern life, along with the grind of a truck taking a grade, the snarl of a neighbor's lawnmower, the endless whisper of passenger cars. If we seek a glimpse of the distant plane, we're apt to miss it unless it's spewing a contrail. It's more than six miles high, going too fast to track by its sound. It's in another world.

Technically, that world is the high border of the troposphere, abutting the stratosphere. That high air is smooth and clear as crystal. Aerial bumps and visual distortions diminish above 10,000 feet, along with oxygen. It's also brutally cold out there. Even flying in the tropics, temperature drops astonishingly as altitude increases. But aboard that distant airliner no one feels the impact of this climate. Pressurization kicked in as its doors closed, sealing passengers away from the stark world they'd soon enter. Cabin temperature is controlled.

Climbing steeply out of the uneasy smog that clings to earth, the Captain has straightened on course in the upper air. The First Officer announces in the traditional no-sweat drawl that though we folks on the flight deck are lookin' at a real good flight, y'all best keep those seat belts fastened while you're settin' down. So the passengers drift into that state of traveler's torpor—unmoving, unthinking, uncaring—which makes life more bearable for the ever-stressed cabin crew.

That's how most people experience flying today. But to much of the military, the high world is the office. When tough young Top Gun or Red Flag pilots leave the ground, it's to commute to their place of business, seven or eight miles away—straight up. They get there very quickly and go right to work, aggressor squadrons pulling their tricks, defenders reacting. Images flash on cockpit computer screens, and heads-up displays (HUDs) seeking targets, proclaiming hits or misses by air-to-air missiles that are never quite fired. Winners and losers become apparent in a war that never quite happens. Both teams learn.

And to astronauts, high altitude is merely an inconvenient, sometimes uncomfortable threshold at the doorway to space. They must cross this band of friction, spending fuel recklessly to get through it, before they reach their real world, silent, serene, night-black above a big, beautiful, blue planet.

Beauty was hard to find in the high sky over the ravaged Europe of 1943 and '44. Here came the great bombers, the blackened Halifaxes and Lancasters of the RAF every night, the silver or olive drab Flying Fortresses of the AAF every day. Many experts considered daylight raids foolhardy, almost suicidal missions. And they were almost right.

Rumbling into the German skies of *Festung Europa* at some 25,000 feet, met by the best defenses that a determined enemy could mobilize, the B-17s took terrible losses. But their vast numbers, fed by what was then the world's finest industrial system, finally turned the scales.

Hundreds of Fortresses would thunder off aerodromes in East Anglia, close to the North Sea, quickly form up, and begin their long parade to Germany. The engines growled a bass processional, and fighters, rendezvousing with them and weaving in escort, added their tenor to the song. The music lingered a little behind them as this "air army" vanished high in the eastern sky. Then the last notes faded.

It seemed an invincible force, but...the fighters could only stay as long as their fuel held out, then with a rueful waggle of wings they'd peel away and head home. Alone, target bound, the bombers had to depend on their own massed guns for protection. Their box formations—"V"s stacked upward—covered large blocks of air with a field of fire. They'd need it.

Waist gunners swathed in sheep-lined leather, sucking oxygen, would watch the sky from open gunports, feeling the sting of temperatures far below zero.

When the inevitable German fighters appeared, it was almost a relief, a warming of the blood. Here came the bandits, rising from their fighter sectors, Bf-109s and Fw-190s, noses bright with squadron colors. They'd overtake the bombers while out of range, swing along beside them to look them over, then pull ahead of them and bank to meet them head-on, 20-mm cannon flashing from wings and noses as they bored in, one squadron after another.

The blunt, plexiglass snout of a Fortress was vulnerable to fast attacks like these where enemy planes closed them at some 500 miles an hour. Some would be hit, but from their nose guns and top turrets, tracers reached out toward the German fighters, and a few of these would break away, trailing smoke. Most of the '17s would grind on, steadily nearing the target.

Now fighter attacks would increase, planes striking head-on, then curling in toward the flanks and tails of the lumbering bombers. And now even more Fortresses would falter, fall back, sometimes spin, sometimes explode in an enormous flash. Yet amid the hammering guns, sweating pilots held course, and bombardiers crouched at their Norden sights, preparing for the bomb run.

Suddenly, the swirling enemy fighters would veer away, and the entire sky over the target would flash and blacken with the blaze and smoke of a curtain of flak. Big guns, far below, didn't try to "snipe" individual bombers, but instead poured shellfire into a narrow area through which the planes had to pass. The antiaircraft shells built high walls of explosions, of flying shrapnel. Nothing that flew could breech these walls—the original "iron curtains"—without taking losses.

Some bombers flamed and fell away. Others, only nicked, held their course, surging straight through, now controlled by the bombardiers all glued to their sights.

Shrapnel flew, and pilots, navigators, and gunners tried not to hear it, tried not to see a wing crumple in the next flight, tried not to count the blossoming parachutes: three…five…eight…perhaps, but too often falling short of it.

At last, pilots would feel their planes lighten and hear the blessed message, "Bombs away!" Now for a turn toward England—a gentle turn so that shattered wings would stay on and shattered humans would stay alive. Again the enemy fighters would slash into the attack, nipping at stricken Fortresses like prairie wolves converging on the stragglers from a stampeding herd of buffalo.

Those Fortress crews that survived the great and terrible raids never forgot the sight of friendly short-range fighters meeting them at last over the Channel. As a smitten Yank bomber staggered past the white cliffs, a Spitfire would often circle it, scanning its wounds, calling ahead, sometimes orbiting above as the huge plane, ragged, fragile, blood-soaked, bellied in at the first aerodrome it could reach.

The blackest days ended at last as new long-range fighters arrived from the States. Here came the P-51s, the Mustangs, which were fast, high-flying, well-armed, clean-lined, maneuverable, and hungry for combat. At last, high clouds took on a silver lining for the bomber crews. Getting home seemed a real possibility.

They had little time for heroic postures, those flyers of the European Theater. They lacked a Lord Tennyson to trumpet their endless charges over Germany, again and again, day after day after day, or to mourn the terrible gaps in their formations as they returned to their bases: "Not the six hundred"—or the three hundred, or perhaps twelve hundred that had started out. But the vision of those thousands of young Americans holding their course, unwavering, through the storm of death, doing their miserable duty, remains fixed in the minds of all who honor courage.

The memory deserves, perhaps, a small nod from those airline passengers who got a window seat and—now waiting for their chicken breasts on a frozen bun—stare out at the high sky. Blue. Clear. Vast. Empty.

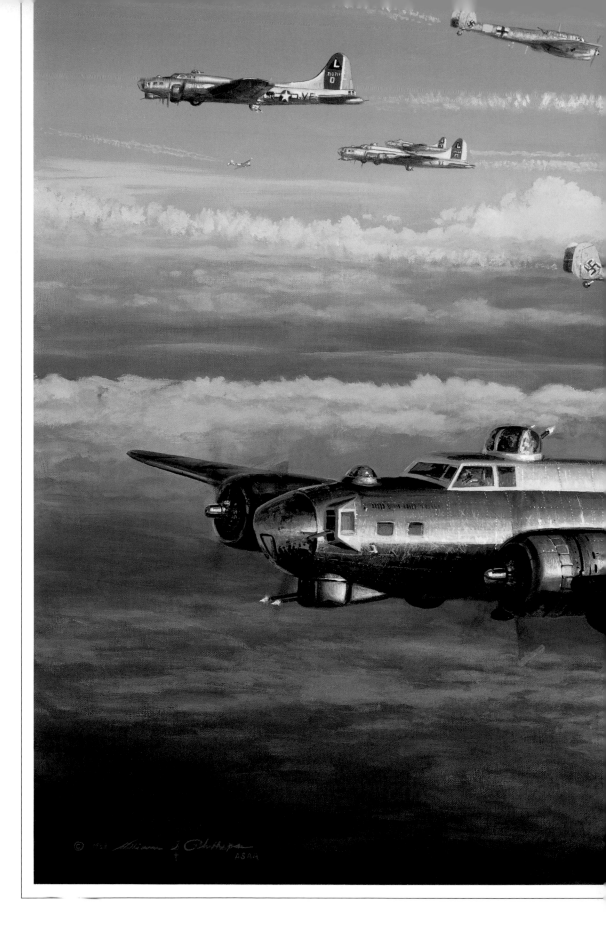

FIGHTING THEIR WAY OUT

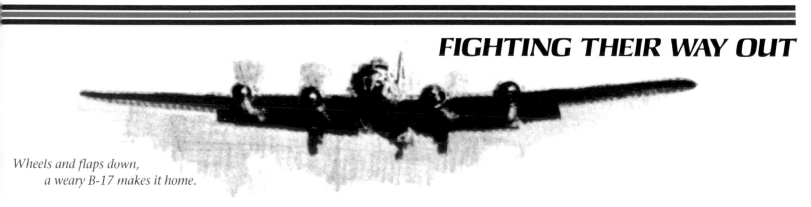

Wheels and flaps down,
a weary B-17 makes it home.

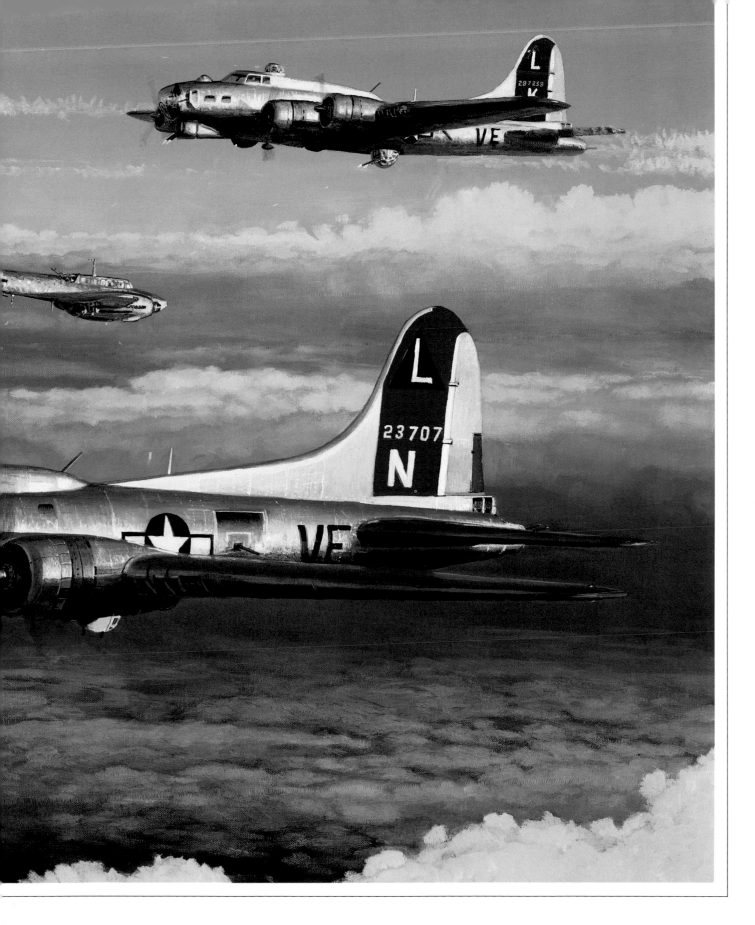

These Flying Fortresses fought their way deep into Germany for a strike. They took losses as they got past the fighters and through the wall of flak that guarded the target. Now, with wounded aboard, riddled equipment, engines losing power, but at last rid of bombs, they swing toward England and try to keep together as they face the fighters again. A swarm of twin-engine Me-110s meets the B-17s head-on, cannons blazing. Gunners slip on blood as they scramble at their turrets and waist guns. Tracers stream from twin .50s as the battle rages anew. But at last a Messerschmitt plumes smoke and slides away. Others follow. And the next fighters these Fortresses meet will lift wings to show stars or rondels—a welcome home escort.

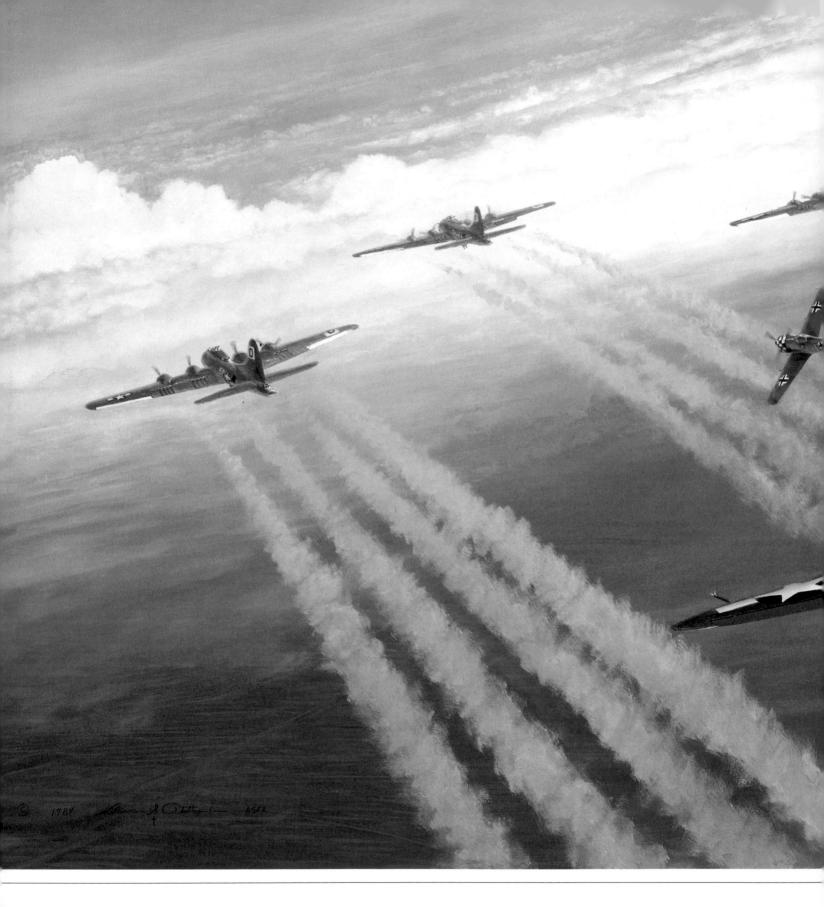

THE HUNTER BECOMES THE HUNTED

Here's a true war story, unfolding at 21,000 feet over Germany on a clear March day in 1944. A stream of B-17s 94 miles long soars toward the target—Berlin—contrails ribboning astern. A unit of the 100th Bomb Group, at the head of this vast "air army," suddenly spots 21 Focke-Wulf 190s, star fighters of the German Luftwaffe, nose cannon rippling flame as they sweep into the

Col. Hub Zemke, beside his P-47, one of four participants who signed this painting.

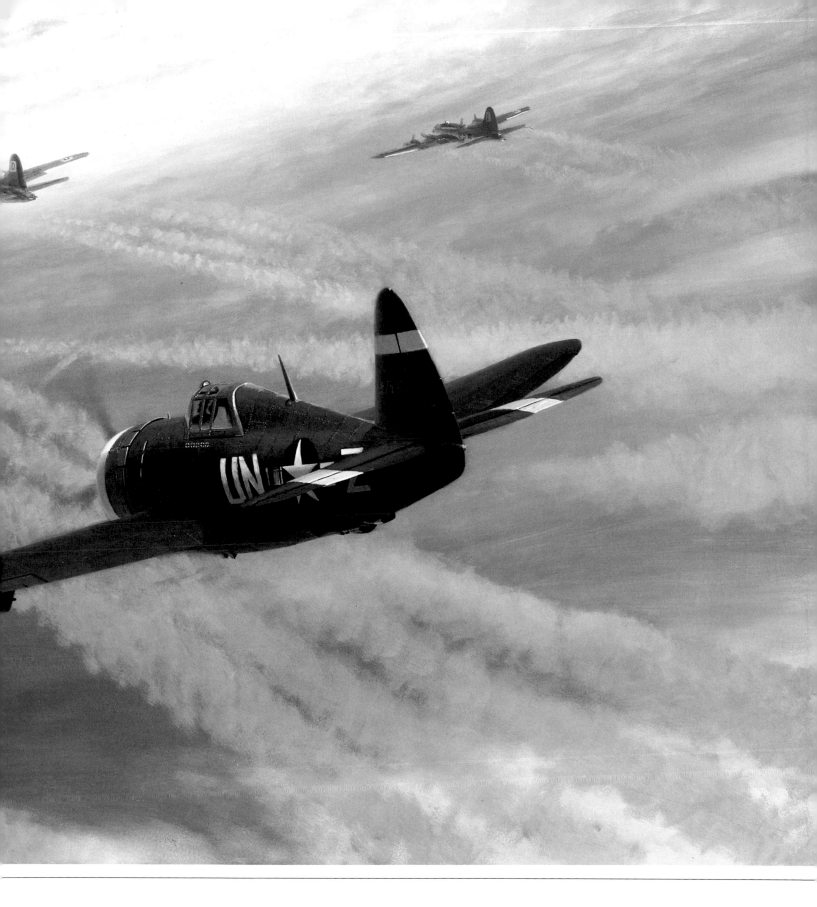

attack. Huge Fortresses smoke, falter, sag out of formation, spin helplessly.The Fw-190s snarl away to reform, but one pilot turns back for another pass. At that moment eight escorting P-47 Thunderbolts, who've seen the bandits and roared back to help, reach the scene and go straight to work. After a gutsy fight, the lone German, well-clobbered, bails out. Phillips'

painting catches the lead P-47 charging in like the cavalry on the slick-lined Fw-190.

Years later, both fighter pilots, German and American, met, along with two survivors of those badly mauled B-17s. All four signed Bill's work while cameras caught the touching reunion for a video. Bill's art had evoked a thunderous moment that only those four veterans could fully share.

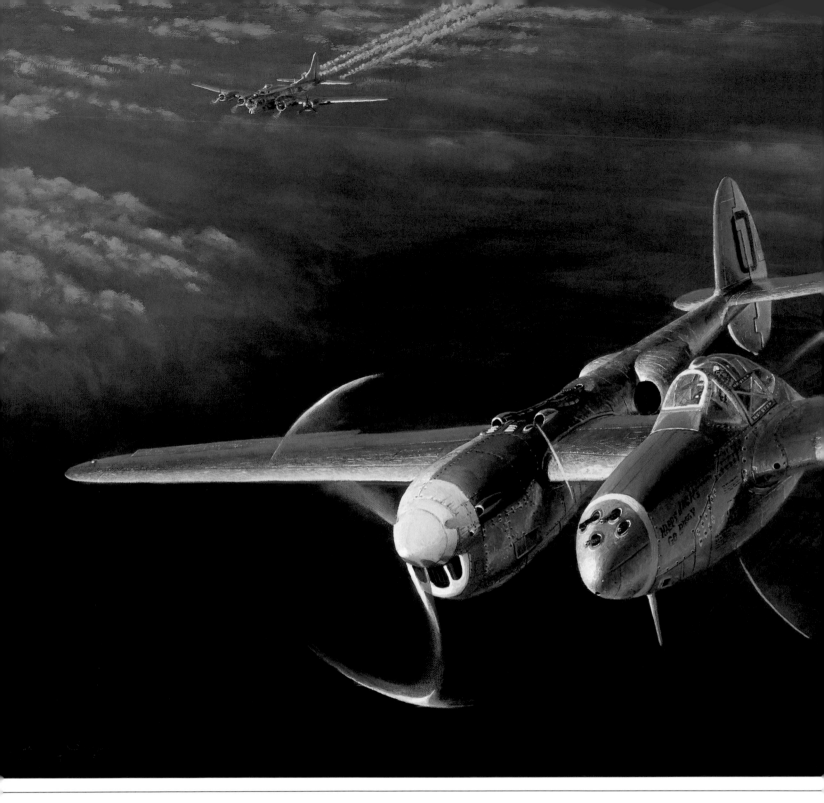

TOP COVER
FOR THE STRAGGLER

A P-38—the lovely Lockheed Lightning—weaves above a damaged B-17, struggling home from a mission over Germany. This fighter pilot, Jack Ilfrey, needn't lift a wing to display his white star and avoid a burst of gunfire from the bomber. The shape of his plane is unmistakable—twin booms, twin tails, a gun-packed nacelle—and a most welcome sight right now.

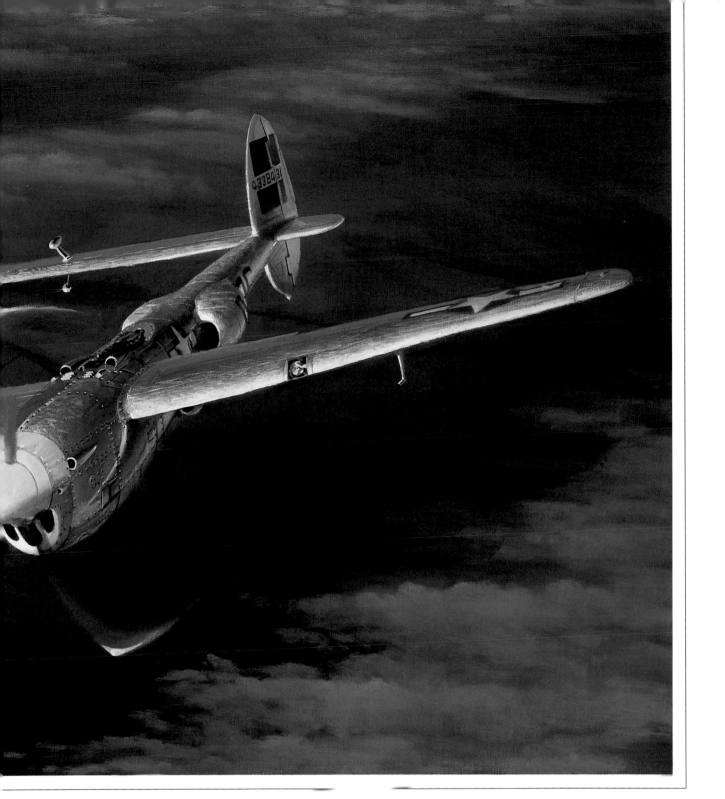

The P-38 was generally second choice for fighting the Luftwaffe. But it stymied Japan's agile Zero by making a straight fast pass, and getting out in a fast, shallow climb. The Zero sought a whirling dogfight, zooming straight up, wheeling on a dime. It couldn't cope with Lightning tactics. So the P-38 squadron leaders used to tell their new men, "Keep your airspeed at 300, and shoot when you see a meatball."

A P-47, fine for top cover, receives maintenance.

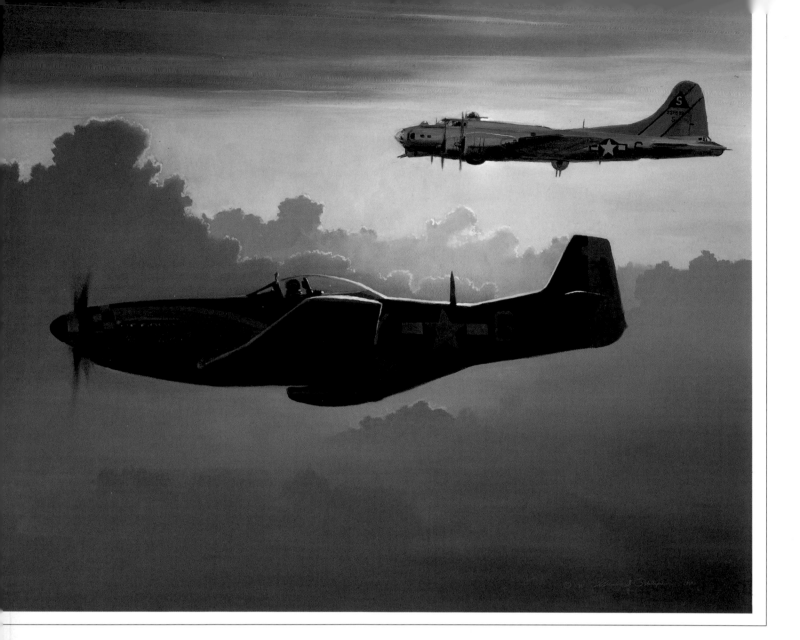

SUNSET SERENADE

A new long-range fighter finally made life easier for the beleaguered Allied bombers that brought the war to *Festung Europa*. It was the Mustang, the North American P-51, one of the world's most beautiful airplanes. Here she is, simple and sweet-lined, loping home beside that other great-hearted warrior of the '40s, the B-17. They have fought side by side this day, and now, as clouds redden with sunset, and earth darkens, they come together companionably. Their engines sing a serenade: the deep grumble of the bomber's four big radials and the baritone of the '51's Packard-Merlin, now throttled back from the snarling tenor of combat. "The sky seems to sing, too," says Phillips. "Up in those clouds, tones of color constantly shift and harmonize."

NEXT TIME, GET 'EM ALL

P-40s of the American Volunteer Group dive on a bomber formation of Japanese "Sallys" over Burma. These fighters were the famed "Flying Tigers," army and navy pilots who in 1941 signed a contract to fly for the Chinese. They resigned their American commissions (with President Roosevelt's blessing), sailed for Asia, and furnished, at last, solid competition for the veteran "Eagles of Nippon," who had ruled the skies over China since the mid-1930s.

The AVG didn't get into action until after Japan attacked Pearl Harbor. Then its squadrons got a cram course in tactics from their famed commander, Col. Claire Chennault. Fight in pairs, he told them. Hit and run, turn, and hit again. The new P-40s were daubed with Chinese markings and shark mouths, and were soon at work. Here, during one of many Japanese raids in early 1942, Bob Neale and a wingman catch the Sallys cold.

The Flying Tigers shot down all but a couple. According to AVG legend, the pilots' usual noisy post-scramble exultation was somewhat cooled when Chennault said, "Next time get 'em all."

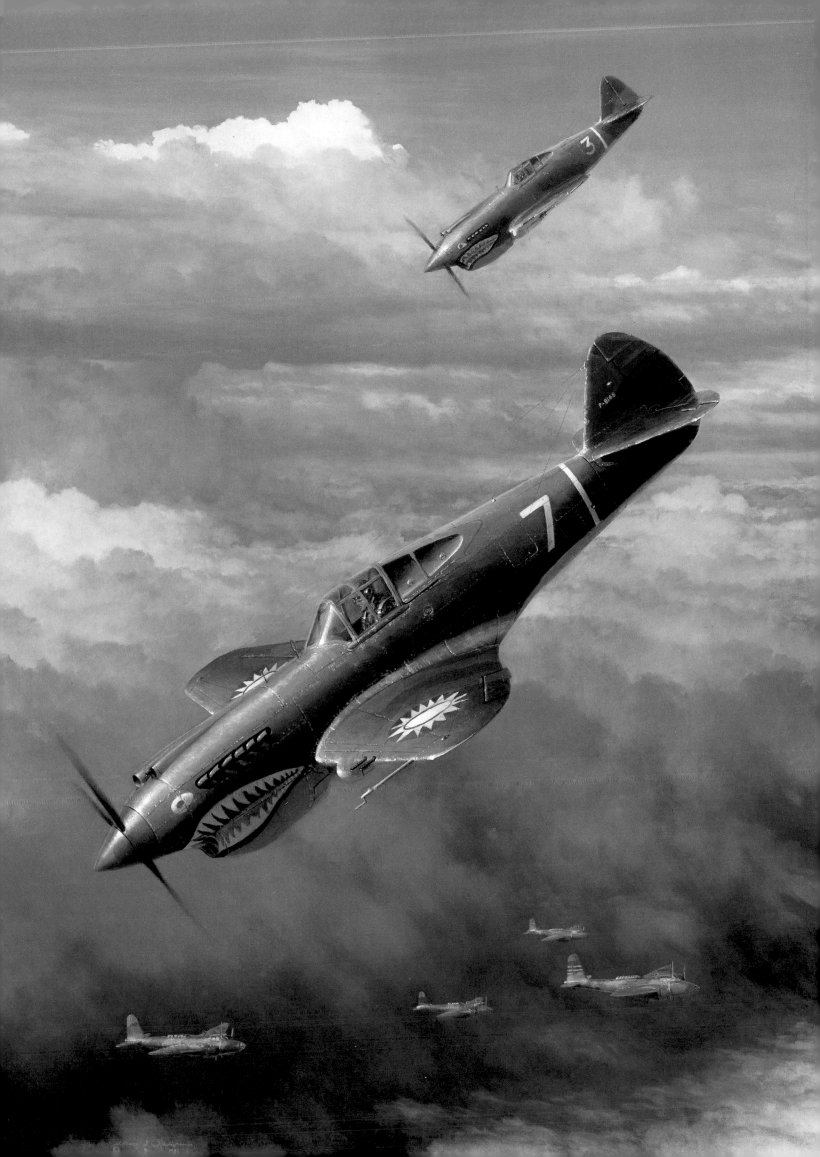

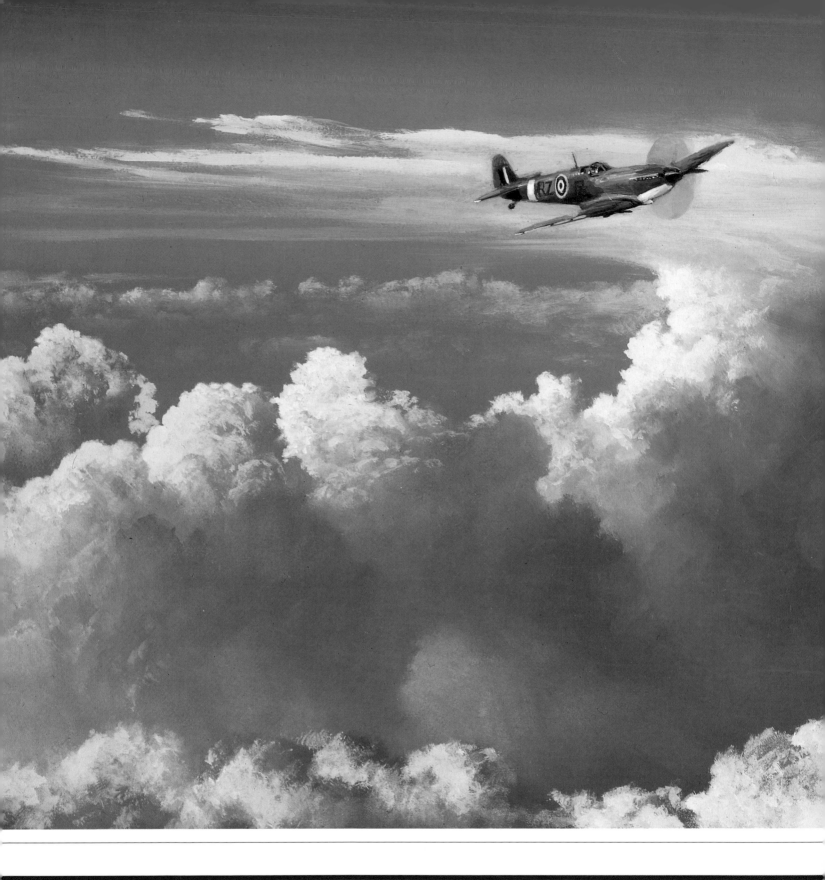

ALONE NO MOR

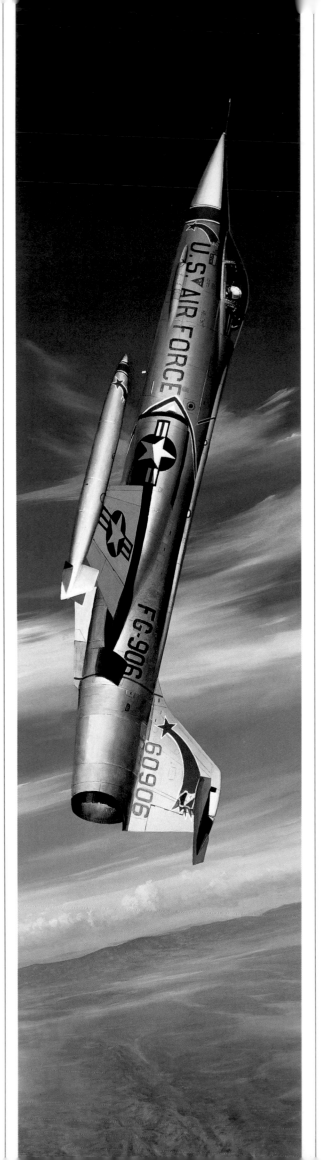

OVER THE TOP

The F-104 was one of the results of the search for speed that absorbed designers early in the Cold War. Of all the "century" series of American planes, F-100 and up, the 104 flew so fast (Mach 2 and then some) and high (over 55,000 feet) that it was chosen by NASA as chase plane for the X-15 and a trainer-utility vehicle for astronauts.

Bill Phillips loves this sleek man-carrying missile, has caught this one just as it starts around the top of a loop over the bleak landscape of the Mohave Desert. The sky shades from blue to the black of space.

The slightly pinched fuselage (the "Coke-bottle look") speeds the airflow. The leading edge of the finlike wing is so sharp that a plastic strip is fitted over it on the ground so crewmen won't cut themselves on it.

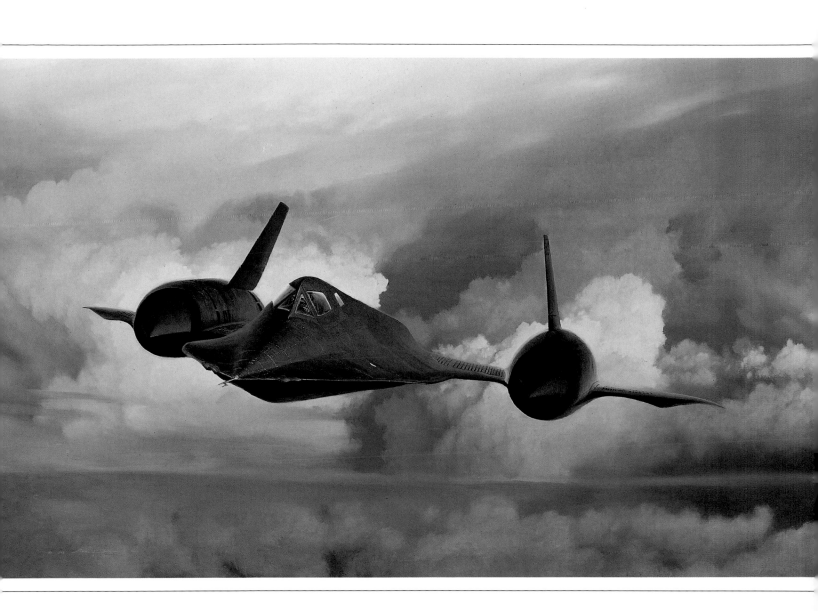

RIDING THE THUNDER

As though it were the future itself, come to shake us in our boots, the SR-71A Blackbird screams out of a stormy sunrise, weirdly unfamiliar, even a little frightening. The Blackbird was designed by Clarence "Kelly" Johnson, genius of Lockheed's "Skunk Works," where his U-2 spy plane was conceived. This monster of the high sky takes over from that delicate U-2, flying at a steady speed of Mach 3 more than sixteen miles up. On a flight from London to Los Angeles, across seven time zones, it arrived almost four hours before it left!

Only two people handle this great beast whose length is 107 feet. The nose juts far out from the delta wing, and the entire fuselage is flattened and curved to become a lifting body like that of the space shuttle. Little is told of the Blackbird's talents as a reconnaissance aircraft. But from the height where its feels at home, it can survey nearly the entire state of Colorado—at once. Then it's bye-bye to the Blackbird!

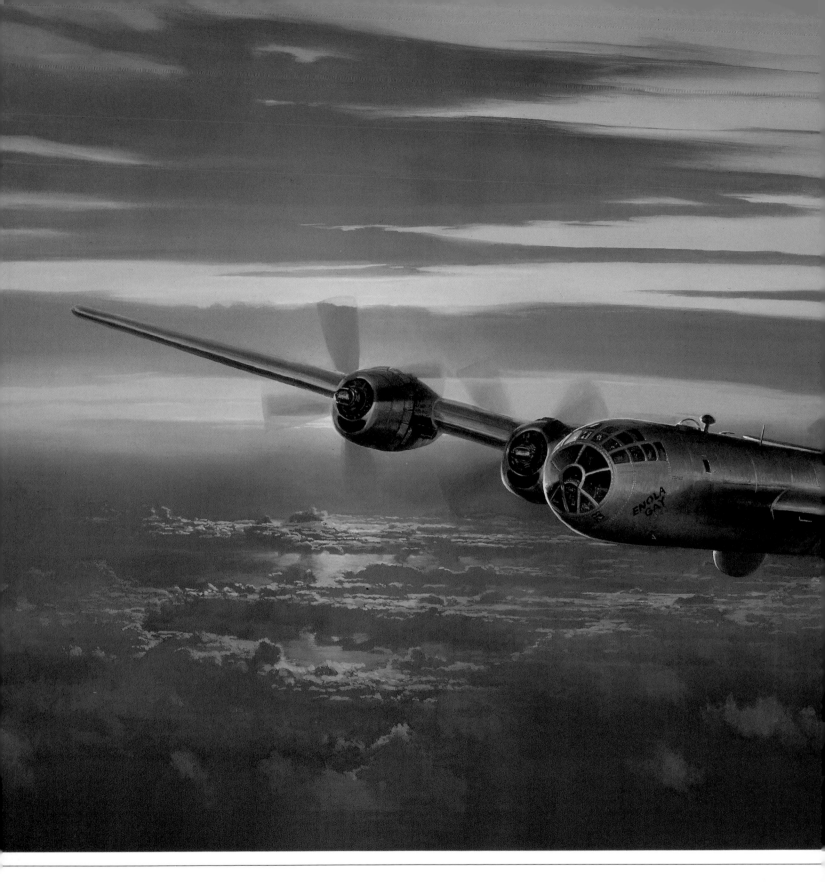

DAWN, THE WORLD FOREVER CHANGED

She was masterfully engineered, a mighty, long-range, heavy bomber with a design based on all that the superb B-17 Flying Fortress could teach. She was the B-29, the Superfortress built to carry the war to the heart of Japan from hard-won Pacific islands. She could tote ten tons of bombs, travel more than 4,000 miles, hit targets with wondrous accuracy while her crew worked in pressurized comfort. She cost millions—and so did the bomb she finally dropped. On the early

morning of August 6, 1945, this B-29 named *Enola Gay* soars high over the Pacific on course for the Japanese city of Hiroshima. Superforts hammer Japan daily, still the enemy does not yield and make diplomatic contact with the United States to sue for peace. President Truman has made the agonized decision to use the just-tested atomic bomb to end World War II.

So the *Enola Gay* has taken off from Tinian in the Marianas. Pilot: Col. Paul Tibbets,

commanding officer of a rigorously trained unit, called the 509th Composite Group. Cargo: one 10,000-pound bomb known as "Little Boy." Destination: Hiroshima.

At 8:15 that morning the bomb fell. It burst above the city, and a great white light filled the air above and the earth below, like a sudden second dawn. And thousands of lives ended as a new age began, unforeseen, barely understood, its fullest implications as yet a mystery.

Make no mistake,
low flight has always been dangerous.

LOW AND

MEAN

…pilots count the odds
of obliteration because of a thermal bump
at 600 miles an hour…

LOW AND MEAN

Serene it's not. Ground level flying is bumpy, hot, dusty, dangerous, and for those of us who like it, it's sheer fun. "Pulling a buzz-job," we cadets called it when I went through training, and it was so utterly taboo that the word "buzz" had to be whispered for fear that an instructor might overhear.

Yet three months after graduating, I was at a fighter training pool, flying P-39 Airacobras around and above a place called Charters Towers, in the semi-tropical state of Queensland, Australia. Our instructor, a squadron pilot on detached service from New Guinea, was outraged, but hardly surprised, that we had never been allowed to practice low level flying. He put us in flights and proceeded to indoctrinate us, four planes at a time.

To all of us new pilots that flight was a feast of forbidden fruit. From takeoff to landing, we seldom soared higher than 50 feet above the ground. The terrain rolled gently with scattered gum trees, and no houses, and our formation spread apart as each pilot clung to his own path over it. Trees flashed past; meadows lured us lower until we seemed to brush a blur of grass. We'd sweep up a hillside, crest it in a blink, then press down its slope, swerving to follow a gully, suddenly flinching as a cloud of white cockatoos rose before us and somehow scattered from our assault. No wonder such flying had been forbidden. This paradise had its perils.

The P-39 was in her element at 50 feet or lower. Down here her lack of a supercharger didn't count. Her Allison engine gulped the heavy air and purred with pleasure. Her plexiglass canopy became a picture window for her pilot; as trees suddenly threatened, he could simply lean away from danger and she'd flip away.

Trees might give way to a long swale of pasturage, and our 'Cobras would settle almost into it, four slip-streams leaving four swathes of flattened grass to blaze our trail. Sometimes a few Herefords would pause at dinner to look up in bleary bewilderment as we swept by, little higher than they. Then a rocky knoll might loom ahead. We'd lean again, and every plane would lift a wing to clear it.

There was a river. Down we would go, two planes at a time, and flick along its surface as though to prey on basking fish. And the glassy water, meandering unhurried toward its destiny, would suddenly quiver and rise into tiny whitecaps as our instant gales struck it and then died away. A sudden bridge? If it was wide, with no fisherman watching, to tell tales, why bother to zoom over it?

Never was there such flying again. For in the real world of combat, getting down on the deck was all too often a last-ditch escape tactic. You did this when a Zeke was glued on your hip pocket, toying with you, scoffing at your '39's relatively ponderous turns, waiting for a convenient moment before touching off those smashing 20-mm cannon and earning another American flag for his cockpit coaming. Your best bet was to lead him low over the ack-ack, and hope the eager gunners shot down the right plane.

As we gained air strength in New Guinea, our P-39 squadron began to receive more low-level assignments. "Strafe enemy gun positions along Shaggy Ridge," the orders would say, "but stop when you reach the Australian lines." And we would have locations marked in coded coordinates and red marks crayoned on a topographical map.

But how different the real hills. Always we seemed to attack a green swirl of jungle with only half a heart, for we had no assurance that we were right, no glimpse of what was going on beneath the rain forest canopy. Our tracers would stream down into the leaves and vanish, and our eyes would water as brown smoke from our pounding guns filled our canopies, and cursing it we would pull out before—as sometimes happened—someone snatched up the branch of a tree with his wing and flew it home.

So we'd chase along the ridge like hounds snuffling after a sly fox. Identifying the Australian lines was easy. We'd suddenly, incredibly, see right ahead a human figure on a bare patch of ground—a tall soldier clad only in shorts and boots, waving a big floppy hat over his head. And we'd stop shooting and maybe do a slow-roll over him, and others like him would crop out of the ground and wave.

The Airacobra enjoyed this work, and loving her as we so perversely did, we were delighted to find some-

thing she was good at. But other planes were also good at this lowdown flight. Britain's Bristol Beaufighter, flown by the Aussies, packed a noseful of guns between two forward-thrusting engine nacelles, and approached a ground target so quietly—"Whispering Death," they called it—that the shocking crackle of bullets was often all the enemy knew of it. And the mighty Thunderbolt, built for high altitude, was a wonder at shooting locomotives. Clipping over French hedgerows, the "Jug" would spot a German train, pick out the engine and charge it like a hunting cheetah, down at the same level. As the boiler exploded, the plane would whip right through the debris, its pilot praying to be spared the ignominy of death by flying smokestack.

Fighters weren't the only planes to work close to the ground. The great bombing raids on the oil-fields of Ploesti, in Romania, were carried out at treetop level by thundering B-24 Liberators. They took heavy losses, but scored important hits because of the element of surprise. Then there were Britain's "dam-busters," those RAF Lancasters with specially trained crews, who, in attacking at night, tried to rupture Germany's hydroelectric power grid in the Ruhr by cracking its great dams.

The huge bombers skimmed over the moonlit lakes that the dams had formed, and released round bombs that skipped along the surface until sinking beside the concrete walls. There, the delayed explosions shook the structures and managed to rupture two of them. Again, the cost in planes and men was almost suicidal—nearly 50 percent. But a technique was proved out. It had already been used in the Pacific when B-25 Mitchells wiped out a Japanese convoy in the Bismarck Sea off New Guinea by "skip-bombing" the ships at mast-head level.

In such raids, bombers came at their targets so low that radar was almost useless in spotting them, anti-aircraft guns had trouble getting clear shots at them, and the planes, flashing directly over their targets, could be sure of many hits.

Oddly, as jets gave us higher altitudes and more speed, tactics often brought the field of aerial combat down near the ground. Sun-warmed earth could deflect a heat-seeking air-to-air missile, so fighters built for 50,000 feet found succor in 50, and speeds of Mach 1.5 gave way to eight-g turns at 250 knots.

Even the huge B-52—the "BUFF," as pilots called it (for "Big Ugly Fat Fellow")—would desert the rarified heights for which it was built, and get low and dirty. As a gunship, the monster bomber rumbled just over the ground belching its firepower right and left.

Make no mistake, low flight has always been dangerous. The 50-hour weekend pilot, breaking all rules by buzzing his sweetheart in a rented Cessna, has a fair chance of dying on her front lawn, a better chance of being turned in by her irate neighbor and so losing his license for a while. And in the military, pilots count the odds of obliteration because of a thermal bump at 600 miles an hour, or of mushing a few feet too far after a strafing run, or of being tired at the end of a mission and losing perception of the nearness of Mother Earth.

From a boat I once watched a fellow pilot, flying his Thunderbolt low over still water, misjudge the clear surface and touch it with his propeller. His plane vanished behind an explosion of spray, then reappeared, staggering upward, water streaming from it. With his engine howling at full throttle and rpms, he struggled toward our nearby base, nose high, speed barely above the stall, steam trailing behind.

Yes, he made it. And that evening the whole base paraded past his plane to stare at the propeller, all four of its blades curled back 90 degrees for about half their length. The near-tragedy attested to the fabled might of the good old Jug, for-ever remembered as a fighter that would get home despite a grievous wound.

Also, it reminded us pilots that low could be mean. But when the next chance came to get gloriously down on the deck, where the ground streaked under us, where we were untouchably fast and free, we jumped at it. Danger? Sure, but not for me. Never for me.

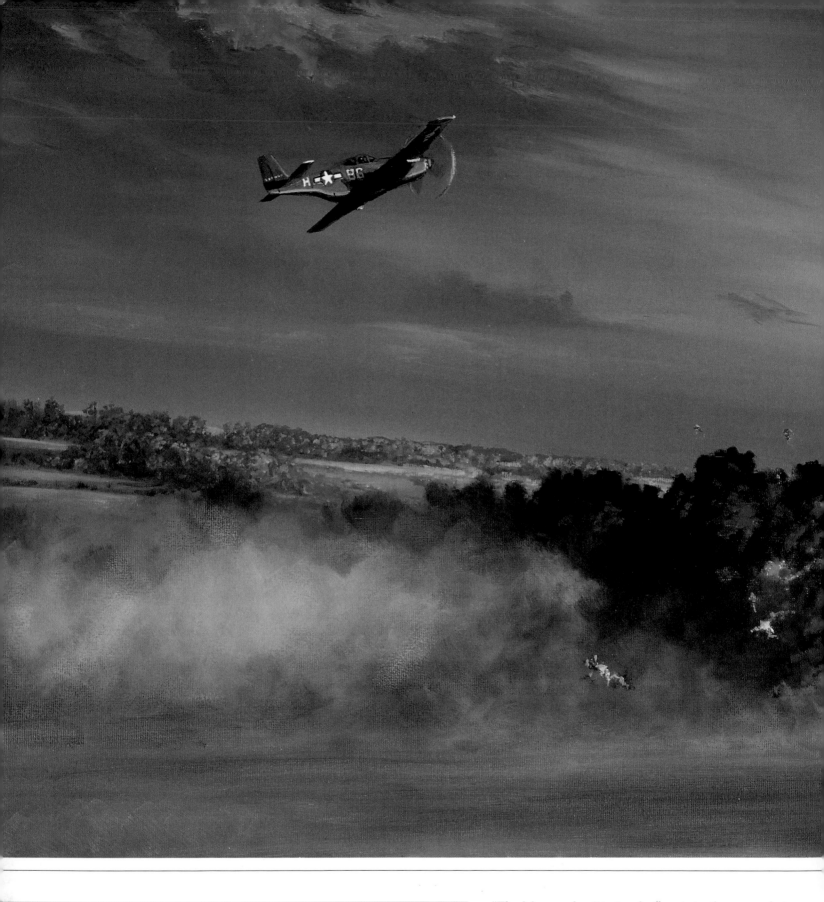

A BANDIT GOES DOWN

"The Messerschmitt simply flew into the ground at full power and blew up like a bomb."

That was how Bud Anderson described one of the strangest of his victories over Germany. His book, "To Fly and Fight", takes this moment for its cover, by Bill Phillips. Anderson writes that his mission, that spring day just before the Allied invasion of Normandy on June 6, 1944, was escorting bombers to Bernberg. The Messerschmitts intercepted, the American Mustangs tore in. Bud, flying "Old Crow,"

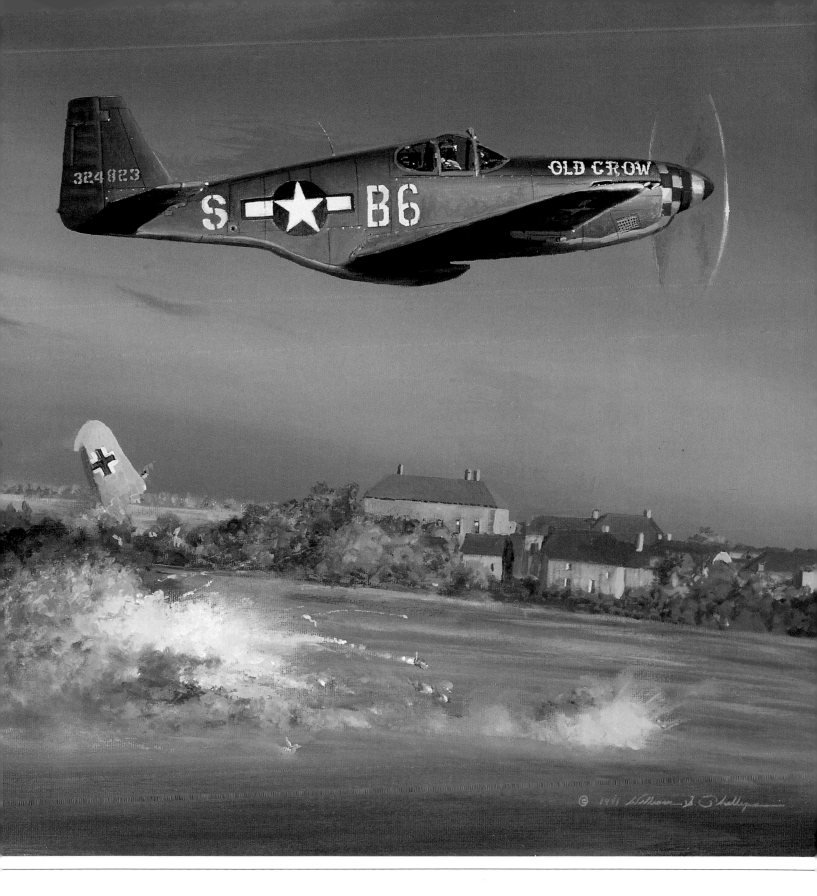

raked the last German, who broke away and dove for the deck. "He must have been very green," writes Anderson. With his wingman he followed the German down.

Hedgehopping sometimes gives a scared pilot the chance to shake off pursuit. Not this time. "As I closed in to fire, he must have looked back...and inadvertently shoved forward maybe an inch on the stick. At that height and speed, an inch would have been more than enough."

Anderson and a new Old Crow with no drab paint, just aluminum.

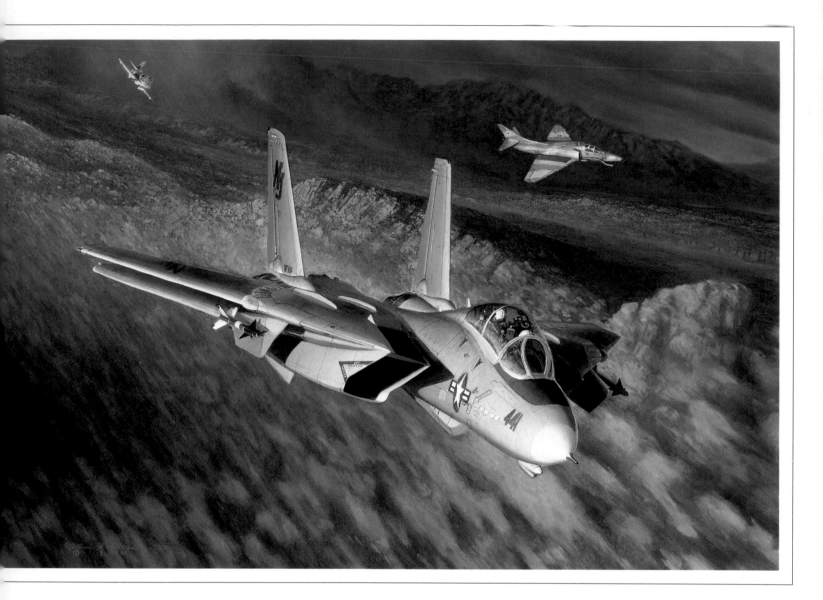

RANGE WARS

An F-14, the navy's big, all-around fighter, pours on the coal as two A-4s from another squadron give chase. The F-14 Tomcat has a variable-sweep wing. Swept back, it allows a speed beyond Mach 2. Extended, it gives the plane a stable approach for a carrier landing.

Both the F-14 and the old reliable A-4 are two-seaters, and Bill Phillips, invited to Miramar, outside San Diego, by the navy, logged time with an A-4 squadron as it went through its exercises over the training range.

This painting is one of many inspired by Bill's low-level flights at this time.

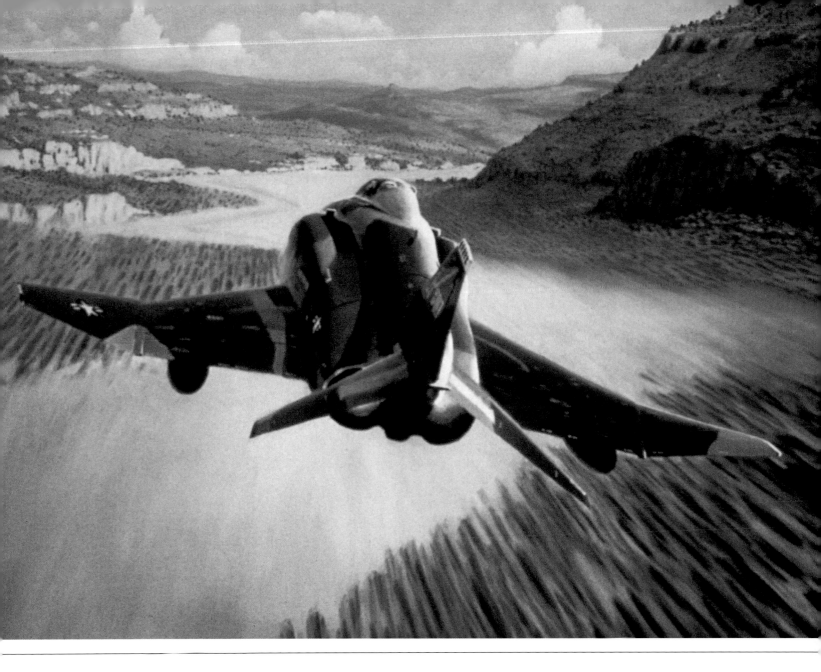

HOT IN THE CANYON

Sage brush streaks just under the wing of this RF-4 of the Nevada Air National Guard. Joining them, Phillips found all his senses on edge as the ground came so close. "You're only a split-second away from disaster," he recalls.

Bill flew back seat in one of the planes of the 152nd Tactical Reconnaissance Group from Nevada to meet a tanker plane over Idaho, and refuel.

The flight then swung through the corner of Oregon, Bill's home state, and back to Nevada, way down low and smoking along at about 500 knots.

Bill notes that, as in many of his paintings, he gets across a sense of speed by blurring the foreground. "I find that this technique works quite well," he says. It is, in fact, a Phillips trademark. He does it better than anyone else.

Reload of weapons pod on an F-4.

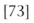

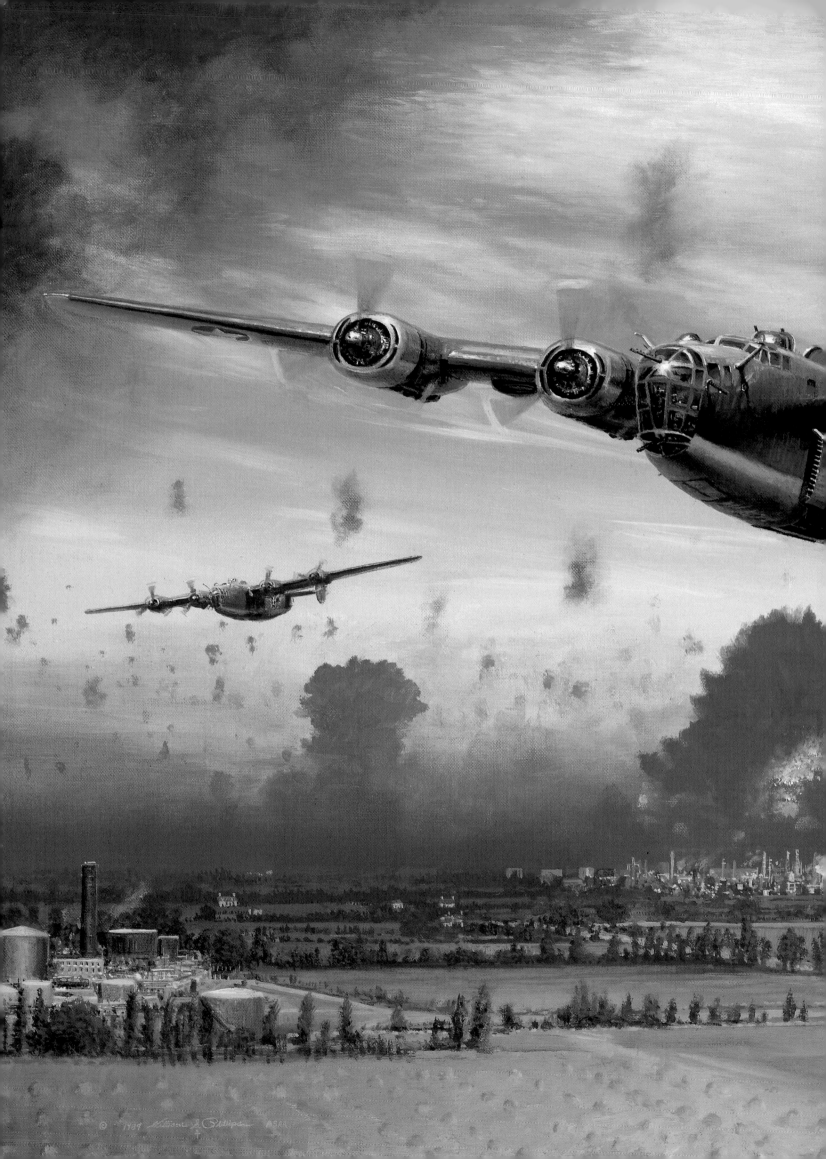

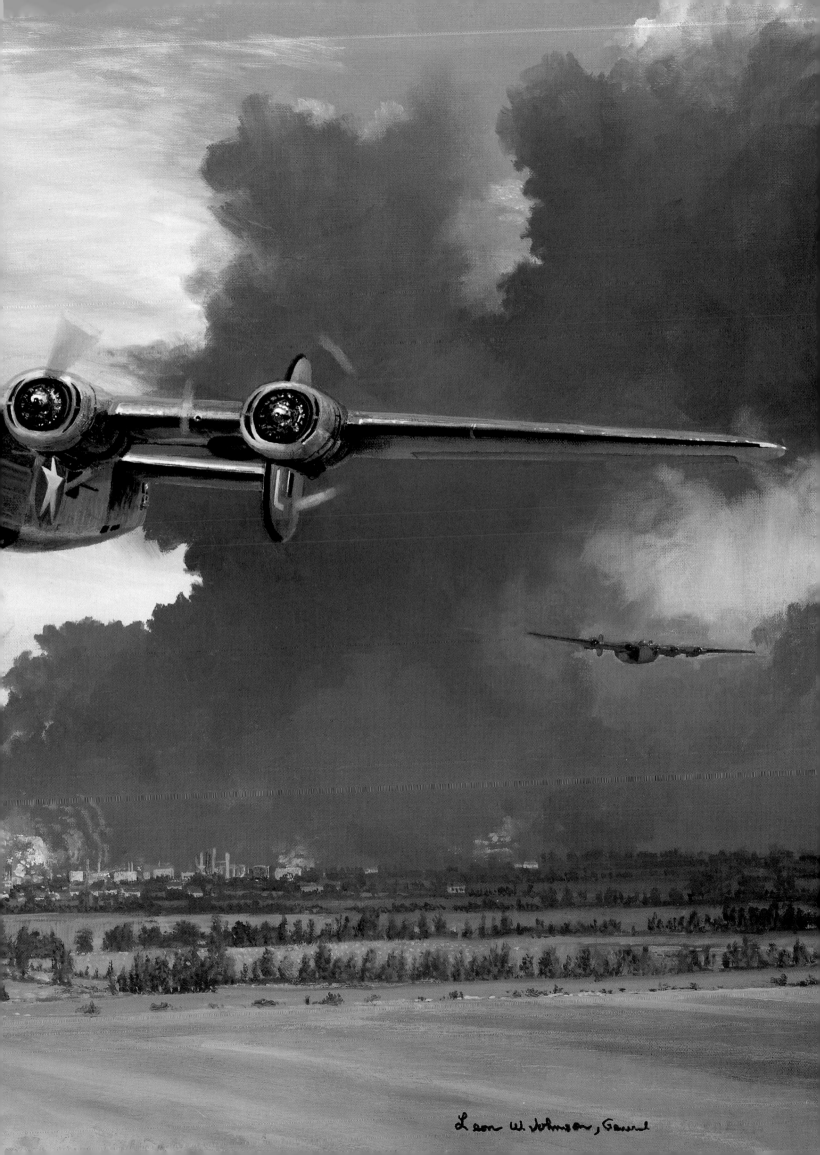

Leon W. Johnson, General

PLOESTI–INTO THE FIRE AND FURY

Whether or not they took part in this action, World War II airmen never forgot Ploesti. The name came to mean an ultimate challenge, a time to go ahead against terrible odds.

A distant target, the Ploesti oil fields in Romania were vital to Hitler. Nazi flak and fighters massed around them and tore into the 164 B-24 Liberators that swept in just over the treetops on a Sunday in August, 1943. Losses: 45 of the huge bombers downed; eight interned when they landed in Turkey; 53 damaged. Low-level attack had failed to catch the enemy by surprise. Yet Ploesti's oil output was cut by 40 percent.

When Phillips first painted this event, he put the oil refineries in the foreground. "Looks like an oil company ad," a critic said. So Bill turned the refineries into wheatfields, with surviving planes limping away from the inferno.

THE GIANT BEGINS TO STIR

On the 18th of April, 1942—167th anniversary of Paul Revere's ride—Lt. Col. Jimmy Doolittle's B-25 leads the way to Tokyo for a bombing raid to show the world that the United States is still alive and kicking four months after Japan's attack on Pearl Harbor. The 16 B-25 Mitchells, army medium bombers, have left the carrier *Hornet*, and take individual courses for Japan at 200 feet above the waves. And now Doolittle sights the enemy shoreline and veers past coastal vessels so he can hit Tokyo from its less protected northern side.

It seemed a mad scheme—army bombers taking off from a navy carrier just to drop a trifling 16 tons on a factory district. But the raid boosted American morale in those dark days. Attending a raiders' reunion, Bill Phillips heard the reminiscences of a grand bunch of men, and interviewing Gen. Doolittle, "I saw the old airman's face light up, his eyes growing distant" as he recalled the Tokyo mission.

The memories stirred Bill especially, for his father played the role of pilot Don Smith in "Thirty Seconds Over Tokyo." He asked that all the raiders sign his painting, and that each surviving senior crew member sign a print—now one of the most valuable in existence.

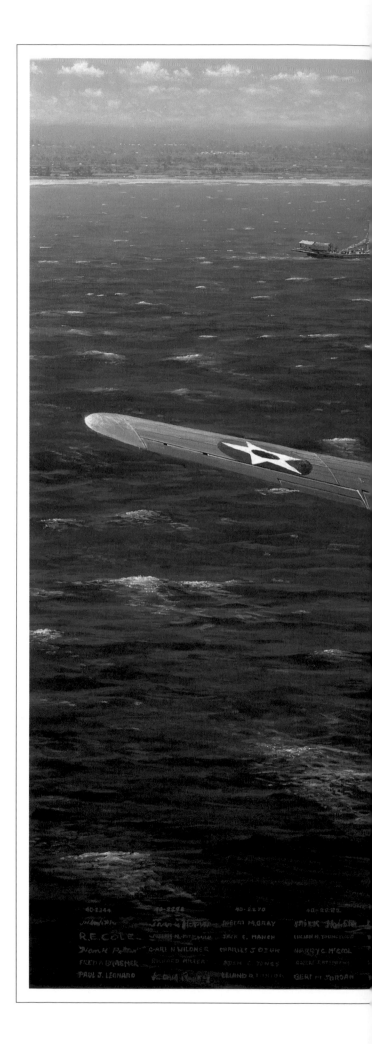

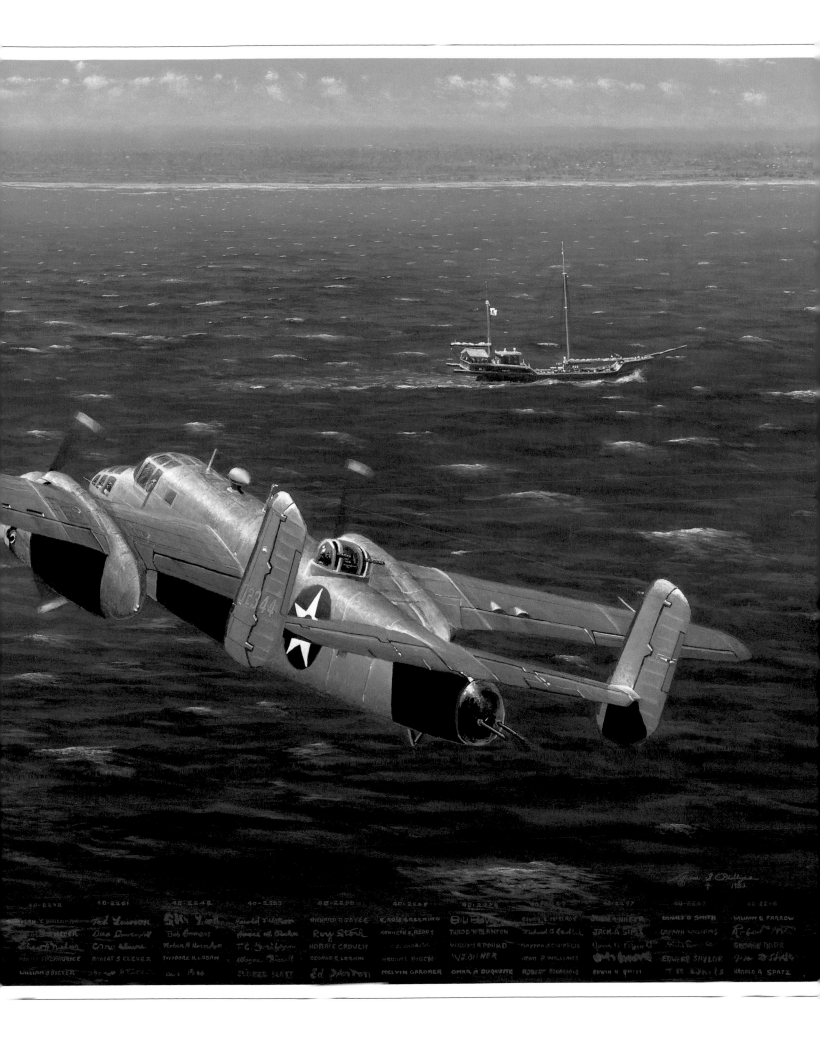

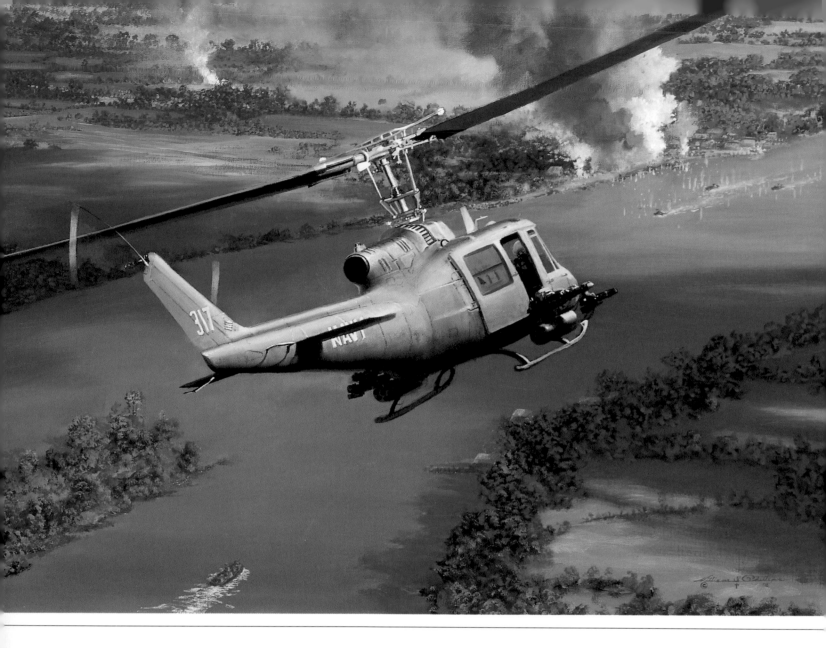

RIVERINE SUPPORT

A navy "Huey" weaves above a patrol boat on a Vietnam river. Helicopters were developed during World War II, did superb service in Korea evacuating wounded troops, and in Vietnam went on the offensive. Small gunships like this were quick to strike with devastating firepower if they got the nod by radio from river boats or ground patrols. They would dive for the trees then turn into the target, coming in so fast and low that the sudden thunderous flap of rotors rocked the enemy at almost the same time that bullets from nose guns and rockets from pods were snapping and blasting into camouflaged depots or gun emplacements.

Like all who served in Vietnam, Bill Phillips fully appreciates the helicopter—a versatile, effective fighting machine for the army, navy, air force, and marines.

Heavy-lift 'copter used
in logging operations by Ericksen Skycrane.

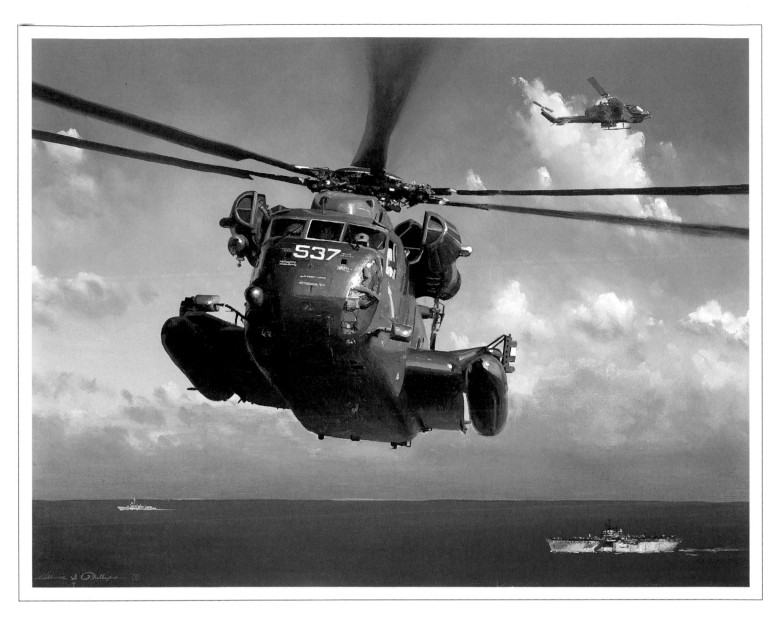

HEADING FOR THE MINE DANGER ZONE

A huge, three-engine navy Sea Stallion helicopter sets off on a mine-sweeping mission during what artist Bill Phillips calls "Gulf War One." This was the safeguarding, by the U.S. Navy, of oil tankers in Mideastern waters during the Iran-Iraq conflict that preceded Desert Storm.

Bill was assigned to the navy at that time as combat artist. "I served aboard ten different ships," he recalls, "and flew in these big helos, also in Hueys, and also went by ship into the area called the mine danger zone. So I saw the operation from both sea and air."

The helicopters chug along, nose-high, towing an electronic device which explodes the mines it discovers. When searching for submarines, a helicopter can hover above a suspicious area and dunk a sonar into it. If the detector finds a target, depth charges or torpedoes can then be dropped from ships or other aircraft to finish it off.

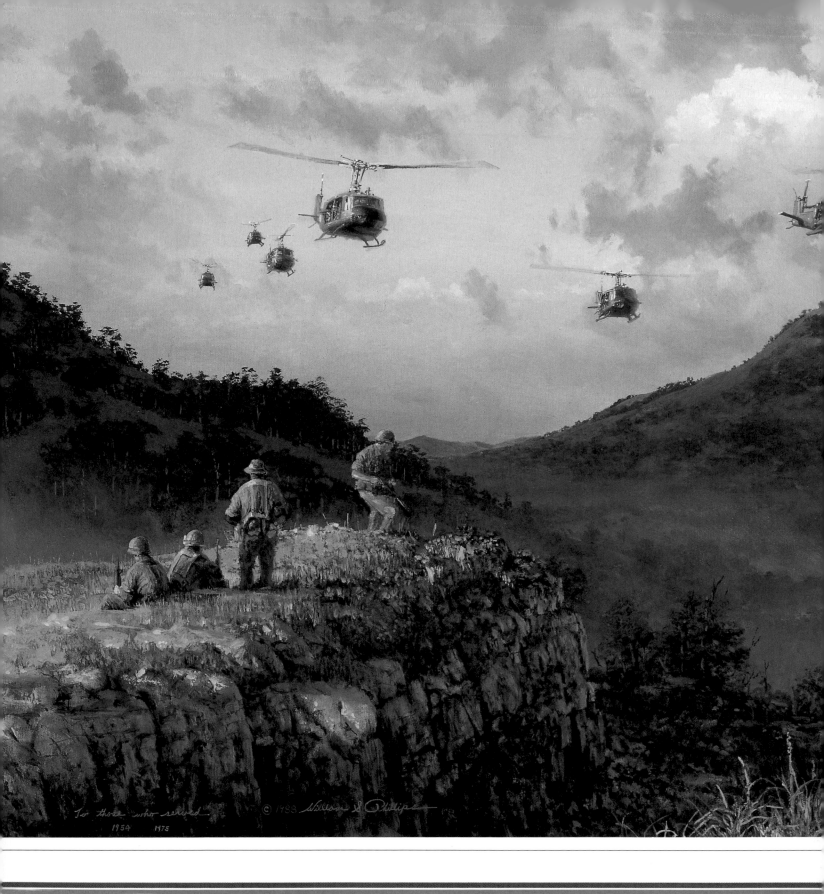

To those who served
1954 1975 © 1988 William S. Phillips

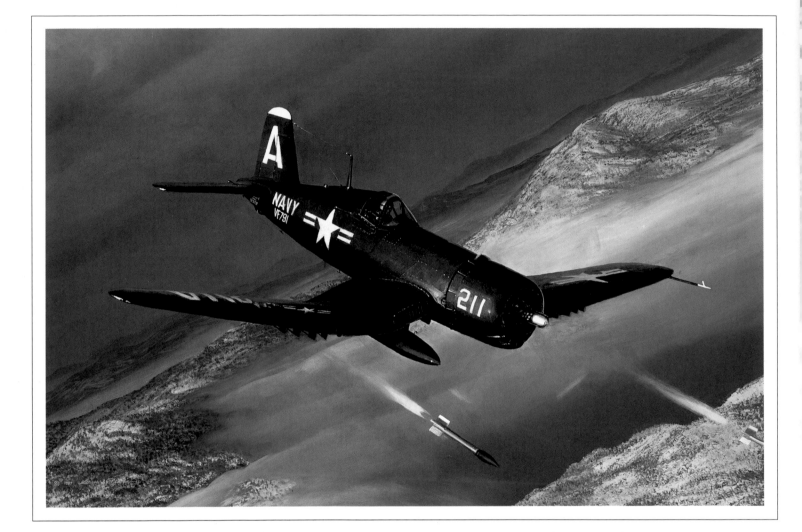

TIME TO HEAD HOME

The bleak sky grows darker; a chilling mist sinks into the icy Korean valleys. The only hot spots in this painting are the last two rockets of this Corsair, streaking for a hillside target.

World War II's old F4U, the Vought Corsair, flown by the likes of marine ace Greg Boyington, earned a spot among aviation's legends. Tough, fast, reliable, it packed ample power to lug new weapons like rockets. So off it went to fight in Korea, along with the slick new jets. This one fires its last load. It's done its day's work.

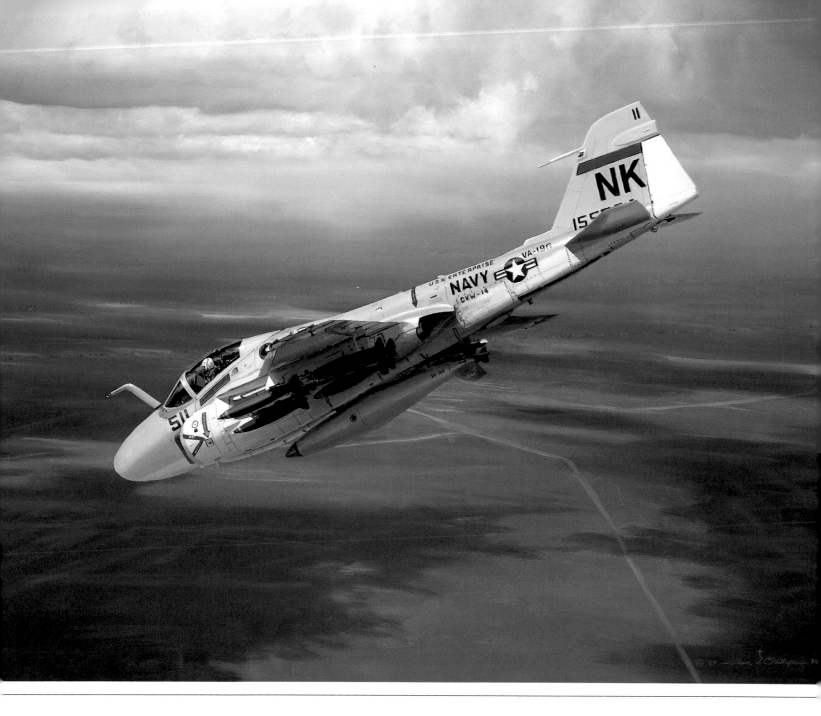

GOING IN HOT

This navy A-6 Intruder, heading down on a mat of jungle, is about to smash a Vietcong target. This was a job it did very well, in any weather, thanks to electronics.

Pilot of this diving A-6, is Stephen Coonts, author of the best-seller—later a film—"Flight of the Intruder," also of "The Cannibal Queen," and of the introduction to this book about the art of his friend, Bill Phillips.

Originally from West Virginia, Steve Coonts put in two combat cruises with Intruders aboard the carrier *Enterprise* during the Vietnam war. He then served as an A-6 instructor for two years before going to sea again on USS *Nimitz* as catapult-arresting gear officer. After nine years of active duty, Coonts became a law student at the University of Colorado. But writing took over his interests, and all his books have done well. The old days of tearing up patches of jungle with this heavily armed, carrier-based bomber are now far behind Stephen Coonts.

Yet few pilots know the Intruder so well.

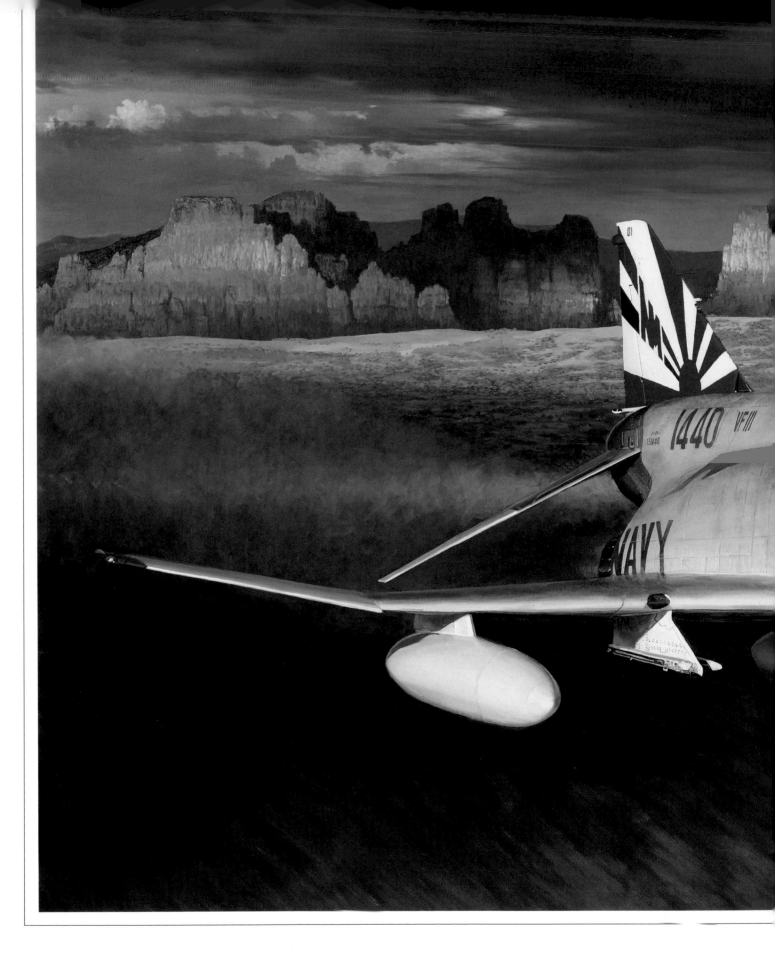

SIERRA HOTEL

Bill Phillips loves this painting—warm canyon colors, a head-on view of a great plane in which he has spent many hours, splashed with plenty of color and a shark's nose. "Reds, oranges, golds, and a little ground rush all add up to a feeling of speed and power," says the artist.

While doing research aboard the F-4, Phillips, a six-footer, has crammed himself into the back

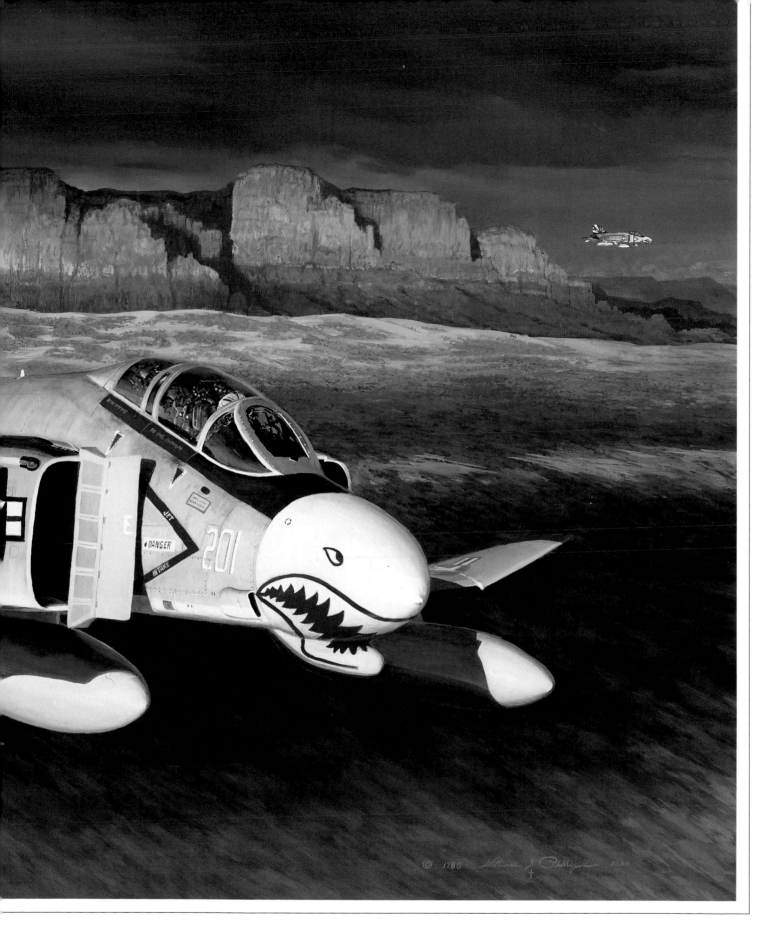

© 1988 William S. Phillips ASAA

seat with his camera, ready to catch moments of action that provide the memories of flight that he paints into his scenic views. He reports that the back seat of a Phantom during a swooping, diving, twisting ACM (air combat maneuvering) mission is a remarkably poor platform for a photographer. "Great for shooting off weapons," he says. "Lousy for snapping pictures."

The F-4's canopy is very confining compared to that of the newer F-15 and F-16 with their picture-window visibility. They've both proved fine for Bill's photography. After his hands-on research, the artist goes to work in his studio, composing the painting that he sees in his head.

"Sierra Hotel" is radio code for the letters S and H, air force for really *fast*.

During the event itself,
your mind was a chaos of flashing ideas,
plans, actions and reactions:

MIXING

IT UP

Meet him head-on.

Look out behind. Break straight down.

Now up. Keep the speed.

The story goes that in early 1943 a P-40 squadron in the Pacific spotted specks high above, glinting in the sun the way Japanese Zeros did. Quickly, the P-40 pilots called them in:

"Foxy leader from Foxy Blue Two: Bogies! Bogies! Two o'clock high!"

"Foxy from White leader: Bogies now at three high!"

"Foxy leader from Foxy Yellow Four: Bogies moving to six o'clock high!"

And the leader answered: "Okay, Foxy, I see 'em! Don't drop tanks yet, boys! I see 'em! I see 'em!"

Then came a new voice in a normal American accent: "We see you, too, Foxy."

Of course you were always watching for them, so it would be wrong to say that enemy planes ever came as a surprise. But sometimes there were more of them—or fewer—or they were more aggressive—or less—and often they did unexpected things. For those quick, illusive shapes in the sky, called "bogies" when first seen, then "bandits" when identified as enemy, were not mere elements of nature, not clouds or sunbeams or reflections or migrating songbirds, all blindly doing the things that science explains. Those shapes had human brains.

Between those gleaming wings, designed for speed and high stress, sat young people, the same as you. They controlled powerful engines and batteries of devastating weapons. They reacted to danger, to opportunity, as quickly as you; perhaps quicker. Their eyes might be better than yours—20/10 instead of 20/20. And they might be wonderful shots, judging deflection with instant assurance, instead of a guess and a prayer.

They were sure to be very bright, some doubtless brighter than you. Quite likely some were medical or law students, with minds that could cope with organic chemistry or torts and contracts. Probably some were teachers or engineers, knowledgeable, quick to plan ahead. Possibly there were talented artists or poets in that formation, driven by inspired imaginations. No wonder they were unpredictable. And of course they saw you, too, and definitely intended to

destroy you, and to avoid being destroyed by you.

Those thoughts only occurred to you after the fight was over and you lay silently on your cot and stared into the blackness of deep night. During the event itself, your mind was a chaos of flashing ideas, plans, actions and reactions: Meet him head-on. Look out behind. Break straight down. Now up. Keep the speed. Roll and haul out right. There's a shot! Hits? Maybe. Look out behind.... All in a blur.

In World War II, action was fast, and a whole catalogue of thoughts passed through your head in half a second. In World War I, the action was half as fast, and the thoughts could afford to take a little longer. Also, because of the newness of aviation, where every pilot was also a pioneer, combat was complicated by inescapable considerations: Can I keep this crate flying, or will I spin out? Will my guns jam? If I dive any faster, will the wings stay on when I pull out? How did the German ace, Immelmann, do that turn of his, anyway?

Another of Germany's first aces, Immelmann's friend Oswald Boelcke, developed basic tactics for aerial combat: dive at your prey from out of the sun or from behind a cloud; get below him and pull up under his unprotected belly; then open fire. This "Fokker bounce," as it was dubbed, worked fine until everybody in the sky tried it at once. Then it turned into that writhing, circling, snarling melee called a dogfight.

Fast as they were for their day, the first World War's fighter planes—Fokkers, Albatroses, Spads, Nieuports, Sopwiths and a host of others—quickly slowed when the dogfighting began. Then only maneuverability counted. Engines roaring to hold them in the air, torque twisting them to the edge of control, the little biplanes staggered around steep turns, stalled at the top of abrupt climbs, fell out of rolls, as pilots tried to snap shots at the enemy and dodge his return bursts.

This violent flying inspired designers to go for extreme maneuverability, as in Baron Von Richthofen's bright red Fokker triplane. It pirouetted through its dogfights, spinning around one wing, climbing like a leaping cat, looping and rolling far too tightly for any

biplane to follow. But it was slow. Allied pilots learned to slice right through a gaggle of triplanes, picking targets, firing and breaking away without joining a whirling fight which they'd probably lose.

That kind of tactic became standard a generation later, in World War II: Meet the enemy head-on, at full throttle. Take a shot and keep going until you can turn and get back into it. Over England in the summer of 1940, each new day produced a routine spectacle: German bombers droning over to smash the British air bases; Spitfires and Hurricanes clawing up to slash into them; Messerschmitt Bf-109s diving on the British planes. And the serene sky was ribboned by creaming contrails and echoed the snarl of engines, the stutter of guns.

Pilots wanted speed as well as maneuverability—more and more speed—and it increased during that war. Jets made a bow before it ended. They demanded revamped tactics since Boelcke's rules of dogfighting had no bearing on missile-armed planes, closing at a thousand knots. Now the intense pressure of combat had to include clattering radio messages and radar blips along with firing a missile when you saw a speck.

But it turned out that planes traveling like bullets weren't very satisfactory for air combat. They needed guns as well as missiles, and they often found themselves fighting down on the deck, writhing around hills and through canyons, instead of up where their designers thought they belonged. So, quite ironically, old-fashioned maneuverability has made a comeback on drawing boards.

Fighters capable of twice the speed of sound are being built now with deliberate instability. They can wrench themselves, faster than a thought, into maneuvers too extreme and too fleeting to be named. But they are too dicey for a human to handle. Computers control them, sensing far faster than the finest pilot every change in airflow and pressure on the flight surfaces and reacting to each tiny twitch. In combat, computers translate the pilot's every wish, every surge of adrenaline into sizzling turns, sudden climbs, whiplash rolls, and blistering dives with an agility that no pilot can match.

Aircraft have grown so far from their fragile beginnings that it's hard to see any family resemblance between the newest stealth fighter and the awkward struts-and-piano-wire Wright biplane that the U.S. Army, in what many considered a spasm of insanity, purchased in 1909. But one aspect of flight remains constant—the people who do it.

Today's fighter pilots, male or female, heads crammed with computerese, eyes scanning the monitors that rule the flight, may seem vastly different from the misty old-timer in leather helmet, goggles, and streaming white scarf. But remember, they've both always been bright humans—probably capable of doing law or medicine, perhaps of teaching or designing, possibly of painting or composing. And they've shared one trait as they've gone into action—controlled recklessness.

Using every gift of physical ability: sharpness of eye, instinctive coordination, hardness of muscle to hold an eight-g turn yet not black out; using all the hard-learned cockpit skills, you, the fighter pilot of every generation, have turned toward the foe. You've stayed alert to the battle's broad picture, keeping what RAF pilot Mike Spick calls "Situational Awareness," even while diving, twisting, rolling, to find your moment.

And when it came, you've snapped on a mental switch and turned suddenly reckless. Now! Go for your prey! To hell with the consequences! You're a lioness on the last dash of her hunt—no more careful stalking; just a streaking charge, a quick slash, and an antelope torn and tumbling, dead in the dust.

Triumph! But now snap off that switch. Fall back on normal skills, normal procedures of flight. A death wish doesn't win a battle.

Controlled recklessness. A strange knack that you have all shared. It's always come to you when you've mixed it up, up in the warring sky.

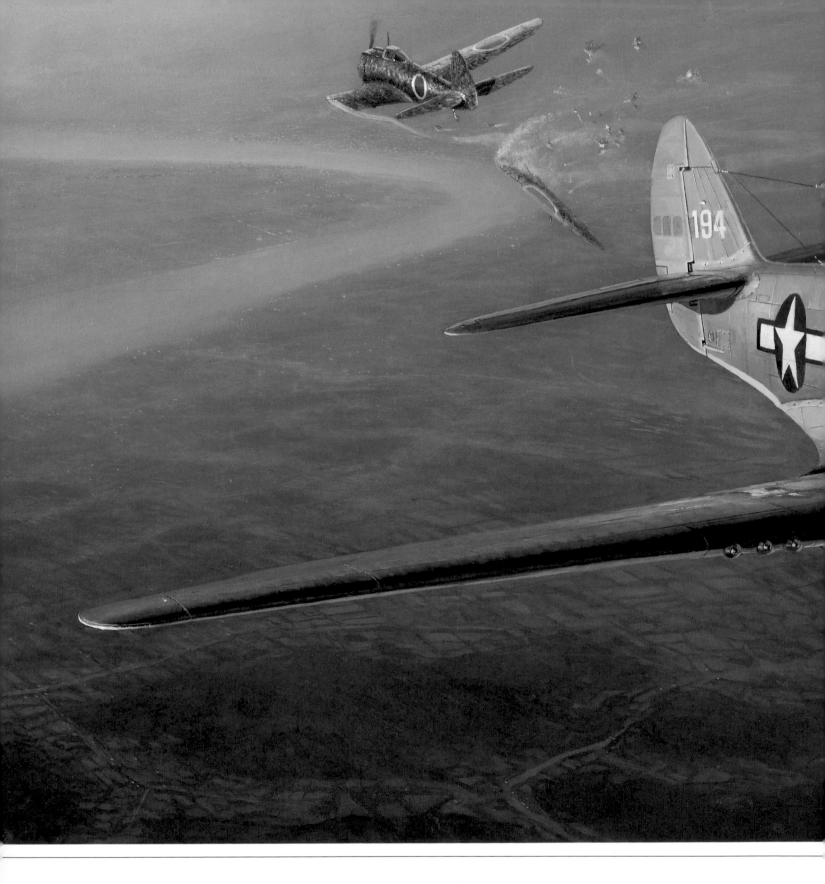

INTO THE TEETH OF THE TIGER

This sturdy P-40 has just won a game of chicken with a Japanese Oscar. It happened over China, where Don Lopez of the 14th Air Force, flying his "Lope's Hope," met the enemy in a head-on pass.

"I could see my bullets flashing on the front of his engine," wrote Don. "I could also see his guns winking...."

The two fighters closed fast, neither giving an inch. Then in a split second, the Oscar flipped to the right. Crunch! The P-40 lurched as its left wing was struck by the Japanese. Lopez saw that he'd lost about a yard of wingtip, fought for control, and craned around to see the enemy plane spinning

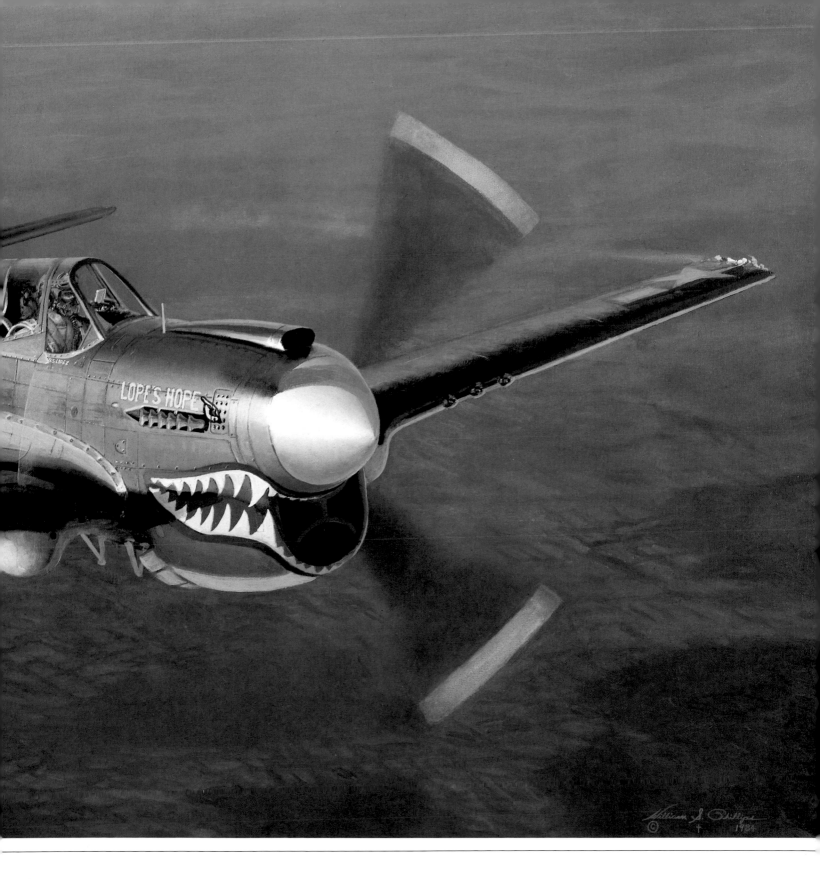

down. Its entire left wing was fluttering earthward after it.

This was Don Lopez's first combat with the Japanese, and a victory of sorts since the enemy "augered in," and Lope kept flying. He continued the mission, though his airspeed read 0 since the pitot tube that controls it had been broken away.

This episode from Don's book, "Into the Teeth of the Tiger," became a Bill Phillips painting which was co-signed by Don and later became the cover for his book. Lopez became deputy Director of the Smithsonian's National Air and Space Museum. He's never forgotten the debt he owes to his tough P-40.

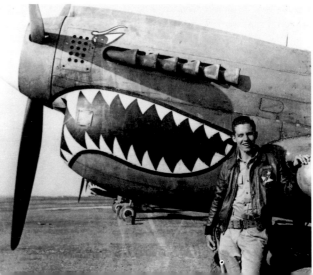

Don Lopez in 14th AF days beside Lope's Hope.

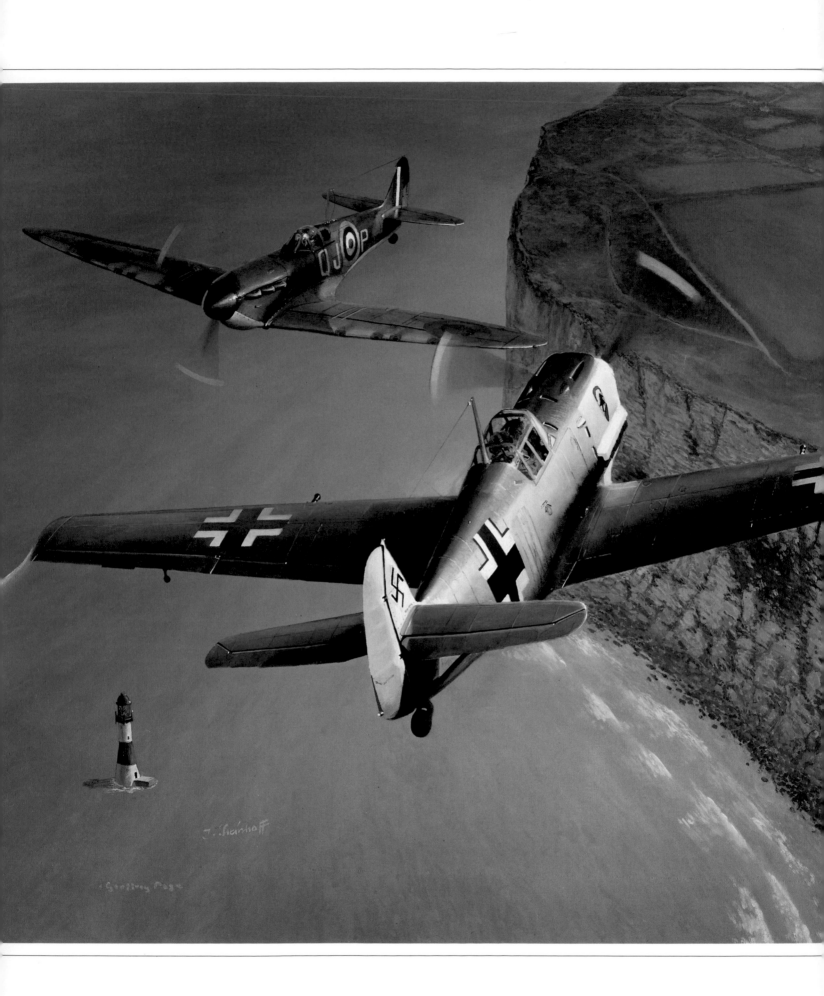

CONFRONTATION AT BEACHY HEAD

They're at each other's throats, a German Bf-109 and an RAF Spitfire, passing close enough to ram. And right below them, at this moment of meeting during violent combat, the white cliffs stand tall and steep above the English Channel.

This is Beachy Head, southernmost point of Sussex, where the chalk cliffs form a long, white banner that lured the Roman legions, who landed not far away, and William of Normandy, who won the country at Hastings, a few miles off.

Since then, for centuries, the white cliffs have challenged Britain's foes. Beacons burned on them to warn of Spain's vast Armada, sailing up the Channel. Patrols watched from them to glimpse Napoleon's invasion fleet. And now, in the summer of 1940, snarling fighter planes lace the air above the cliffs with twisting contrails and streaks of dark smoke, as they sky-write the epic known as the Battle of Britain.

Again, an enemy eyes these daunting cliffs of England and the air force that guards them. Winston Churchill dares Hitler to try: "We are waiting.... So are the fishes."

Who won this particular shoot-out? Who knows? It was just a moment when two brave pilots met at the lists— a brief encounter in a long war.

Classic Bf-109 packed 20-mm guns, but lacked range.

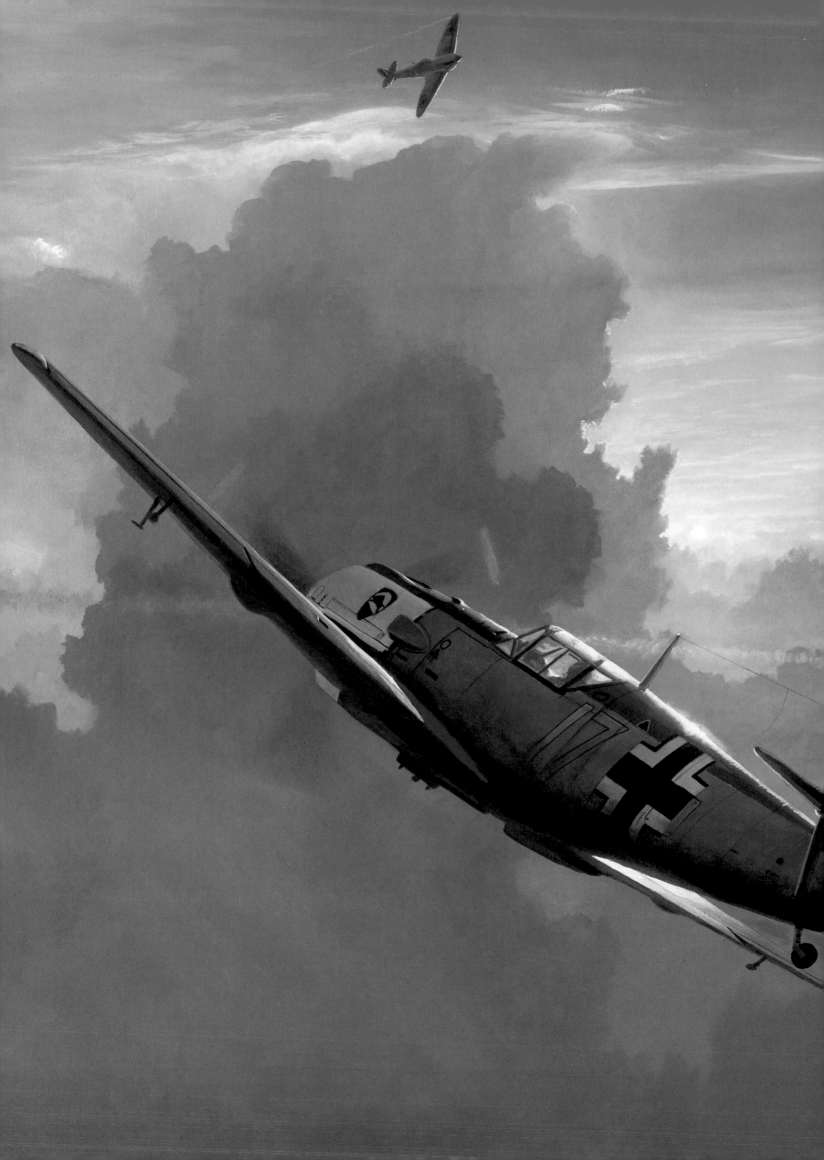

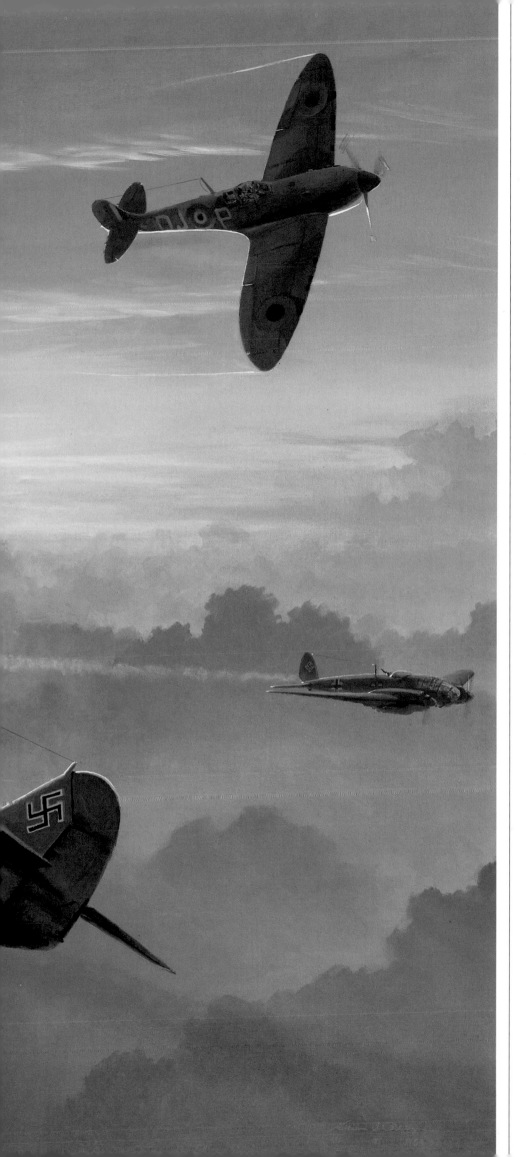

HELLFIRE CORNER

A typical moment in the bewildering melees of the Battle of Britain. On the right, a German Heinkel 111 has been clobbered and streams smoke. In the foreground, a Messerschmitt Bf-109 wheels to help nurse it out of there. But two RAF "Spits" cram around to burn the Jerry. At this moment, the betting is on the Brits. They outgun the enemy. But in an eye's blink another 109 may dive out of nowhere, guns ablaze, change the odds and split this rat race into two new ones. Then abruptly every plane may be alone in an empty sky. That was the Battle of Britain. At this stage, German pilots had more experience than British, and their morale soared as Hitler triumphed everywhere. But the old RAF, with its "flying club" tradition, turned into a tiger pack and learned fast. Their fine fighters scored; if hit, a pilot could bail out, return, score again.

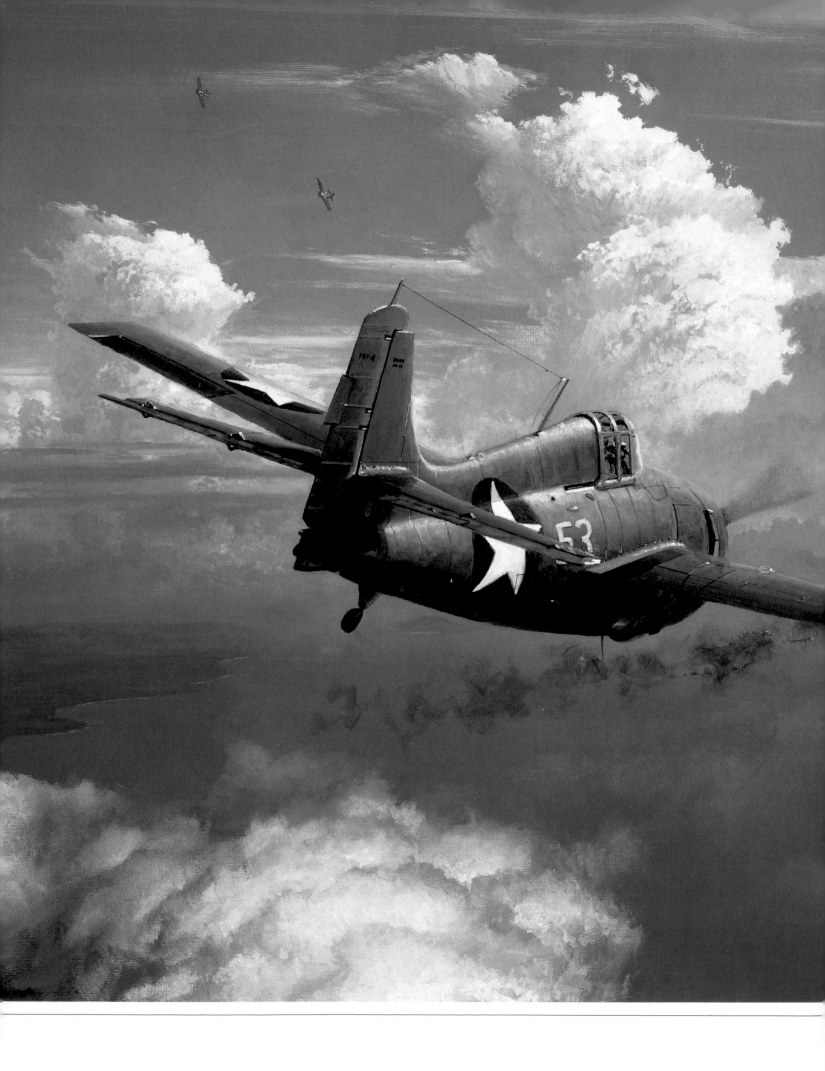

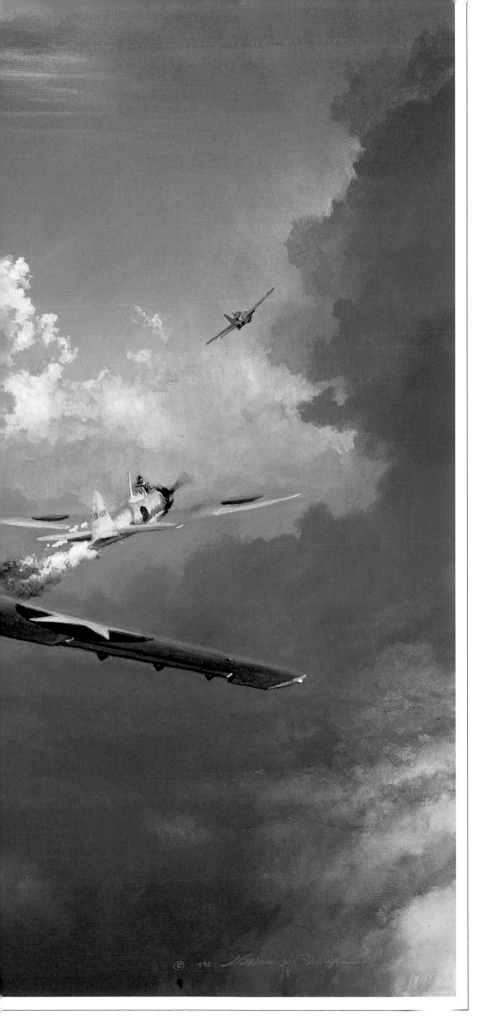

WHEN YOU SEE ZEROS, FIGHT 'EM

Joe Foss lines his old Wildcat up on a Zero and blasts away. It's a long way to South Dakota for this farm lad. He joined the marines after graduating from college, wangled a transfer from "grunt" (infantryman) to pilot trainee, and made it to Guadalcanal in a plane generally outclassed by the Japanese.

The Wildcat may have been in over its head, but not this pilot. Foss arrived in the thick of it, met Zeros every day, and scored. After his first victory, he got separated— often a fatal mistake. Zeros "bounced" him and he dove for the deck, recalling that the Japanese planes were said to shed their wings in a dive.

Wrong. "The wings didn't come off," reported Joe, "and they really salted me." Well-riddled, he crash-landed his Wildcat, remembered the lesson, and for a while was shooting down an average of three a day.

Foss, seen below after a mission, admitted that he wasn't a good shot. "I just get up there and stick those guns up his tail. When you see Zeros," he later told his squadron, "fight 'em!"

Whatever works. In 63 days—two tours— Joe Foss shot down 26 planes. He lived through it, too, and years later became Governor of South Dakota.

A weary Joe Foss after a mission

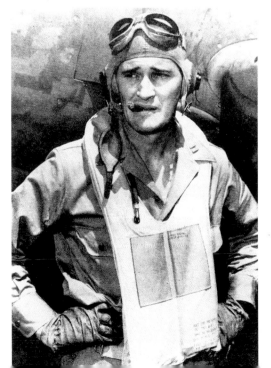

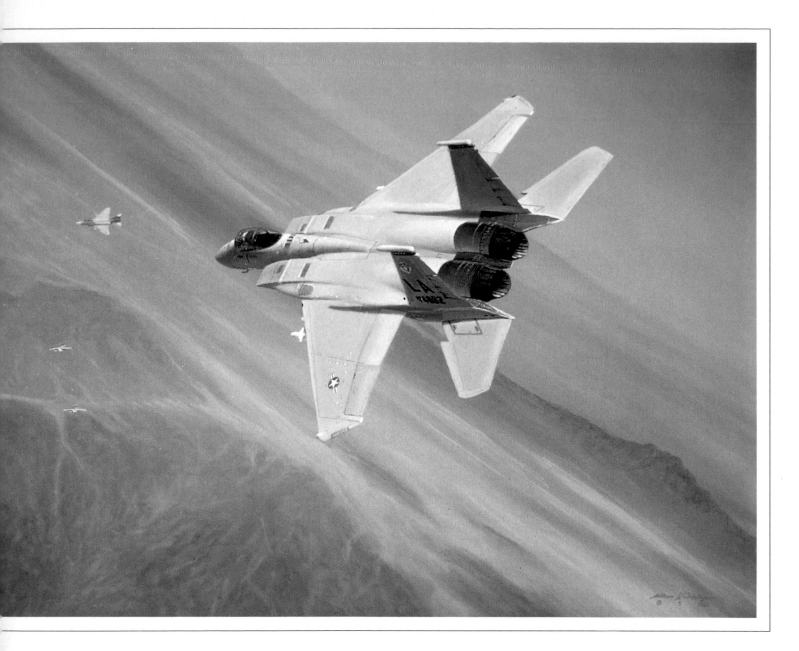

TOP GUN

LETHAL ENCOUNTER

"People look at this painting," says Phillips, "and say 'Hey! That's an air force F-15! Top Gun is a navy set-up.' And I agree. But I point out that right here, over the Nellis training range in Nevada, this USAF F-15 is barreling down on that navy F-4 and the two Intruders, and has them nailed. The air force guy is top gun."

So it's a play on words. And it gave Bill a chance to paint a top view of the F-15 Eagle just as it's rolling into an attack.

Bill was hosted by this USAF squadron from Luke Field, Arizona, on his first artist's assignment for the air force.

The "Thud" hauls out of there hard enough to spin wingtip streamers as her afterburner kicks in. The damaged MiG-17 begins its trip to the ground. It's an April day in 1967 and a busy one for a USAF Major, Leo Thorsness (left). He and his backseater have been taking on, according to another flyer, "most of North Vietnam."

"Thud" doesn't sound very complimentary for the Republic F-105 Thunderchief, but to her pilots it was a term of wry endearment. The big workhorse, heavy with her weapons, did her job nobly. On Thorsness' mission, three of his flight were hit; one crew ejected; the major orbited to guard the downed flyers, blasting this MiG. He was awarded the Medal of Honor. A few days later he and Capt. Harold E. Johnson were shot down. They spent six years as POWs.

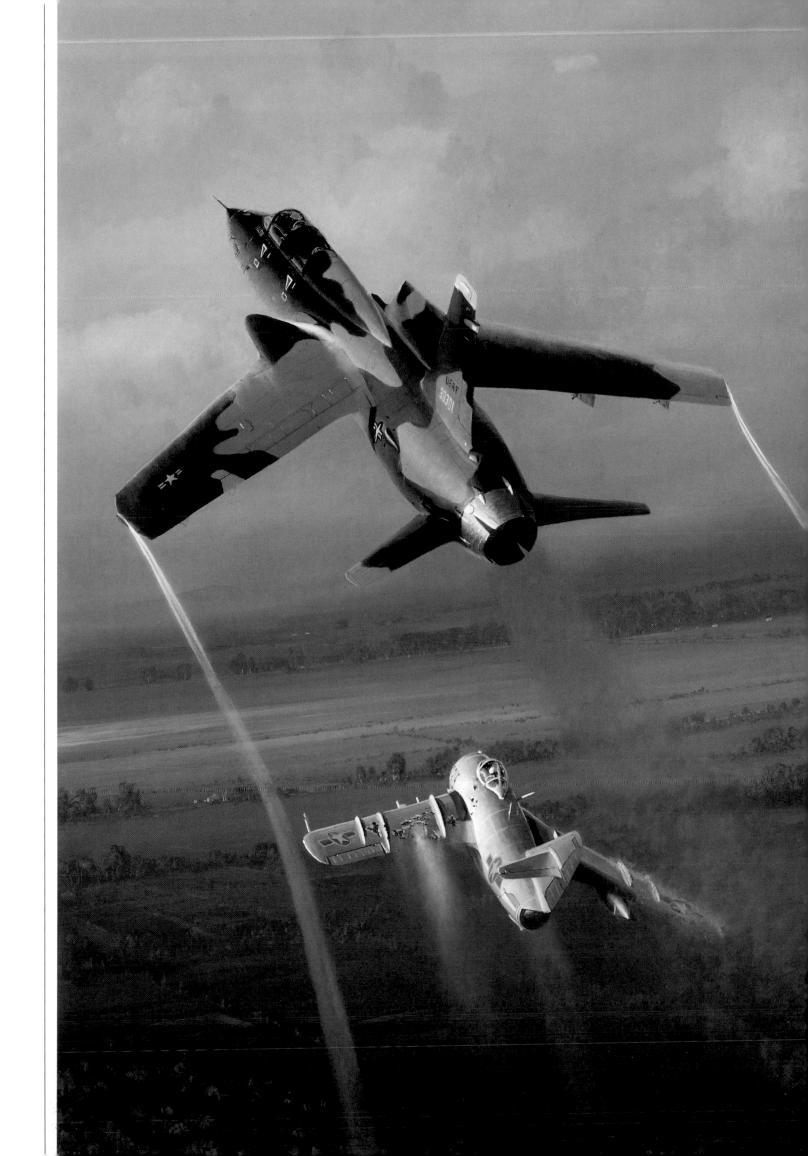

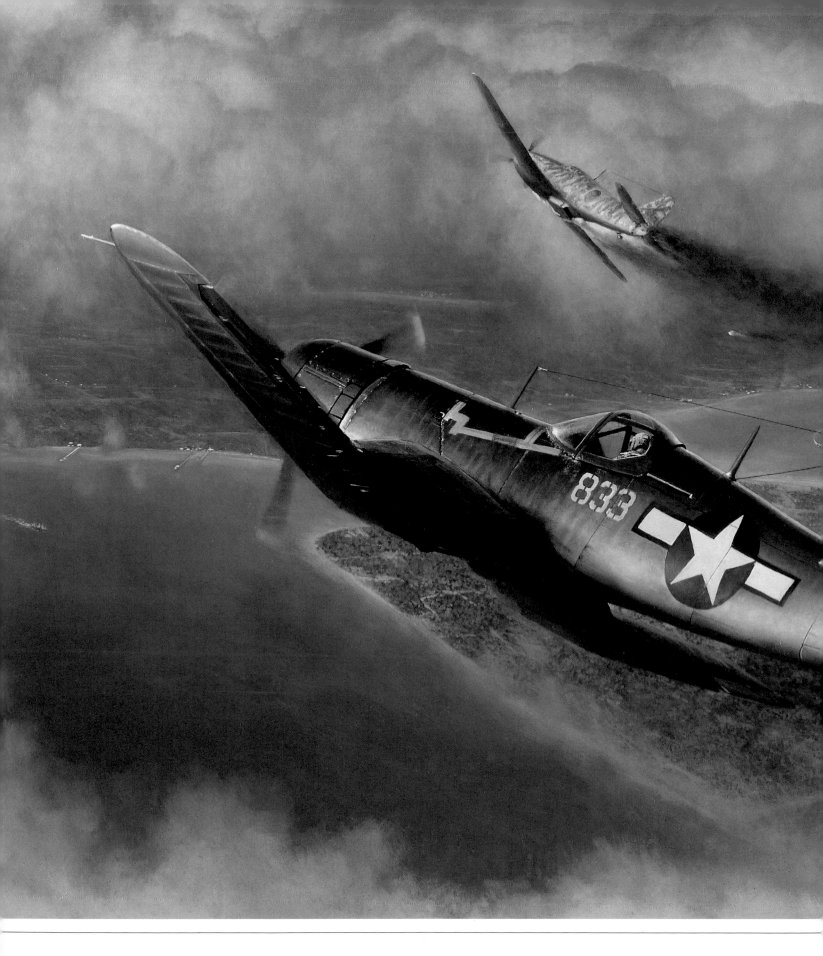

THOSE CLOUDS WON'T HELP YOU NOW

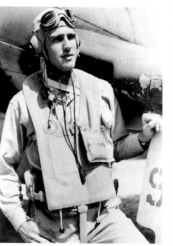

Marine ace Marion Carl (left) smokes a Tony over the great Japanese bastion of Rabaul, New Britain. Carl flies an F4U-1 Corsair here, but like Joe Foss, he was blooded at Guadalcanal in the old Wildcat.

The Japanese Tony baffled Americans when it first showed up. They took it for a German Bf-109, and figured Hitler had shipped some to Hirohito. But no. Kawasaki had first built it in '41 for the Imperial Army—a sleek, long-nosed fighter with liquid-cooled engine. The Tony was fast and agile. U.S. pilots found it firing 20-mm cannon at them, saw their own .50 cal. ammo ricochetting off heavy armor plate, and took an instant dislike to it. "A Tony's a bastard..." went one 5th Air Force song.

Flown by one of the old-time Eagles of Nippon, the Tony would indeed have been very formidable. But fortunately, as the quality of Japan's planes rose, that of its pilots began to drop.

That takes nothing away from Marion Carl. He once had to bail out, but when he returned to his squadron he kept right on building his score.

Like any fighter in trouble, the Tony veers toward the clouds, the build-up of cumulus that you could set your watch by in the South Pacific. But as Bill's title says, it's too late now.

F4U-1 Corsair:
a deadly foe
for Japanese planes.

TWO DOWN ONE TO GO

This painting became a poster for "Black Wings: The American Black in Aviation," an exhibit at the Smithsonian's National Air and Space Museum about the original Black fighter group, formed (after much controversy) at Tuskegee Institute in Alabama during World War II. It depicts the second victory in one day by the group's Clarence D. Lester, known as "Lucky Lester" to his squadron mates.

Phillips learned the story of this action from the old pilot himself as they sat together in the museum's staff cafeteria. Bill sketched on a paper napkin as Col. Lester told how he and his beautiful P-51 had already shot down a plane, then spotted this Bf-109 and got in a good burst. Lester saw flaps come down and canopy fly off. The Messerschmitt slowed, and Lester started to overtake it so fast that he had to pull up and to the right. Looking down, he saw his enemy stand on a wing for a moment before blowing off and opening his 'chute.

"The man looked up at me," Lester told Bill. "His helmet was gone, and his blond hair was blowing in the slipstream." Bill chose that moment of Lester's second victory that day to paint "because a defeated pilot survived."

Lucky Lester flew on and clobbered another German fighter before bringing his Mustang back to base. Three victories in one day! Little wonder the group earned the esteem of the Army Air Forces and of all Americans.

Lucky Lester in the cockpit of his P-51 mustang.

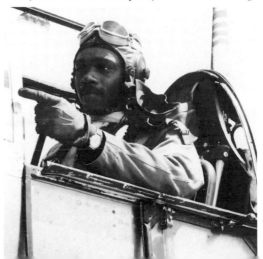

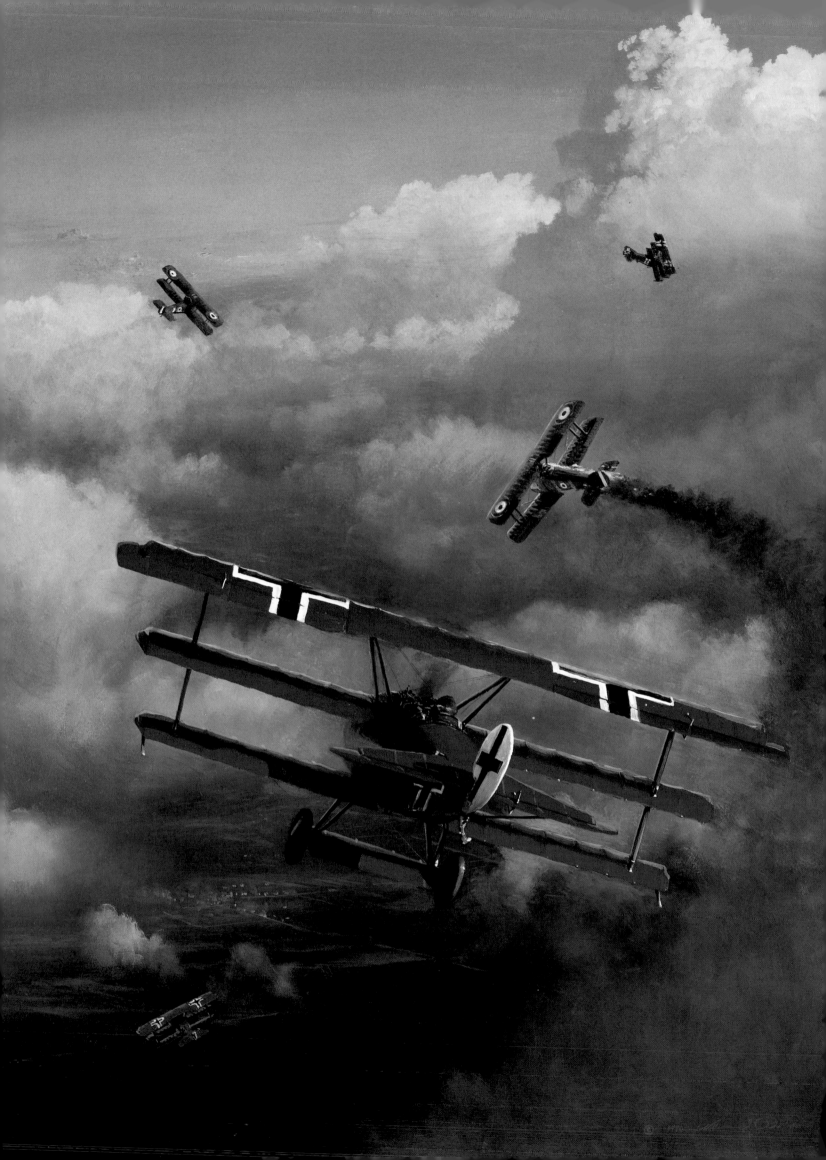

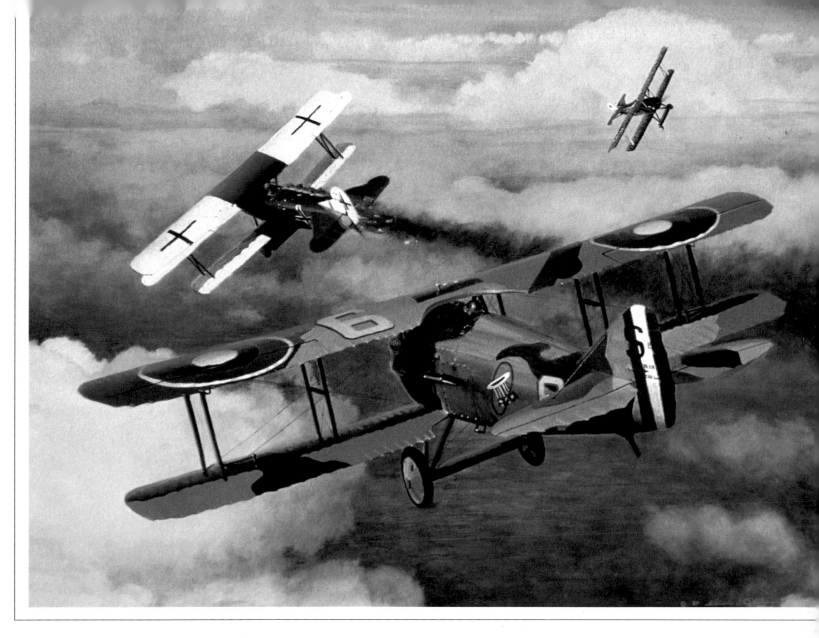

THE BARON SCORES

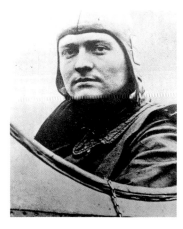

The bright red Fokker triplane always seemed to come out of nowhere. Your flight of Sopwith Camels would be flying high over the lines, scouting the German trenches to spot any build-up for an offensive. Your eyes would constantly swing across the sky above and behind to catch sight of enemy planes. And then this red flash would climb under you, nose straight up, guns blazing.

Richthofen! Every Camel would surge away, banking, climbing, diving, but that incredibly nimble triplane always stayed inside your turns. Every time, it seemed, one or two of you would fall away, smoking. Baron Manfred von Richthofen (above) was too good, his plane too spry. He had asked for this quickness of turn and climb, and since he was as famous as the Kaiser, Tony Fokker built this *dreidecker* (triplane) for him. In it, the Red Baron raised his score to 80. In it, he was killed in 1918.

TWO DOWN TO GLORY

American pilots of World War I were first blooded in the famed Lafayette Escadrille. But when the U.S. entered the war, it took time before its units, flying planes borrowed from Britain and France, got into action. Among the first of the "impatient virgins" to score was Reed Chambers, friend and flying buddy of the great Eddie Rickenbacker in the 94th Aero Pursuit Squadron, first to be formed entirely of Americans.

Here is Reed's plane, with the 94th's famous Hat-in-the-Ring insignia, shooting down a German in 1918. Bill Phillips recalls spending days of research for this painting. "There are so many World War One air buffs that I knew I'd stir up a storm if the planes had the wrong colors, even if the weather wasn't exactly right."

Air is restless, mobile, and quite indifferent to the wishes of those creatures who

CLIMBING

THE CRAGS

move through it. But it is a beautiful element to traverse, to endlessly explore.

CLIMBING THE CRAGS

The Sunday morning Cessna drops a wing toward the white flank of the mountain, so near now that tiny blemishes appear on her creamy complexion—streaks from a small slide, an outcropping of rock just under her sharp ridge of snow, sometimes a line of unidentified tracks, perhaps even a party of climbers negotiating her face. Everything seems dangerously close to the plane's wingtip, except those climbers. They restore the perception of distance, for they're toy figures, their expressions unreadable as they turn to wave.

That's close enough for an aircraft to come to a mountain. For though the air seems still and clear around her saw-tooth peaks and there's no sign of blowing snow in the curved white cols between them, the wind is there. Count on it.

Wind is a permanent factor in the high country, as reliable a feature as the peaks themselves. And those who fly among the crests and along the ridges know that as the constant wind meets the immovable mountain it is shoved upward, rising in a giant surge. Soarers in dainty sailplanes rely on this "mountain wave" to keep them aloft. They skim above sun-warmed slopes, searching for the rising air, and finding it, feeling its giant boot kick them upward, they circle like buzzards, using every scrap of lift, storing up altitude that they may have to spend later to get home. Seeing a sailplane sniff along a high hogback, the cagey Cessna pilot will cruise there, too. When the plane lurches and the altimeter flickers upward, the throttle can come back to save fuel.

But if they slip over to the leeward side of the mountain, pilots must pay the piper. Here the wind burbles and drops, pushing light aircraft downhill, earthward, in a tumbling rush of air. The sailplane, knowing enough to keep away, clings to the crest where the lift is best. But the Cessna, grown careless by reliance on horsepower, may wander too far and be caught in the sudden, silent, invisible, down-ward torrent. Its throttle comes on full, and it roars its bewildered fear. Its nose rises as it tries to climb, yet still its altimeter unwinds. It's enough to make a pilot spend next Sunday in church and leave the mountain to herself.

Since her high crags disturb the flow of air, mixing cold and warm, the mountain manufactures clouds. They may stream away from her peaks like banners, wrap her like a shawl, mushroom darkly above her, or cover her feet with a white rug.

In the tropics, cumulous clouds build up around her, starting to rise with the morning's temperature, then boiling upward faster than many a plane can climb. They dress the mountain in an extravagance of shifting, bulging contours, a fashion based on puffery. "Those clouds have rocks in 'em," say wise old pilots, and keep their distance.

Knowing well the mountain's tastes in her wardrobe of clouds, flyers generally keep clear. But when, on a magically still morning, she's divested of her last veil, and rises vast, bare and gleaming, who can resist her? A powdering of new snow has freshened her makeup to smooth perfection. Sparkling streamlets of water tumble down her slopes as though she had just stepped from her bath. The low sun touches her with rouge, then crowns her with gold. That's when the planes visit her.

Here's the Sunday Cessna, come to flirt. There's a classic—a spotless Beechcraft Staggerwing, paying a call. And yonder a busy bush pilot veers his floatplane off course for a closer look. Even the airliner's First Officer sometimes deigns to notice, assumes his professional drawl, and announces that "you passengers over on the right are goin' to git a good look at Mount Hood real soon now."

As for the military, what air force or navy pilot could resist snuggling up to such loveliness? There aren't many generations of fighter pilots yet, but surely every one of them has taken the risk of making

advances on a glorious mountain!
In Jennies and DH-4s, they struggled
as high as they could beside the Rockies and slid
across a pass or two, buffeted by wind currents. In Curtiss Hawks and early Grummans, they managed to scale a few lofty crests. A flight of British planes topped Everest itself in 1933 to snap the first photos looking down on the world's highest peak. And in World War II, a stream of Douglas DC-3 transports, painted olive drab and called C-47s, made an aerial highway of the Himalayan passes that took them "over the Hump," between Burma and China.

Now the jet fighters, the F-14s, -15s, -16s, -18s, barely notice the mighty peaks that rise so far below their operational altitude. But climbing up, angling steeply for the thin air where flight needs less fuel, the sleek planes will surely howl past a bared peak for a quick glimpse of beauty.

Operations now often bring the fighters low. Their pilots must learn to skim the ground, to dip into deep canyons and rocket past their craggy walls. At 600 miles an hour, this kind of flying is so incredibly demanding that they have no time to notice the trivial jolts of turbulent air.

But to the light plane pilot, nosing into valleys, gullies, ravines is as demanding as it is thrilling. Wind again is the danger. Its direction is often unreadable, yet the walls of a canyon may intensify it to gale strength. A narrow glen is apt to trap the wind so that it blows the length of the chasm instead of across it. This gust can get very strong and baffle a light plane. In his splendid book, "Song of the Sky," author and aviator Guy Murchie cited a case in point:

A commercial pilot in Alaska, flying an ancient Curtiss Jenny for fun, ventured into a narrow chasm and met a powerful headwind. Though his air speed remained normal, he saw that his ground speed had dropped to the pace of a tired snail. Not having all day to fool around, he decided to get out. Since the canyon

was too narrow to allow a U-turn, and the rim too high for an easy climb, he simply throttled back, killed off a little air speed, and backed out.

Nothing illustrates more clearly the truism that all flight is within a block of air, and whither it goes, so goes the flyer, whether scuttling through a narrow pass, or surging over a ridge and down the other side. A bird may continue to fly in a hurricane but it will end up a thousand miles from its nest. A pilot may hold faithfully the compass course to a distant target, yet miss it by a hundred miles, because he failed to correct for the crosswind.

Air is restless, mobile, and quite indifferent to the wishes of those creatures who move through it. But it is a beautiful element to traverse, to endlessly explore. And when its clouds hold neither rocks nor lightning, but rise in creamy contours, the sky can become a wondrous playground.

In the most demanding days of World War II, fighter pilots who were returning, weary and sweat-drenched after a long mission, sometimes celebrated their release from tension by staging a "rat-race." In line astern, all 16 planes of a squadron would play follow-the-leader through the mountains and valleys of cloud, soaring upward to top a looming crest, rolling and split-essing into a darkened corridor, banking through a gleaming crevice, clipping the top off a sudden crag of mist. At the end, they'd slice down through a hole in the cloud cover and burst out over the mottled land below for a fast, low pass, one after another, above some astonished villager—preferably a girl.

Then, regaining composure, trying to act like grown-ups, like officers and gentlemen, they'd reform and parade soberly to their base.

LAST OF THE BUSH PILOTS

Snow-wrapped mountains reaching higher than a plane can climb...misty glaciers filling valleys...bitter cold of the far north...unpredictable weather.

And in the midst of this utterly hostile environment, a pilot flies an overloaded plane that has probably avoided a thorough overhaul since it flew to the north country. All in the day's work for a bush pilot.

Phillips painted this spectacular vision of man versus the elements for "The Last of the Bush Pilots" a Bantam book by Harmon Helmericks crammed with the endless drama of Arctic flying.

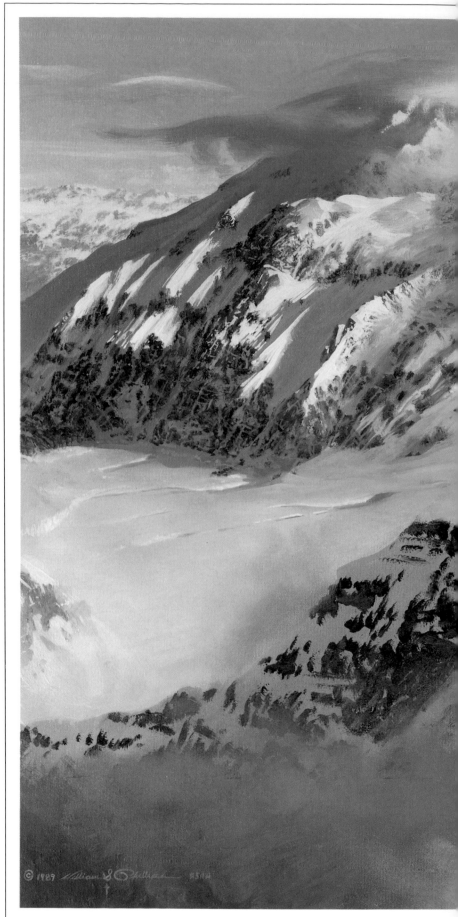

*Old-new confrontation—
ski plane to dog sled—
is routine in the far north.*

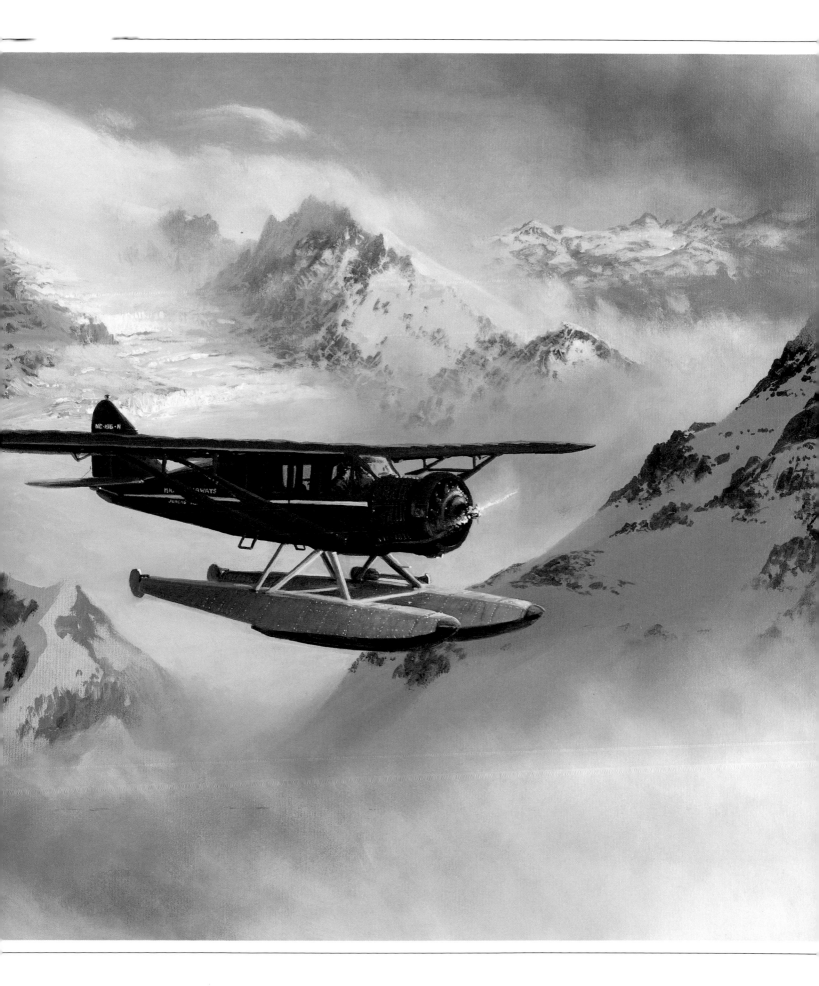

MR. THOMAS TRIES THE CANYON

A day before the Grand Canyon became a National Park in 1919, two hare-brained army pilots flew into it in a DH-4. Why? Because it was *there!* Three years later, R.V. Thomas took this Jenny down into the Canyon and landed it some 3,000 feet below the South Rim, near Plateau Point. No one had ever tried that, but Thomas plunked her in among the sagebrush and got her out again. He had a passenger, Emory Kolb, one of the brothers whose photography has been a park feature ever since.

This painting by Phillips won the Art History Award at the Arts for the Parks competition in 1990.

COASTING TO MONTEREY

They're over water, so it's okay to fly low above the rumpled islands and basking sea otters of California's coast. They're no higher than the seamed cliffs of the shore; lower than the sunburned hills.

The planes aren't real N2S navy trainers of the 1940s, but loving restorations of them. The original "Yellow Perils" and the army version of them—the PT-17s—were built by

Boeing to a Stearman design. A 220-hp radial kicked them up to about 100 mph, a good deal slower than Germany's Fokker D-VII of 1918. But no plane has ever been more fun to fly, and Phillips knows the joy of it.

He catches it here—the sun on your head in the open cockpit; the air sweet in your lungs; the chill blocked by leather; the scenery right in your face as you're coasting to Monterey.

DUSTING THE RIDGELINE

This Ford Tri-motor, workhorse of the north, wears skis.

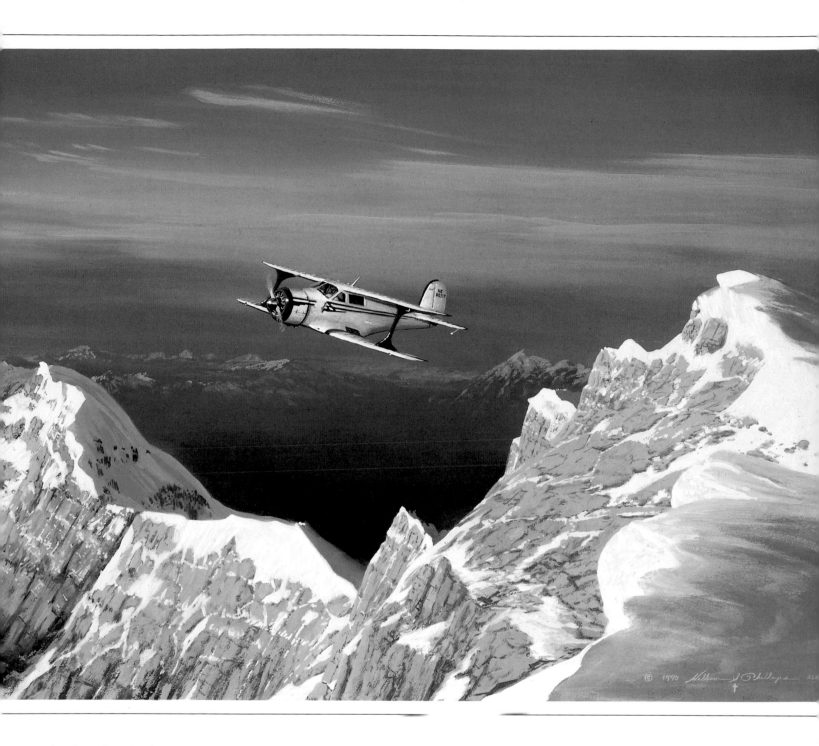

In the Canadian Rockies, Nature is at its most awesome. Jagged peaks, uplifted eons ago by imponderable forces, reach from their massive blanket of snow. The clean, bleak northern sky promises more to come, more eons of snow, of minute changes in the mountains—the cracking away of a rock ledge, the ponderous fall of a dead tree deep in a valley, all unseen, unheard.

And what's that bright, jaunty little thing scudding along above a ridge? Why, that's Man! Hard to believe this insignificant gnat dares hum across such a scene of primordial grandeur. But

the work of eons means little to the pilot of a Beechcraft Staggerwing. He's hearing the tone of his engine and the harmonics of struts and wires, wings and rudder, nuts and bolts, all slicing through air, each with its own note. He's sniffing the indefinable airplane smell. He's feeling the pulse of life in his controls. He's glimpsing a gauge or two on his dashboard, the position of the horizon on his windscreen. And above all, he's gulping down and savoring the visual feast spread before him. Sure, he's insignificant. But belong here? You bet he does!

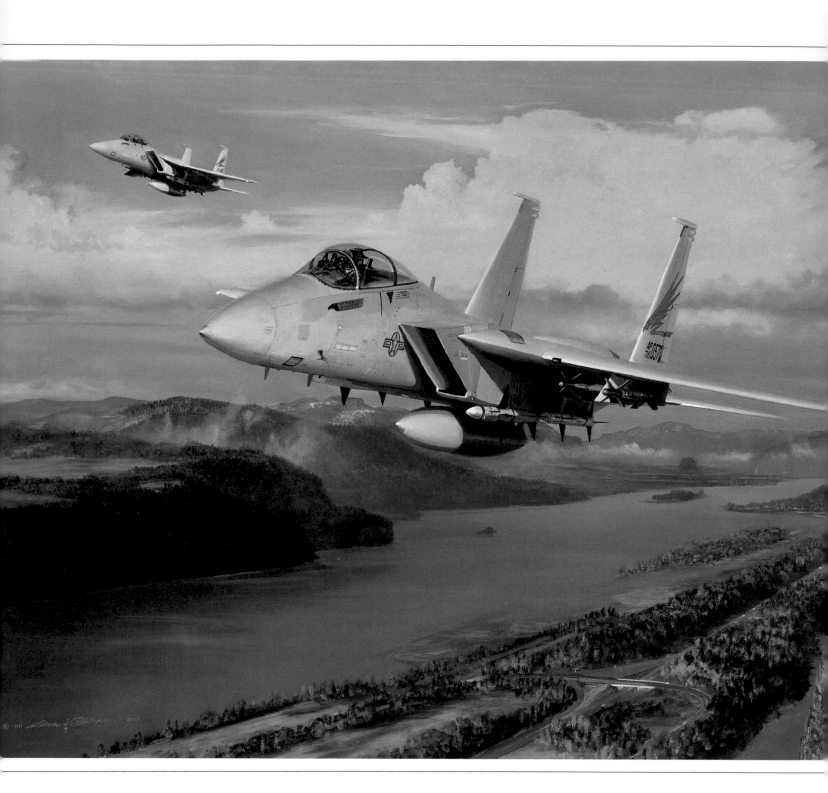

EAGLES OF THE COLUMBIA

Two F-15 Eagles of the Oregon Air National Guard roar down the Columbia River, past Crown Point. Phillips, who lives in southern Oregon, loves his state's scenic riches, and the broad and historic Columbia, a spectacular border with Washington, is one of his favorite spots. This painting offered Bill a chance to do a nose-first view of the F-15. McDonnell Douglas built this remarkable air-superiority fighter for the USAF, to replace its highly successful F-4 Phantom. Lighter and simpler than the huge navy F-14 with similar twin fins, the Eagle is handled by one pilot who flies with a Head-Up Display (HUD) allowing him to check vital data flashed on his windscreen. The pilot flies it—not the other way around—and judging by its combat record in the Mideast, the Eagle is one tough bird to face in anger. Israeli F-15s, jumped by MiGs, cleaned house.

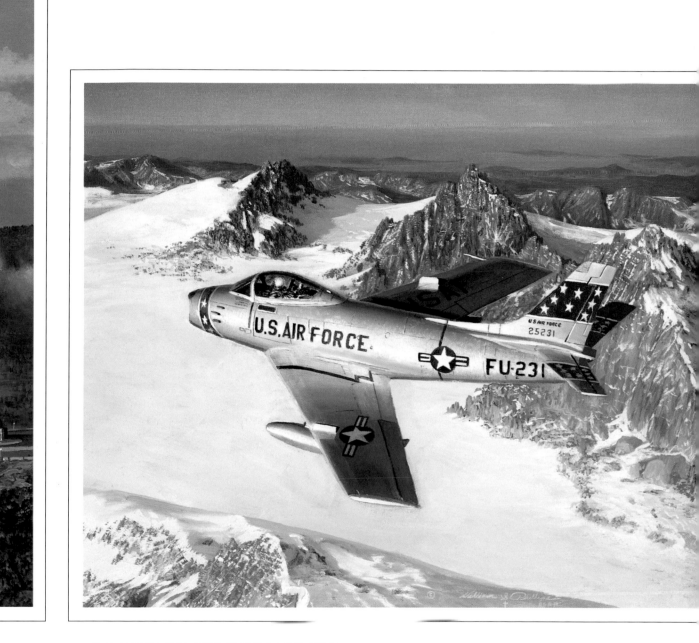

ALPINE DEFENDER

An F-86, the great old Sabre made famous by its victories in the Korean conflict, sweeps above the German Alps. This was in the early stages of the Cold War when American forces were shielding western Europe.

Bill Phillips, whose favorite aircraft is the F-86, painted one in the squadron markings of astronaut Michael Collins' old outfit, where he had flown the Sabre. Bill put the beautiful early jet fighter in this mountain setting.

Michael Collins became the pilot of the Apollo 11 spacecraft, and orbited the moon while his colleagues, Neil Armstrong and Edwin Aldrin, descended to become the first to stand upon it. Mike Collins later became Director of the Smithsonian's National Air and Space Museum.

The Navy also feels it
would be nice if some of those
wide-eyed little boys and girls

PLEASING

THE CROWD

took away a long memory of six
streaking, bellowing, blue and gold shapes,
and a dream of someday flying one.

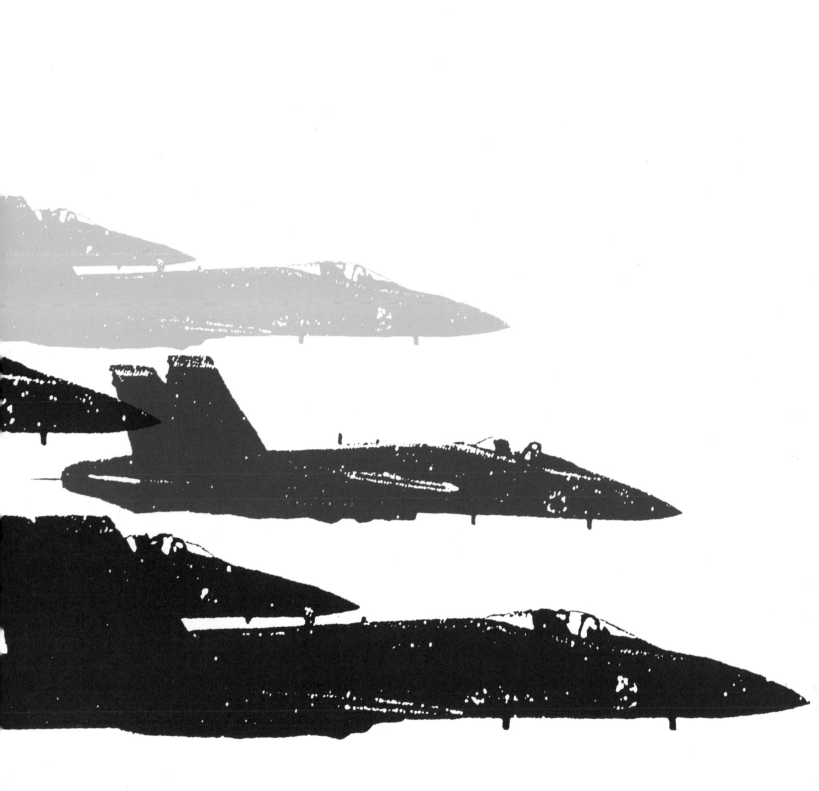

PLEASING THE CROWD

Two of the six Blue Angels have detached themselves from the tightly clustered formation and vanished from sight. Now, as the other four finish a superb barrel-roll, leaving a quadruple spiral of white smoke lingering over the Severn River, the two vagrants reappear, both low, both too fast for their sound to catch up. One is headed upstream, one down, and my God they're on a collision course! And one is inverted, for God's sake! THEY'RE GOING TO HIT!

But they don't. To us spectators, they seem to flash past each other so close that their canopies only miss by a hair. Then with a quick half-roll, the inverted plane rights itself and both streak straight up, rocketing almost out of sight. And the noise catches up—a ringing double screech that explodes into a shattering blast, then ebbs to booming thunder rolling over Annapolis.

The Midshipmen of the U.S. Naval Academy try to act as though this sort of thing happens every day of their four-year course. But their parents gape and exclaim, and their young siblings—all there for Commissioning Week—gingerly remove hands from ears and keep their eyes peeled for the next act.

The reason for this eye-popping air show—and those like it by the USAF Thunderbirds, the Canadian Snow Birds, Britain's Red Arrows, and many other national air forces—is to show us civilians that our taxes have been buying impressive defense equipment and training remarkable pilots. The Navy also feels it would be nice if some of those wide-eyed little boys and girls took away a long memory of six streaking, bellowing, blue and gold shapes, and a dream of someday flying one.

During the first five years of human flight, we Americans barely realized there was such a thing. Dayton, Ohio, neighbors knew that those two shy Wright brothers were up to something, but not until 1908 did they come out of the closet to show and tell: Wilbur in France, Orville in front of the U.S. Army's brass.

The French, bursting with pride over their own early aviators, had eagerly demonstrated every awkward, fluttering hop that they'd made, a few feet above the ground. The Wright brothers? They had not displayed their machine, so obviously they had nothing. They were mere American "bluffeurs."

In this aura of suspicion, Wilbur Wright finally got his plane uncrated, reassembled, checked out, and ready to fly near Le Mans. On a quiet evening, he took off and simply buzzed around the field for a few minutes, making figure eight turns to test the controls. Only a few people saw the flight. Those that watched were stunned by the sight of this winged creation doing the exact bidding of its pilot, banking steeply, first one way, then the other, rolling easily from one turn into the next, gently landing exactly where it should. This was a real flying machine.

The small crowd was almost struck dumb—but not quite. Word got out that the Wrights were "Les Premiers Hommes-oiseaux," and overnight Wilbur became the toast of the nation, entering—and winning—one competition after another in front of huge throngs of believers.

Orville, meanwhile, put on similar shows for the Army, and finally won the contract for the first American military plane. Watching those Army trials, hundreds of us Americans saw for the first time humans fly—really fly. One man walked away dazed, muttering "My God! My God!" over and over.

And suddenly we embraced aviation with passion. The mere sound of a stuttering engine up in the air was enough to empty every house in town. We neighbors would fill its streets, pointing, waving, chattering. We poured out in huge crowds to see Lincoln Beachey in his Glenn Curtiss pusher race a speeding automobile driven by the great Barney Oldfield, and to cheer little Blanche Scott, "Tomboy of the Air," as, at the last moment, she pulled out of her 4,000-foot "Death Dive."

In World War I, we saw many of our young men go overseas to fly, first a handful to join the British RFC or the French Lafayette Escadrille, then thousands to emulate those early birds. We learned the title "ace," and happily hero-worshipped those who earned it. Then came peace, and our skies were silent, our would-be aces grounded.

We were still besotted by planes, though. The sight of a yellow-winged Curtiss Jenny a thousand feet up still thrilled us. So many unemployed pilots, fresh out of the depleted Army, spent $300 of saved-up pay for a surplus Jenny of their own and set out to earn a shaky living. They formed groups and barnstormed all through Middle America, stunting and selling rides....

Early 1920s.... A prairie town,
not big enough to be sophisticated
about aircraft....

Breakfast time.... That wonderful sound overhead brings us out in a rush—ham and eggs shoved aside, chores forgotten. All of us stare up at a Curtiss Jenny swooping low right over the corner of Main and Grove, and by golly there's someone standing on the upper wing with arms spread! We can see him take off his helmet and—look at that hair blow back! That's not a "him," that's a her up there! A flying circus has come to town!

The plane makes a couple of passes, then veers over toward that flat pasture of McCutcheon's just outside town. We jump into the Model T and follow. McCutcheon's been talked into moving his cattle, and three planes are parked by his milking shed, with a red-lettered sign: "$5 A RIDE." Pretty steep, but the town has some sports who'll cough it up. Already a few are lining up at the shed. There goes one out to a plane, now, along with a pilot in riding boots and a white scarf.

Maybe we get a ride, too. Anyway, the stunts are free, and we watch in breathless silence, clutching each other, as a wing-walker, wind whipping at his white coveralls, scrambles from one plane to another right above. We gasp when a human figure, arms and legs spread, drops from a plane, high in the sky, and a white parachute suddenly blooms above, and comes gently down before us, and the jumper again removes her helmet and lets her hair fall free as she takes her bow.

A Jenny does a series of loops, one after the other, the plane soaring up, then gently over and down the other side, wings rocking a little as it meets its own prop-wash. Then it slow-rolls, its nose riveted on the crest of a low cloud as it pivots smoothly around it. Coming back over us, it swings into a barrel roll, graceful as a ballet dancer, then pulls off an Immelmann, swooping high in a half-loop, and rolling upright at the top of it, almost stalled, perched breathlessly atop a mountain of air. From there it does a thing called a split-S, rolling inverted and dropping its nose to dive straight toward us and pull out with a silky whine over our heads.

The pilots do snap-rolls and spins, violent enough to make you think a wing will come off—they say

sometimes it does—and when they land, goggles gleaming in the low sun, we clap and cheer. And if, that evening, we feel festive enough to have supper out, at that cafe with the pretty waitress, we'll probably see these barnstormers, living it up on chicken-fried steak with lots of catsup. Bed costs them nothing—McCutcheon tells us they sleep on the still-warm grass under the wings of their planes....

They repaired those planes with a roll of wire, a swatch of canvas, a can of dope. They found their way to the next town by railroad track, following it to a station, then passing low enough over it to read the name. Even air mail flyers did that until instruments caught up.

We're told of one young barnstormer named Slim, who once got pretty lost in Mexico, picked up an "iron beam," and followed it to a railroad station. Down low, he made out a sign: "Caballeros." He couldn't find it on his map, so followed the tracks to the next depot and swung down to scan its name. Again it read "Caballeros." What the hell was going on?

Slim Lindbergh didn't know the Spanish for "Gents," but he was smart enough to figure it out. A few years later, he proved smart enough to find his way to Paris, and we made him a hero. His was one of the many record flights that we have cheered: across the Atlantic, across the nation in a day; across nonstop; around the world. Newsreels trumpeted the brave deeds. Every kid wanted to fly....

Old-fashioned barnstorming is over. But at the huge annual Fly-In of the Experimental Aircraft Association at Oshkosh, Wisconsin, we find a worthy descendant. Here, thousands of us watch as the Confederate Air Force sweeps over in a flight of lovingly rebuilt Flying Fortresses, wearing group and squadron colors. And a deep snarl of Packard engines turns old eyes upward to grow misty at the sight of a pair of gleaming P-51s weaving in escort. Then the air hums with home-built single-seaters, kit models, sleek Rutan designs with small canard wings in front, a feast of marvels. And hundreds of us walk away a little dizzily murmuring "My God! My God!"

CHASING THE DAYLIGHT

This painting reveals a new facet of the artist. Bill Phillips is obviously engrossed in action—power and speed and movement. He loves planes because they epitomize these sensations. And it turns out he loves trains, too.

In this California scene, he's put the two together: the rushing thunder of the Daylight on its way to San Francisco from Los Angeles,

and, nearly drowned out, the purr of two navy N2S-3s—Stearman trainers—one already racing the engine, the other turning in to give chase.

On a train trip to the east coast, he watched a restored Stearman fly down and pace his train for a bit. "I wanted that wonderful moment on canvas," he says. And for his train, what could serve better than the brightly colored Daylight?

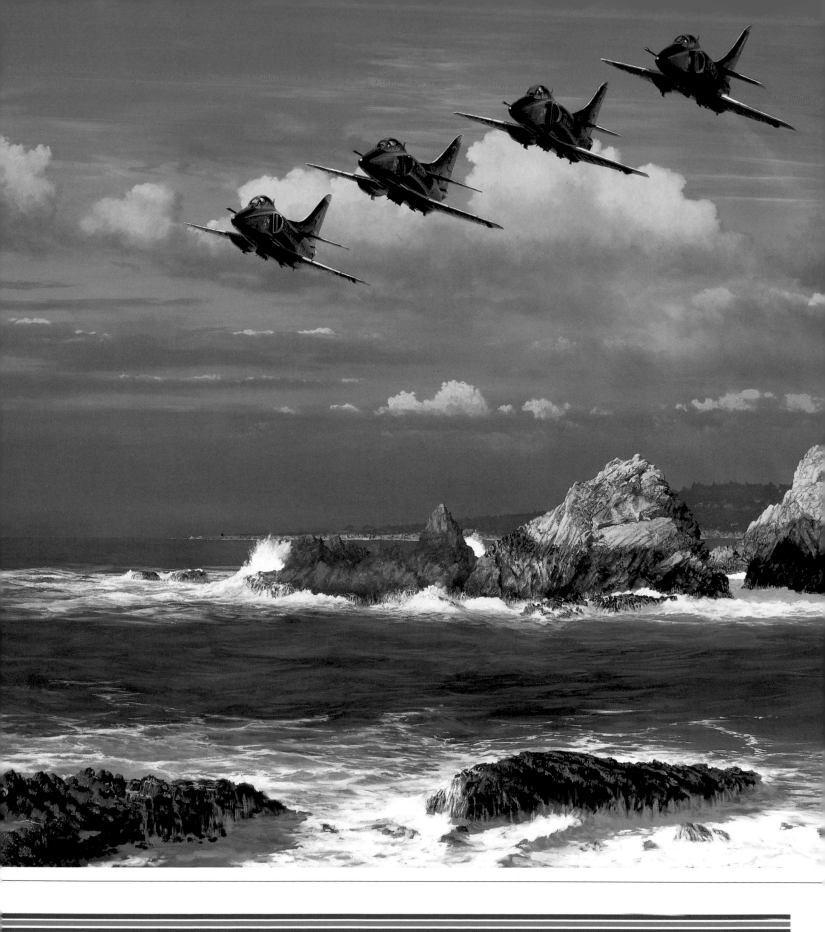

SHORE BIRDS AT POINT LOBOS

Ever a scenic artist, Phillips has lovingly recreated the ancient rocks of this point near Monterey. Scarred by eons of surf, the cliffs are buff above a tidal smear, and topped by wind-torn trees.

And now, above Nature's casual beauty, silhouetted against vagrant clouds, four members of the navy's Blue Angels round the point in a low turn, howling with all their might. Tucked in tight, they flash their navy blue and gold and hold formation with long-practiced skill.

This famous flight demonstration team (here flying A-4s) is also beautiful—and anything but casual. The contrast between them and the background stops most viewers. When the painting first went on display it stopped two ladies.

"Glorious!" said one, and Bill moved proudly forward to introduce himself as the artist.

"Yes," said the other. "The best depiction of Point Lobos I've ever seen. It would have been perfect if only he'd left out those airplanes."

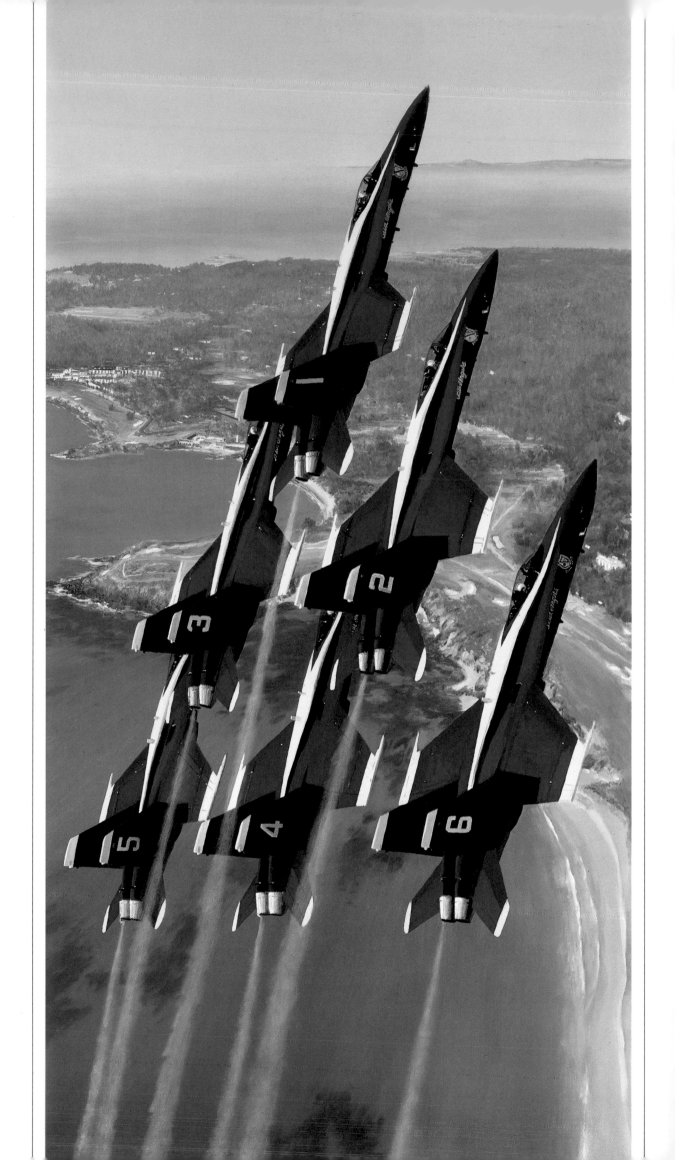

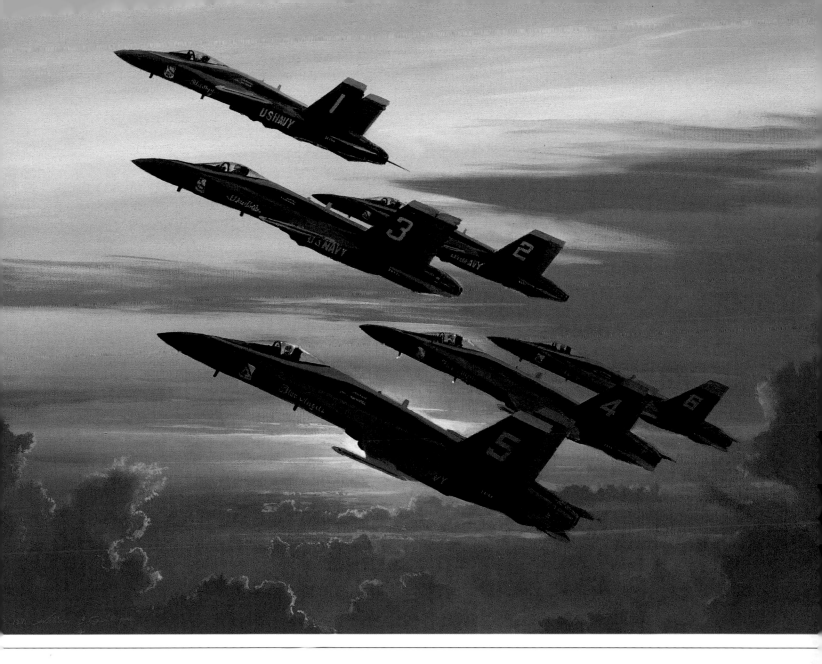

PEBBLE BEACH BLUES

SUNLIT ANGELS

"As far as I know," says Phillips, "The Angels have never flown their show at Pebble Beach. But what a spot to put on a six-plane extravaganza!"

Bill couldn't resist another chance to combine favorite scenery with favorite aircraft.

"I kept thinking of the golf tournaments they have here, and of one of the great old pros just lining up for a five-foot birdie putt. And here come the Blues, hauling straight up overhead. What would that do to concentration, I wonder?"

Not to worry, golfers. The Blue Angels are based in Pensacola, way back east, and have a carefully regulated schedule of demonstrations. One of the best, because of its informality, is over the heads of the parents and sweethearts of young ensigns, newly graduated from the U.S. Naval Academy at Annapolis, Maryland. Yachts crowd the harbor, and the 18th-century town pulses with the thunder of the F-18s as they run through their act above the old Severn River.

This isn't a specific Blue Angels performance; it's just an artist's way of turning six F-18s, packed in their standard delta formation, into a composition of cloud shapes and sky colors, of combining hard, streaking, dazzling power with the soft, silent, gradually shifting sky that gently wraps our planet.

Like most demonstration teams, the U.S. Navy Blue Angels vary their act. After the six planes thunder over their site, two of them split away and put on breath-catching maneuvers, meeting head-on, seemingly inches apart, one looping—wheels and flaps down—inside the loop of its companion, many more "impossible" acts. The four fill in with spectacular mass aerobatics. All six latch together for the finale.

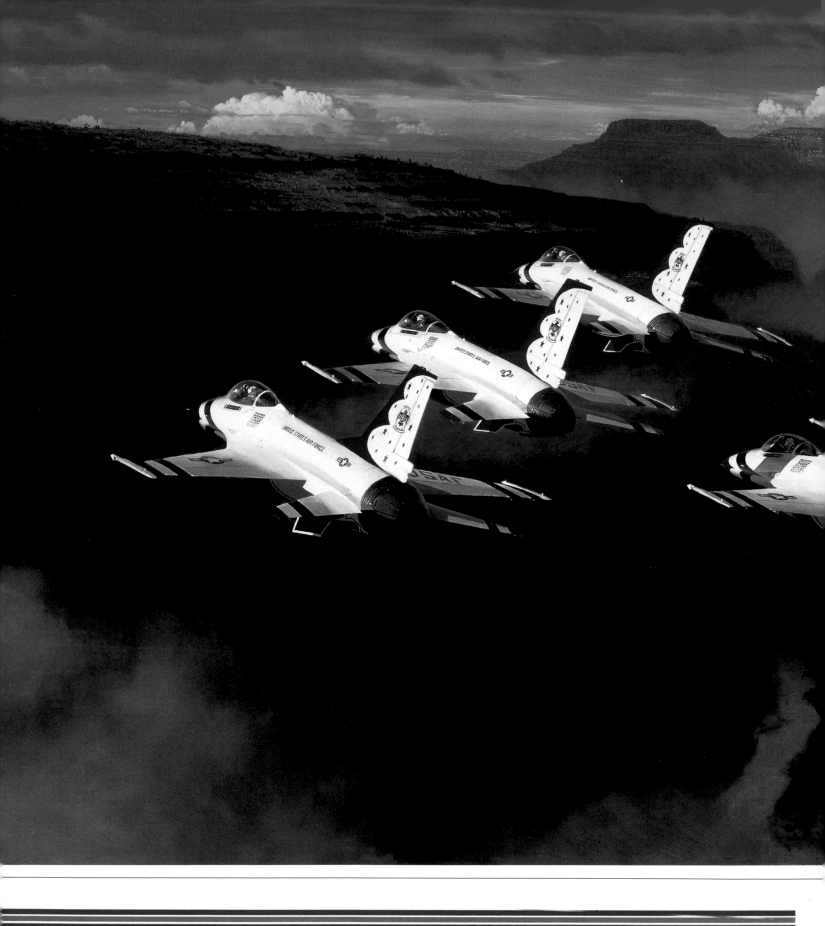

THUNDER IN THE CANYON

*Slick, fast T-38
preceding the F-16
with the Thunderbirds.*

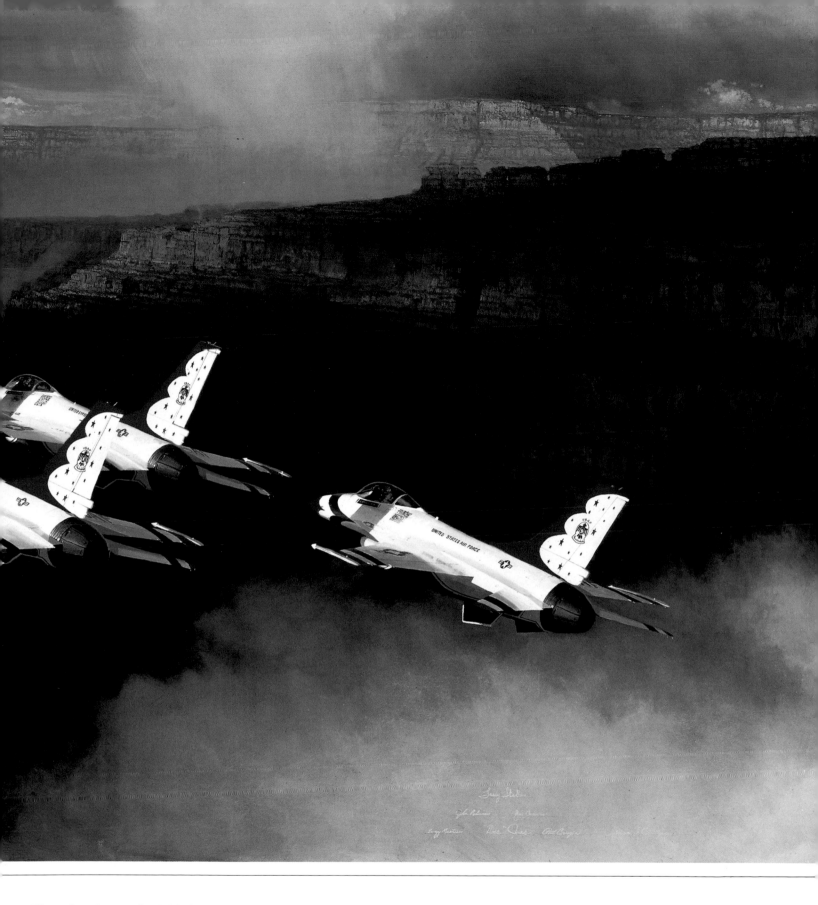

The title refers to the USAF's Thunderbirds, another superb flight demonstration team based at Nellis Air Force Base, Nevada. Bill Phillips, an old air force man, had a yen to combine this air force team with one of his favorite places, the Grand Canyon. Powerful jets like these F-16s would never be allowed to shatter the serenity of this National Park, so Bill had to combine an aerial view of the Thunderbirds with the right background view of the Grand Canyon.

"I flew high over the canyon with a tactical F-16 squadron to get photos of where the painted planes would be. We went inverted so I could photograph the Canyon from a different angle. I rented a helicopter and took photographs down low. Kristi and I walked down into the Canyon to get a close view of the geology.

"Finally I put the whole thing together, adding thunder cells with the sun breaking through." So he achieved what became one of his favorite works.

[133]

WHEN A SURE GRIP MEANS SURVIVAL

The two Curtiss Jennys hold as steady as they can, some six feet apart, while patches of rising air from the warm prairie rock their wings. Knees flexed to absorb the motion, the wingwalker leans into the slipstream. Only the upper wing brace offers a small support for the legs. The wing tip skid of the upper Jenny is too high... now too far out...now behind... now coming forward...*NOW!*

The body straightens abruptly, an arm shoots up, a hand grasps, then the other hand. *She's got it!* Down on the hayfield the crowd shouts as the lithe figure swings up onto the lower wing. A great show, they agree.

Barnstormers sold rides, then formed flying circuses, often with old planes, no 'chutes, no straps, and no FAA to say "No-no." But they kept aviation alive and well.

Bill painted this as cover for Martin Caidin's book about this daring era.

Radio blaring, she's doing the Charleston on the upper wing.

A WRIGHT TO LIBERTY

What an event! Crowds jam New York's ferries, and Liberty herself, ever brandishing her torch, seems to gaze out in astonishment. For here comes a Wright flying machine with Wilbur himself perched on the lower wing at the controls.

It's September, 1909, and New York is marking the centennial of Robert Fulton's steamboat and also the tricentennial of Henry Hudson's landing. Both the Wrights and Glenn Curtiss have been asked to perform, but Curtiss, forced to use a second-choice plane, finds the wind too strong and drops out.

Wilbur Wright (Orville is in France) seizes the chance to display his well-tested Flyer. He takes off from Governor's Island and circles the Statue of Liberty—and the crowd loves it. The canoe lashed under his wing? Possibly he considered it a safety measure. Probably it was for effect. Despite their stiff-collared dignity, the Wrights had more than a touch of showmanship.

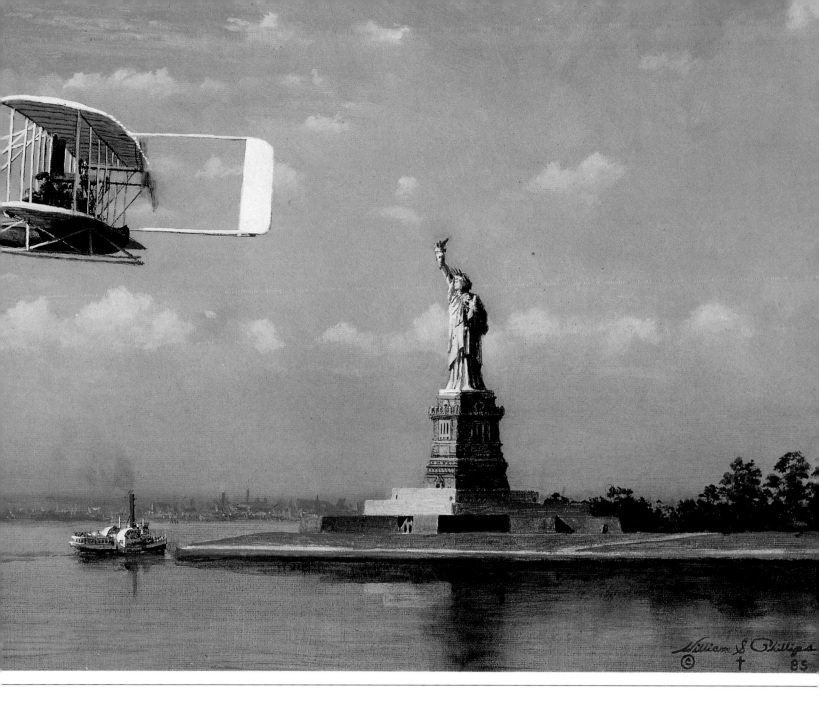

GEE BEE

It was an astonishing plane—seemingly all engine with a fat body and stubby wings—built to win the great land races, the Thompson and Bendix Trophies, of the early '30s. Its name, Gee Bee, spelled the initials of the Granville brothers who designed it. The Gee Bee did win the Thompson in 1932, when the great Jimmy Doolittle flew it. But mostly it just killed its pilots.

"Flying the Gee Bee was the most dangerous thing I ever did," Doolittle told Bill as this painting—the cover for Don Vorderman's "The Great Air Races"—was being planned. Many models of the little speedster appeared, and all were almost uncontrollable bundles of torque.

Jimmy Doolittle poses mistrustfully beside his Gee Bee racer.

[137]

All reactions slowed down
a millisecond or two,
all awareness clouded up a shade.

HEADING FOR

THE BARN

So this was the time
to get bounced, and the enemy pilots
knew it as well as you.

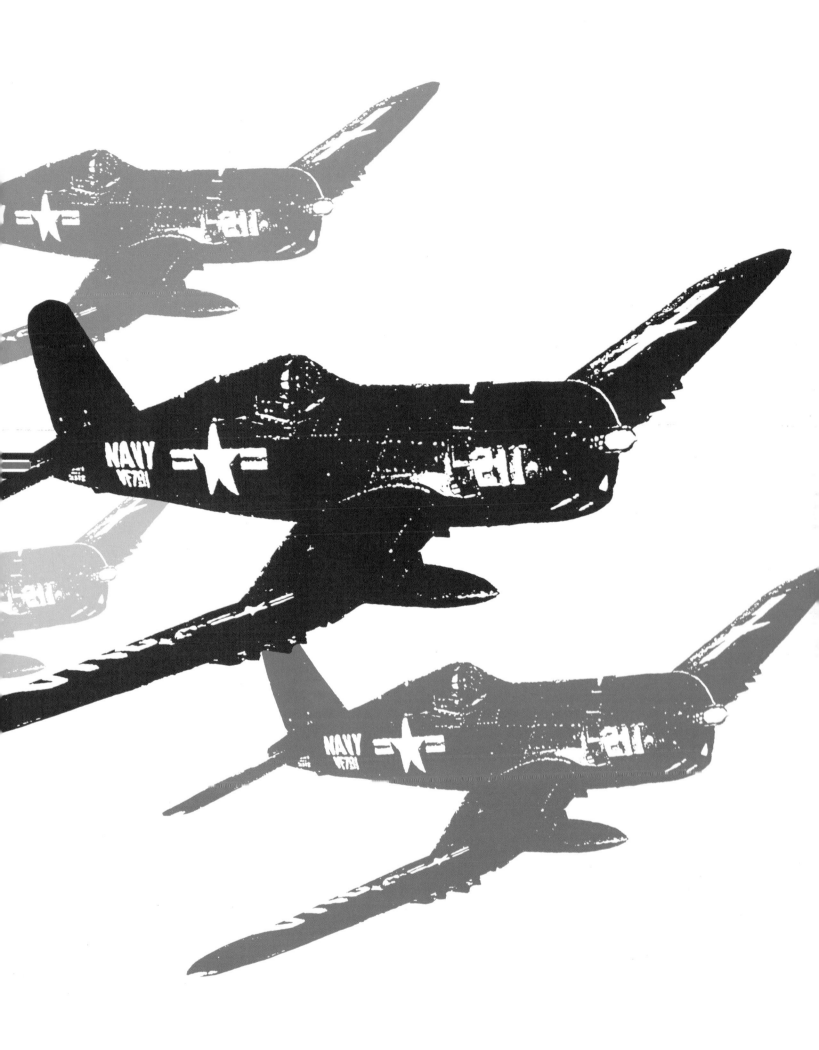

HEADING FOR THE BARN

You'd been in the air more than two hours. You'd switched from belly tank to one of the mains, and the fuel gauges were twitching toward the "E." Five thousand feet below, the coastal water turned clear green as the early sun reached the coral seabed. Earlier, the surface had been savaged by frothing wakes of landing craft charging ashore, crammed with infantry, weapons, equipment. Now the scratches had healed. The violence of the assault had moved inland and was curtained by the jungle that walled the beach. Wisps of dusty smoke, filtering through forest canopy, gave the only hint of warfare.

If history was being made there, you were a poor witness, only sparing a glance or two downward as you orbited overhead. Your eyes were busy elsewhere, because you knew you were about to be bounced by Zeros. The Japanese fighters must be on the way—or already up there, up in the sun, watching you. The sooner you spotted the flash of their white bellies as they rolled to dive on you, the better chance you had of calling them in to your leader. Then, your two flights might have time to turn and meet them. The P-38s flying top cover might dive quickly enough to clobber them before they clobbered you. Just possibly, your squadron might survive this day.

Waiting for the enemy, you searched the sky with burning eyes, churning inside with the expectation of combat. As always, you were wrenched between fear and desire: If only they would come...but, please, not right now while we're in this turn and the sun is right behind us...not now...but maybe now!

And then in a rush of adrenaline, you saw distant planes at ten o'clock level.

Since all eight of you up there that morning were old hands, no one bothered to call them in. They weren't slender and shiny enough for Zeros, not high enough, not quick enough in their turns, not scissoring around in pairs, not flashing their white bellies. They didn't have that feel about them that would have sent your left hand sliding smoothly—from the throttle to the rheostat that controlled the gunsight, to the gun switches, then to the belly tank release.

Abruptly, a familiar voice intruded on the faint crackle in your earphones: "Beaver Red and Yellow, from Beaver Blue and White. We're with you. We're with you."

And your leader's voice: "Got you, Johnny." And then, "Okay, boys, let's head for the barn."

They were longed-for words, but you heard them with strange ambivalence. They meant that the endless orbiting was over, and you felt a wave of relief. But it also meant that you faced the long drive home, easy prey for those dazzling little enemy planes with their bright red markings. Now, somehow, you must avoid the glory of relaxing, put out of mind your weariness, the ache of your eyes, the growing dullness of your reactions. You must tighten once more your ragged nerves, keep your head swiveling, your moves quick.

Yet all eight of you, knowing this, still slipped just a notch. All reactions slowed down a millisecond or two, all awareness clouded up a shade. So this was the time to get bounced, and the enemy pilots knew it as well as you. If they saw you now, heading for the barn, they'd call you in with glee and dive on you at twice your speed, wheeling around a cloud like the one over there, slipping behind you before you could react, flashing through you, whirling, rippling with gunfire.

You strained to see thin, glinting specks at the edge of that cloud, and all the others, and you blocked the sun with your thumb and peered angrily around it. You held formation instinctively and glanced at your compass. It was true. You were headed for the barn, all right. And though you knew you mustn't, you relaxed another small click.

That was how it was, flying back to base in a P-39 on a morning in 1943. A generation earlier, rattling back to "the barn" in your Sopwith Camel, your relief was often tempered by the worries and guilts of being alone. Formations were neither formal nor sacred in 1917. Flyers broke from them when guns jammed, when engines ran rough or fuel low. But duty and comradeship were strong forces to those youngsters to whom the word "gallantry" had not become a silly anachronism.

So flying home alone, you often cursed yourself for not having done better, for leaving your friends perhaps still at it over the lines. You asked yourself, in the startling privacy of 10,000 feet, if there was not the

slightest hint of fear in your decision to head back. You vowed, there in your wind-torn cockpit, ever to face up; never to fail.

For the jet generation, the entire process of a mission is so quick, so intense, so demanding physically and mentally that "heading for the barn" is a mere moment, well lost in the rush. You seek a dot in the sky. When you see it, maybe five miles away, you turn toward it. Even when you're sub-sonic, your speed is staggering; as you meet your target, the rate of closure is twice as fast.

In half an eye-blink, you are at each other, your heat-seeking missile perhaps on its way. If you see an enemy missile coming at you, you may fire a flare, hot enough to draw it, and then get out of there with a sizzling turn that makes you weigh half a ton. In a few more seconds, victorious or not, you may be homeward bound, drained, exhausted, yet still facing the task of setting your lightning bolt on the ground.

Then the base is in sight, the landing process underway, and for a fleeting moment you're on final, the strip coming at you fast, your wheels down, reaching for it, air shrieking through landing gear and flaps. That tiny moment you share with your elders.

You, the lone Camel pilot of 1917, returning to your muddy field, tasted and savored every second of every landing. For you this was no tiny moment, but a demanding ritual, still new, often dangerous—the changeover from one element to another. You washed away all thoughts except to kill power and speed, but not enough to let the drag of thick wings, sturdy struts, humming wires overcome the lift. Keep the little beast from stalling out before it's down. Hold it off, off.... Clump. Three-pointer. Now to roll straight, and avoid potholes. Then hop out, stand on the good old ground, tell Operations what happened over the Somme, and maybe down a little slug of cognac.

You, the pilot of 1943, saw before your nose a strip of steel matting cut in the jungle. Wheels down, flaps down, nose high, you fishtailed to bleed off the last speed, realigned...and...chirp. A grease job. Now a glorious stretch of muscles, a cigarette—guiltless in those days. A cup of coffee, still hot in its vat on the flatbed of a truck, awaited you. And a chance to stretch out on a canvas cot, eyes closed....

You had about an hour to rest. Then it would be time to go up again for the last mission before the clouds rolled in. Again you'd fly to the landing zone, orbit, and this time, surely mix it up with whatever planes the enemy was sending over. You tried to put it out of your mind, but the certainty of coming combat clutched at your innards. You rose and braved the midafternoon heat to walk to your plane and talk to your crew chief:

"Oil level okay?"

"Sure, Lieutenant."

"Full ammunition loads?"

"You bet, Lieutenant."

"Engine sound good to you?"

"It'll get you up there, Lieutenant."

Back to the alert shack. Soon the Operations Officer would give the nod, and you'd climb back into your cockpits and grind up the big Allisons. Then back to the long sky-searching, the sharp awareness, the instant reactions. And finally, whatever happened, you'd hear "Let's head for the barn" again, and this time, with clouds humping over the mountains, there'd be little chance for a last minute bounce.

This time, you'd come home in tight formation and buzz the strip, low enough to kick up dust. And you'd peel up and left, pulling contrails from your wingtips, popping wheels and flaps at the top of your climb, then half-slipping around in the screaming air to kiss the metal, left wheel first, then right. And you'd taxi to your revetment, engine burbling. You'd cut the fuel flow with the mixture control, kill the switches, then leave your baby with the crew chief and head for the bellytank shower that you pilots had rigged. The vile water would feel wonderful, for the work would be done.

Picturing it, you looked at your watch. It must be time to get back to the job and finish this day.

WHEN PRAYERS ARE ANSWERED

A feathered prop on the B-17 tells part of the story. She's survived another brutal day over Germany— but just barely. We don't see the damage inside, the torn wiring, the leaking hydraulic lines. We don't see the blood.

Going through hell was routine for the heavy bombers that struck the German heartland—RAF by night and USAAF by day. At one time, American aircrew members figured that their chances of completing 25 missions and rotating home were down to about 30 percent.

This Fortress, thrashing away on three engines, will make it through this day. The white line on the horizon is a bomber crew's most prayed-for sight: the chalk cliffs of England. Now the escort, an element of P-47s, can peel off and slide down toward their base, mixture leaned out, for by now those boys are flying on fumes.

The wounded bomber will get in somehow, perhaps on her belly. She'll be mended or cannibalized. Her crew will chalk up another mission, and recount what's left— eight to go; only three to go; maybe fifteen; maybe twenty-two.

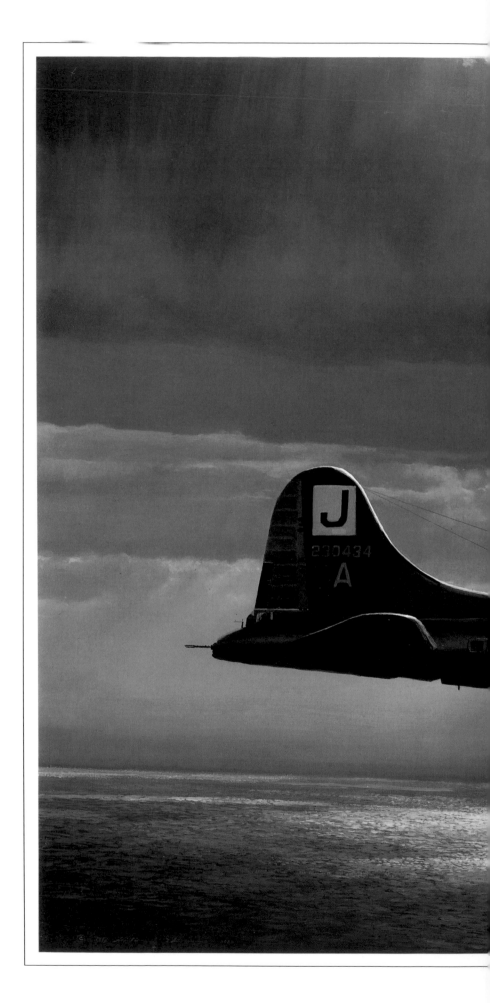

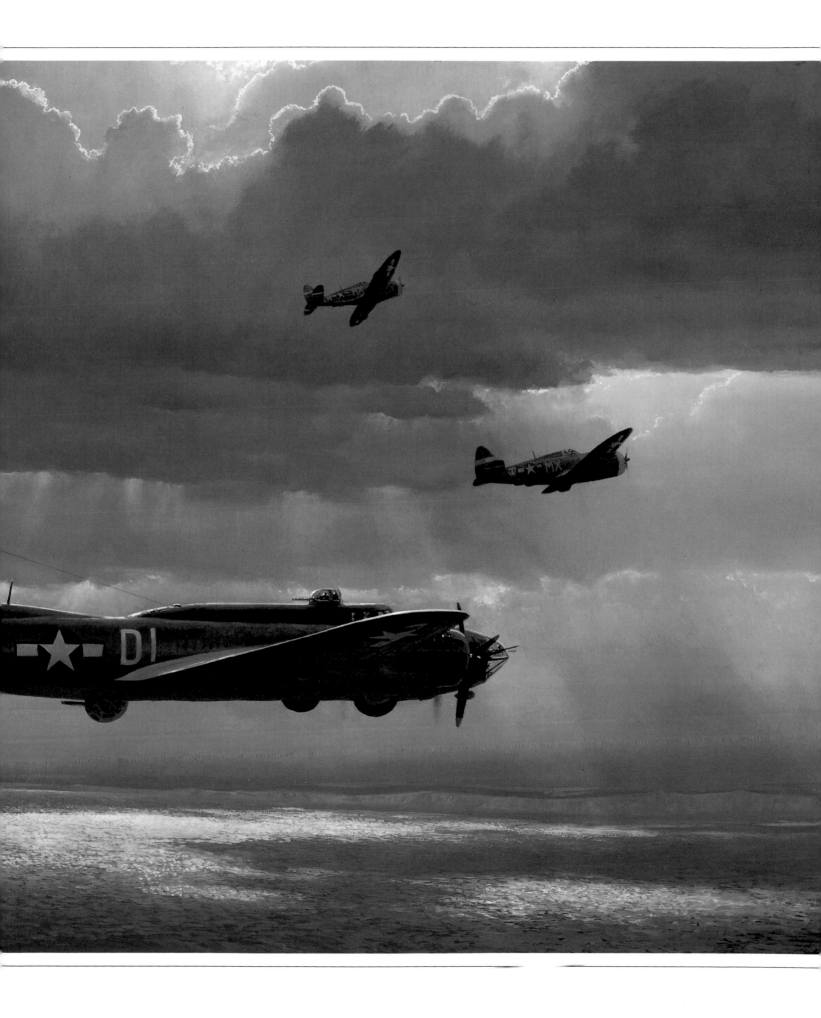

DESERT RESUPPLY

It could have been a travel poster: "Jordan, Where Old Meets New." But Phillips says he saw this scene repeated often when he traveled to Jordan on commission in order to do a series of paintings for the Royal Jordanian Air Force.

"I flew with the pilots in the Mirage F-1—a real coup—and came to know some Bedouins," Phillips says. He points out that this contrast between age-old and modern is not hoked up, nor as dramatic here as it would have been if the plane were a fighter. "After all, the DC-3 seems almost as ancient as the camel!"

Ubiquitous DC-3 has done its work all over the world.

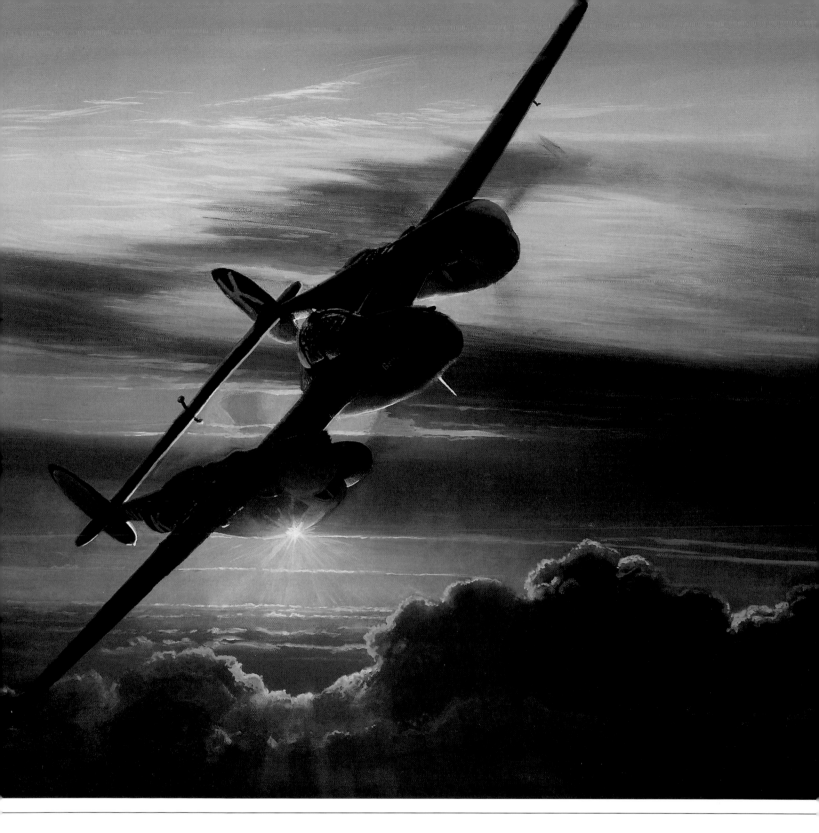

LIGHTNING IN THE SKY

A sight no enemy wished to see—a P-38 appearing out of a sunburst. The afternoon is getting on, the sun lowering, and the pilot is glad to make his turn for home.

The Lightning was a delight to fly—stable, forgiving, comfortable in the cockpit except when her guns filled it with smoke. Her engines drove counter-rotating propellers so the plane was untroubled by torque. "It felt nice," said one pilot, "to snuggle between those two big Allisons when the bullets were flying."

The two Allisons stated the P-38's purpose. She was designed at the Lockheed company as a bomber-destroyer, not a fighter. Her turns were the graceful sweeps of a ballroom dancer, not the skittish twirls of a jitterbug.

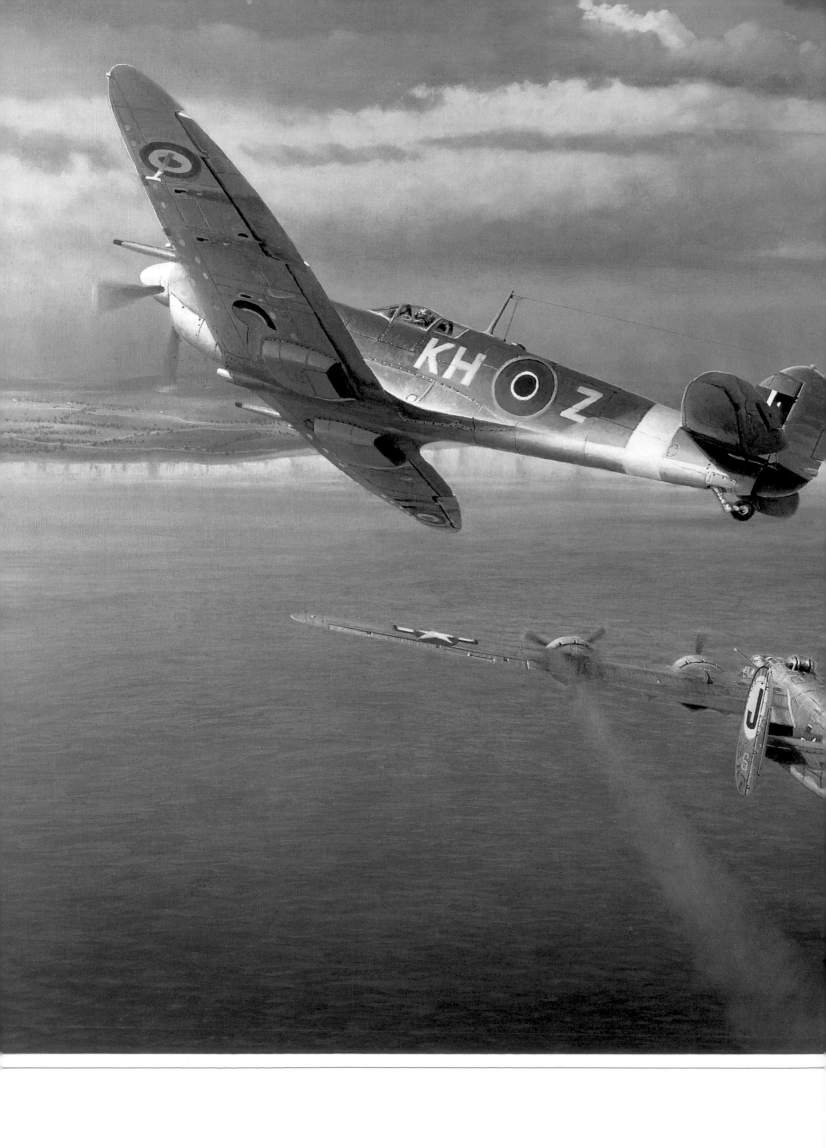

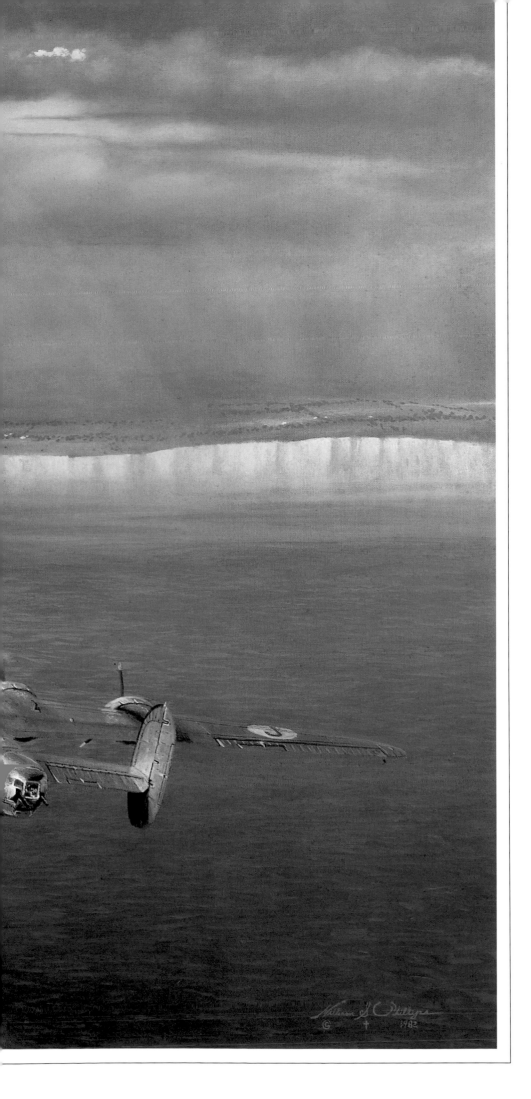

"WELCOME HOME, YANK"

A B-24 has lost one engine and streams smoke from another. She's close to the white cliffs, but not out of trouble. Any second now, the last power may fail. Without enough altitude for a safe bail-out, her crew will brace for a ditching. And the Channel is cold and choppy. She's got one thing going for her—a Spitfire has come to meet her and weaves above. If her pilot chooses to ditch, the Spit pilot will tell Air-Sea Rescue.

When Bill did this painting, he liked it from the start. The mail that it brought proved he'd hit a nerve with many old bomber pilots. Many recalled the exact situation that hung on the wall, the irony of struggling out of enemy skies only to go down a few miles from the home base, the joy of seeing an RAF plane coming to ride herd.

Built as an interceptor, the Spitfire lacked range for escorting the bombers very far. But all agreed that the plane was a beauty. And never more so than when it played Samaritan for its wounded allies.

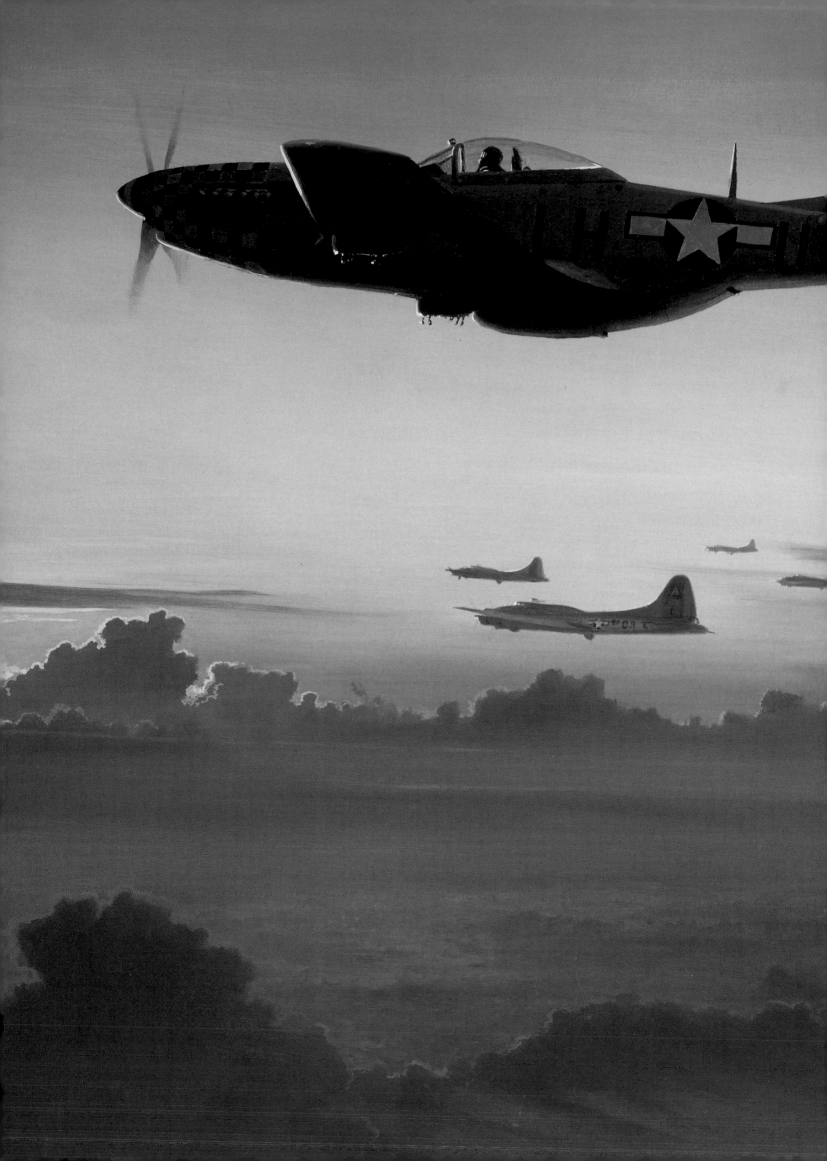

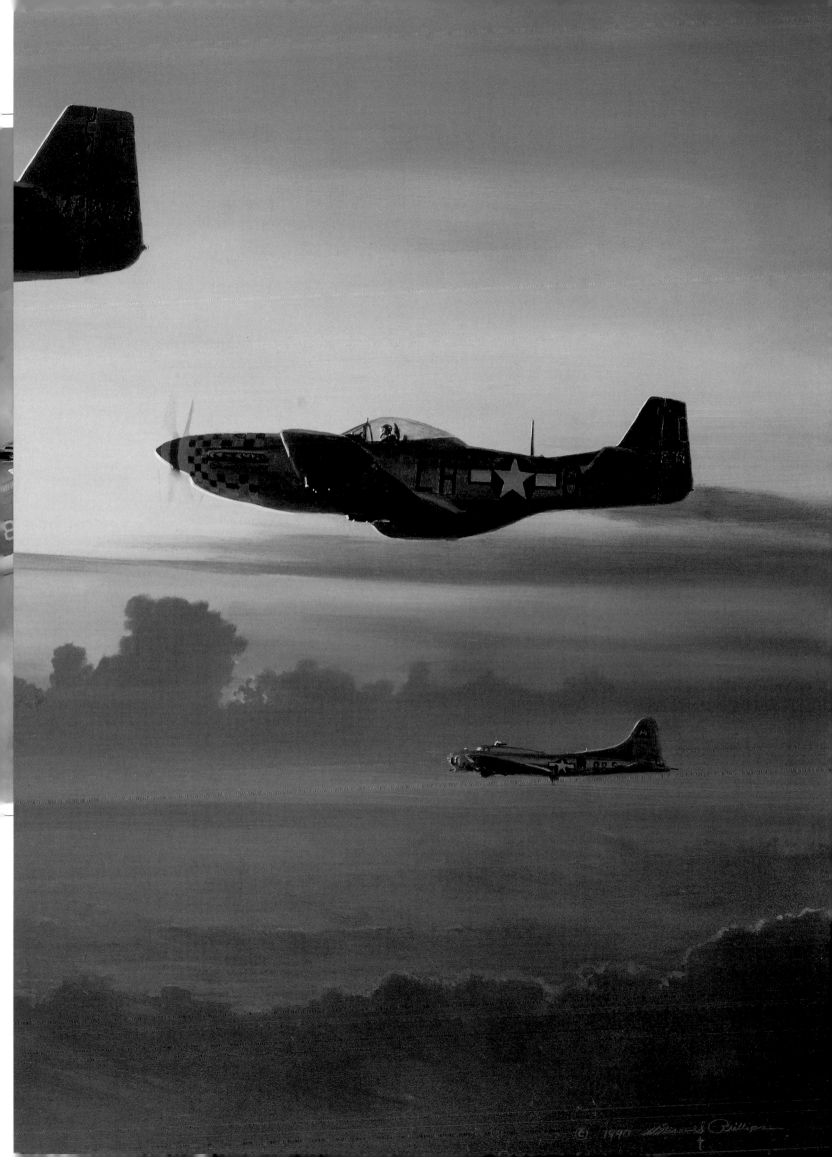

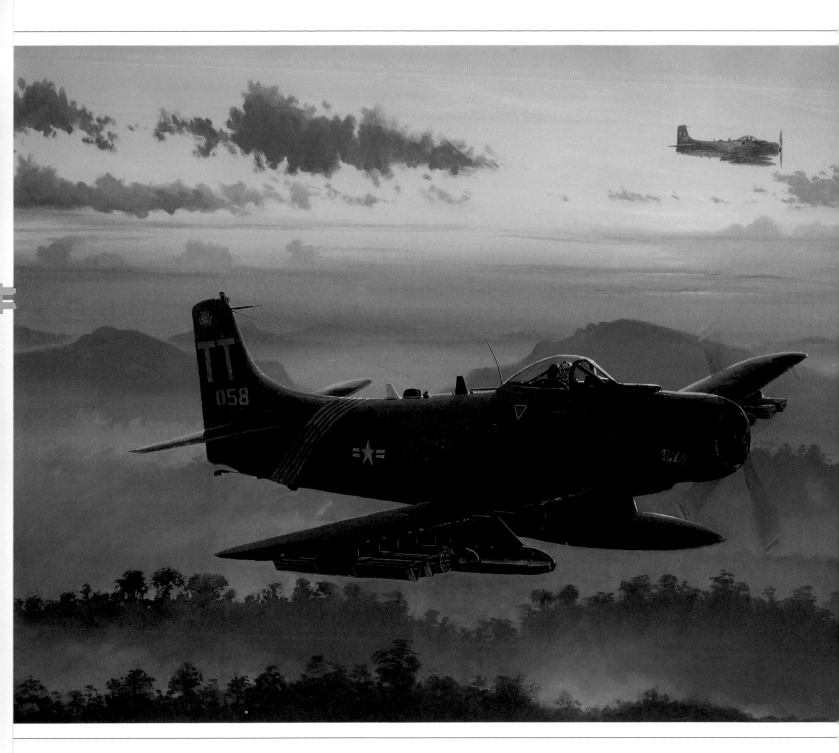

LAST CHANCE BEFORE NIGHTFALL

A pilot is down in that jungle, and the enemy is moving toward him. So is the helicopter, the Jolly Green Giant. So is nightfall.

But the downed pilot has got a guardian overhead, watching the ground, ready to blast anyone who moves in, bent on making a capture. Meet the Skyraider, the A-1, heavy with weapons, chugging along with its propeller, just as though this were 1945, when Douglas built it as a navy attack plane.

It did fine in Korea; and kept right on in Vietnam, among all the jets, though some cynics might have said that the "A" stood for "Antique." The artist, who knew Vietnam only too well, says that the A-1 was supposed to be phased out, but it did its job of ground support so well that both navy and air force hung on to it.

Right now it's helping save a downed pilot, and he's happy to see the pair of A-1s and to hear that good old reciprocating engine snarling above the trees. "The helicopter must get him on this pass, or it'll be too dark to try again," Phillips says.

MISSION COMPLETE

The propeller winds down and stops. The pilot swipes his hand across a few switches, then opens his canopy. The crew chief is on the wing to help with a strap or to unsnap an electric lead.

Another Mustang whispers past on final, engine gurgling. Both men glance at it. Then with a heave, the pilot rises from his seat and steps out on the wing. The crew chief gives a helping hand because he's seen how a man's knees can fail him after long hours cramped in the cockpit. "Everything ok, sir?"

"Yes. Fine." A ritual question and answer. It seems wonderfully silent there on the edge of the field. Just the ticking of the engine as it cools, and the murmur of other planes taxiing, of jeeps bringing armorers and radio technicians out to check and replace and refill. The pilot, Donald Strait, heads for debriefing and some welcome coffee. Mission complete.

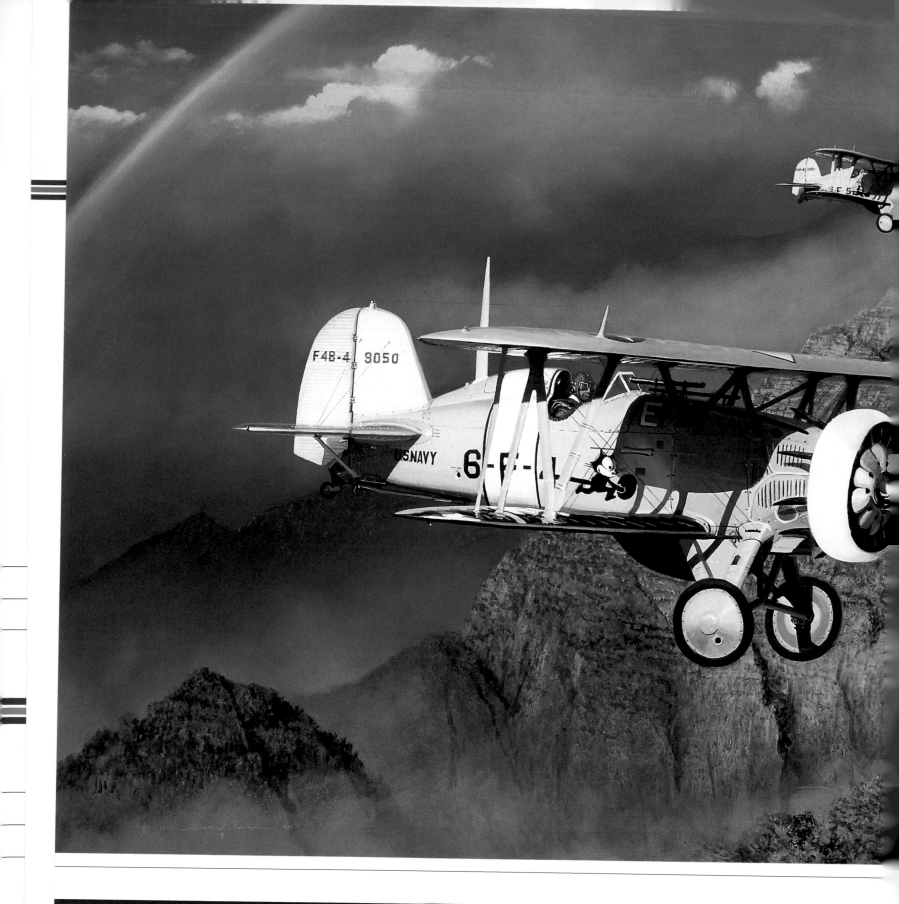

OVER THE NAPALI COAST

This might well be titled "How to Find Happiness in the Depth of the Depression." For in the early 1930s, a college graduate, even from the "Ivies," found it hard to get a job. But if he passed a tough physical exam, he might be accepted as an aviation cadet. And if he was in a class which was not terminated for lack of funds, he might fly a fighter, perhaps one of these F4B-4s.

This was the navy version of the army's P-12, built by Boeing, and if its fortunate pilot was shipped to the Territory of Hawaii, to fly off the deck of one of the spanking new carriers, his cup of joy would overflow.

He'd be stationed at a glorious base near Honolulu

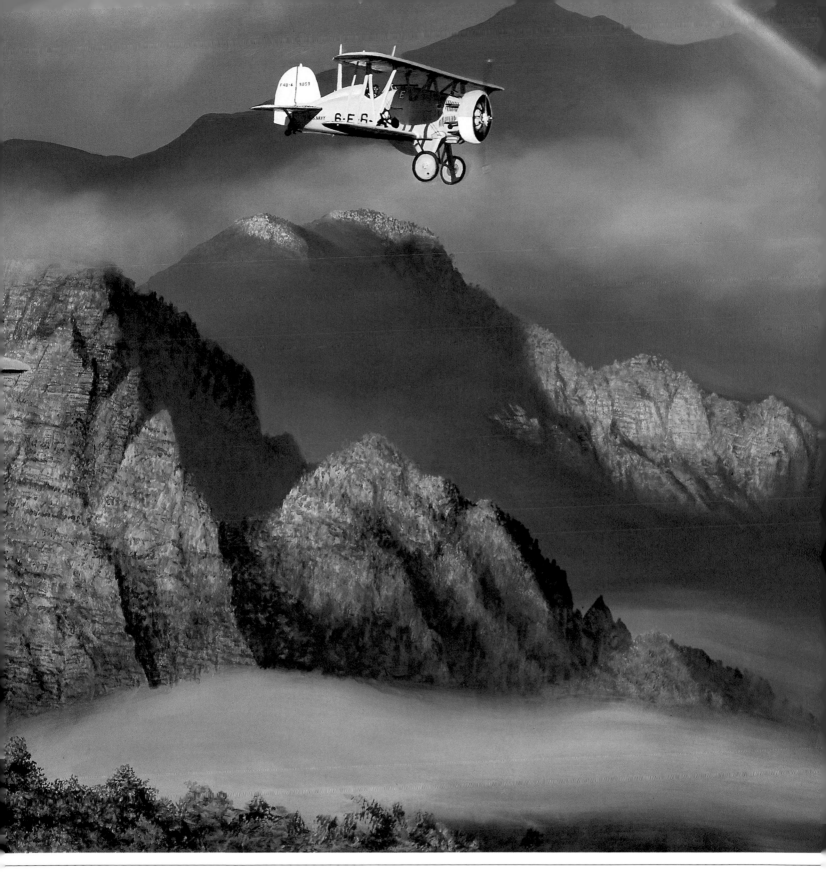

where he'd wear whites all year, enjoy a little revelry at weekend luaus, dance with admirals' daughters at the Officers' Club, and swim in the surf at a beach with the strange name of Waikiki.

And here he is at work, flying with friends over jutting volcanic hills and rich green glades along Kauai's northwestern Napali region. The sun is warm on his goggled face in that open cockpit, the engine is sweet in his ears, and the smell of flowers rises from the damp earth below, fresh as the scent of the lei he wore last night. He feels ever young, that nothing can ever spoil the delights of being based at Pearl Harbor.

Navy BF2C-1, a Curtiss fighter, was short-lived in Navy service, but had the classic lines of the 1930s.

"I had no special place in mind when I did this," says Bill. "It could be anywhere." Anywhere in the Northwest, that is, where the family plane—often a de Haviland Beaver or Otter—does the job of the family pick-up down in highway country.

This scenery, with its mountains and valley farmlands, looks like British Columbia where planes are as common as Toyotas, and flying is so normal that kids fall asleep in the back seat at 10,000 feet. This particular plane doesn't belong to a family, out for a spin to Grandmother's house, but a company, Harbor Air. It's a Beaver delivering a group of passengers or a load of cargo to a distant outpost in the mountains. When they arrive, the pilot will slide into a patch of water—there always seems to be one at the right place— and taxi to a dock. He'll unload, reload, and fly back to Vancouver or Victoria.

Floats are the usual way to go, up in the north country, but oversize tires are used, too.

*Momentarily bound to the earth,
an Ercoupe Alon awaits its next chance to fly.*

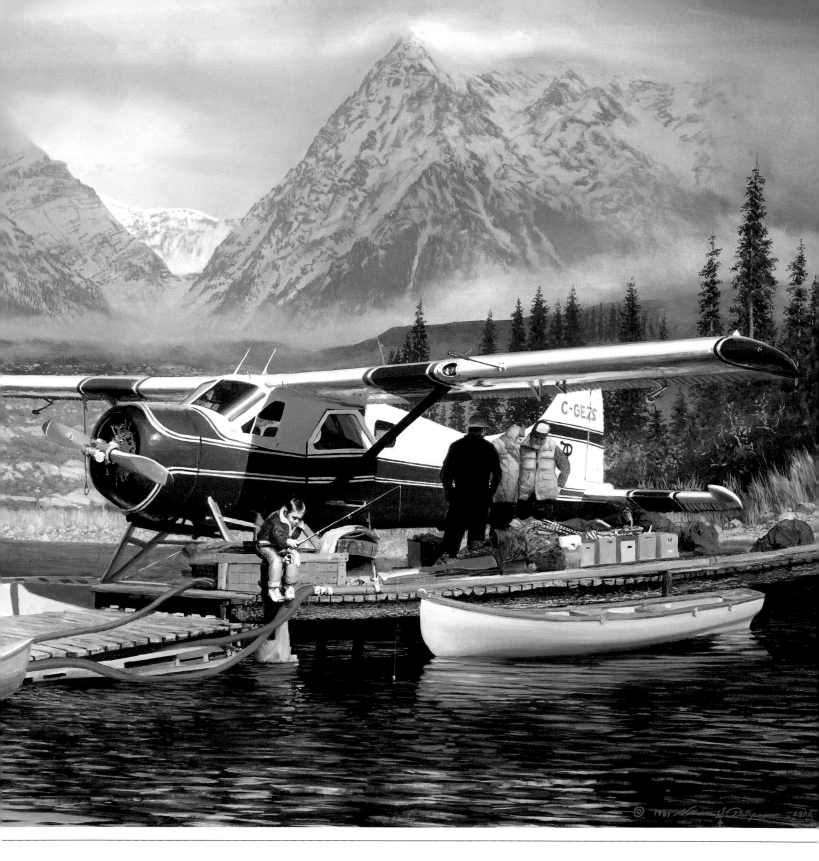

LAST CHANCE

Phillips has a real scenario for this painting: "For the first time, Dad has taken his son along on a fishing trip with a friend. They've had a marvelous time, the boy learning to interact with older men. Now the weather is changing fast, the way it does in the mountains. The Beaver has landed and taxied to the dock. The pilot stands by as the older men figure out what chests and cartons and pieces of equipment are lighter and so should go nearest the tail. The pilot knows that they haven't too much time, for the weather is already moving into the pass in the background, and snow will be flying soon. This is their last chance to get out.

"And in this little pause in preparations for flight, the boy has his last chance, too. For right by the dock he spotted, a few days ago, a monster trout. He's tried for it, but it's a wily old fellow, not about to be taken easily. Still, while the grown-ups are all talking, he's having a final try for the big one.

"His last chance. Everyone's last chance."

[161]

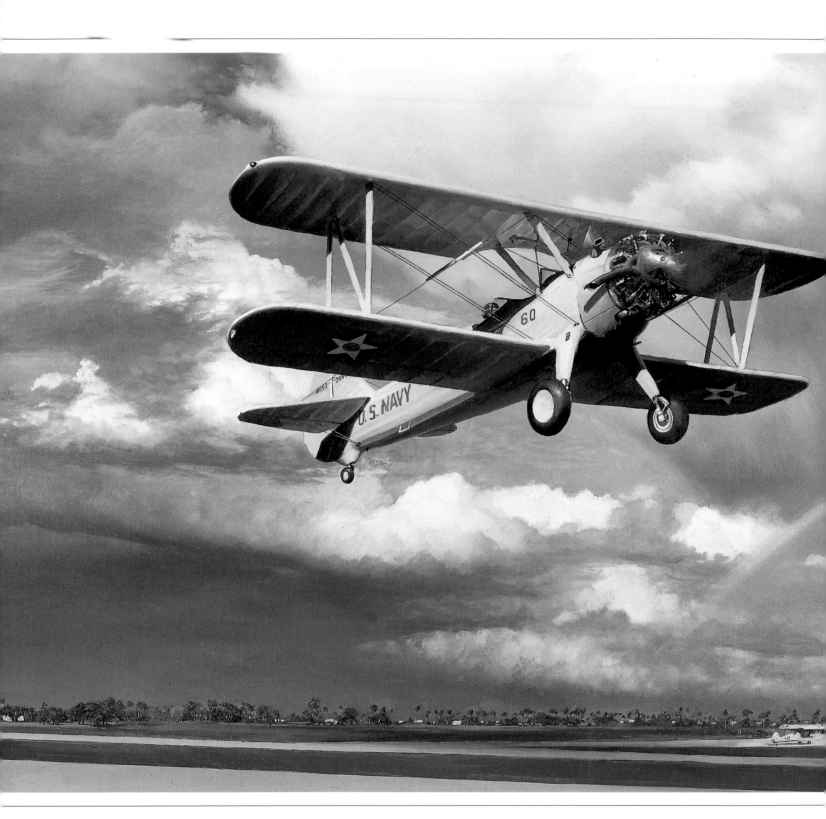

YELLOW PERIL

As golden as youth itself, the navy's famous old N2S trainer starts another youngster on the path to a flying career. Right now, this one is too engrossed in doing everything right to think of all the implications of this, his first solo. He doesn't muse over the mountain of tech orders that lie in wait for him, nor consider wings on his chest, fighters awaiting his mastery, chances of heroism, promotions up to Joint Chiefs. He's thinking: Wow! That front seat is sure empty! This baby wants to climb without that weight. Got to keep the angle, the speed.... Rpms? Okay. Now for the first turn. Ball and needle? No, don't look at it. Feel it. Second turn. Oops! Twenty feet too high. Ease down gently so he won't notice. Hey! He's not here! Time to chop... turn to base...final...plane's light: get down! Hold off...damn, a bounce. One more time, Sir?

BLACK CAT ON THE PROWL

In the evening, when the fighters and bombers are staked down in their revetments, and their pilots are relaxing at the squadron bar, the black cats start moving out. They're PBY amphibians—Catalinas—grand ladies designed to patrol, used daily for air-sea rescue. Painted black, they became night bombers, leaving at dusk, rumbling at sedate speed over distant enemy bases, dropping bombs often fused to go off at intervals all night.

Black Cats. The navy flew them in the Pacific; the Aussies, too. They brought bad luck to Japan.

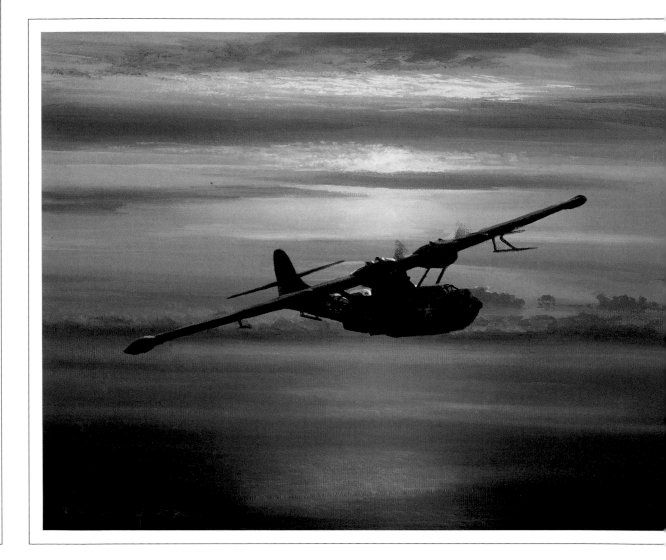

What a downed pilot longed for—
a PBY landing nearby.

INTO THE THRONE ROOM OF GOD

Thunderstorms do strange things. They climb out of sight, rising upward with one heaving bulge after another until they spread into that almost stratospheric anvil top. They block the way of a plane with deep purple curtains, or even worse, green walls that crackle and glow with lightning. And sometimes an F-14 like this one follows holes and corridors past the storm's lurking dragons and into a strange, quiet cathedral of cloud. Here shafts of sunlight find gaps and flood through with rich golden colors as though they'd struck stained glass windows. The cumulus seems almost welcoming here, soft and bright. There's a patch of blue sky above, so this is part of the world, even though it looks like dream country.

Here, says Bill, in this quiet, awesome area surrounded by vast power, is God's throne, where fighter pilots and artists sometimes pay their respects.

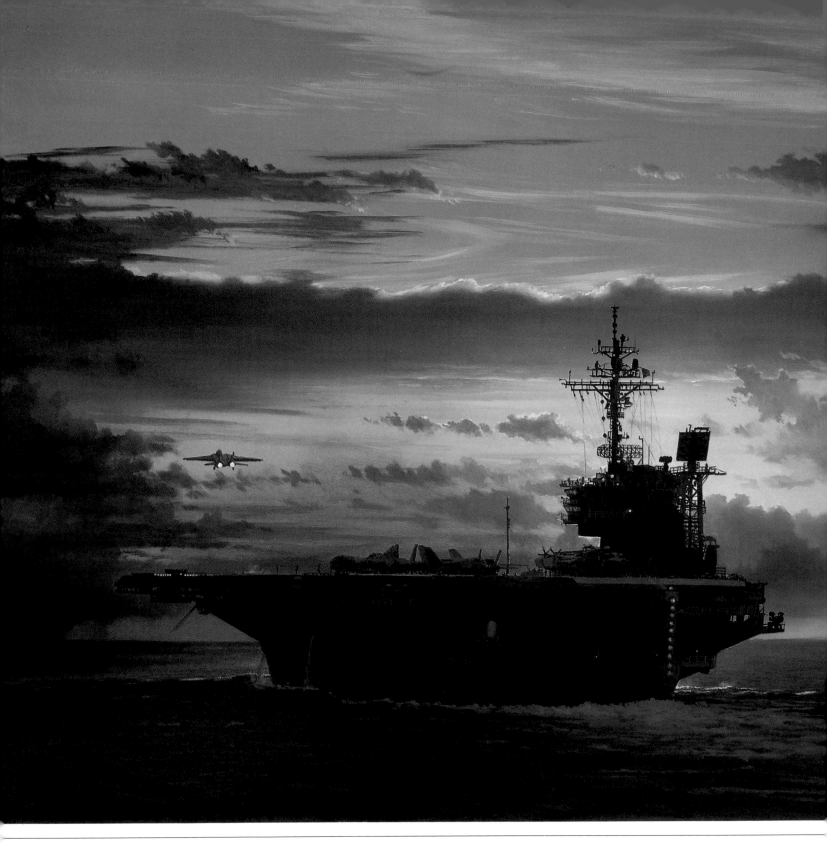

THOSE LAST CRITICAL MOMENTS

This painting hangs on the wall in the Phillips' living room, for it has a special meaning for the artist. It's a reminder of his first visit to a carrier. In 1984 the navy flew him out to the *Kitty Hawk* by helicopter, and he arrived during flight operations. "Before dinner was finished we got the 'Man Overboard' message. It was a young sailor, a deck crewman on night watch, who'd crossed in front of a catapult and was struck by a plane. The man was lost." Bill says the plane circled and

landed because it had been "fodded." That means it had suffered FOD (foreign object damage).

With that introduction to the intensity of the danger, Bill joined the supervisors of the landings and takeoffs from the vantage point called "Vulture's Row" as F-14s hurtled off. They'd return with tail hooks dragging, sweeping toward the stern, trying to line up lights, hold the right angle, kill speed—and keep on living.

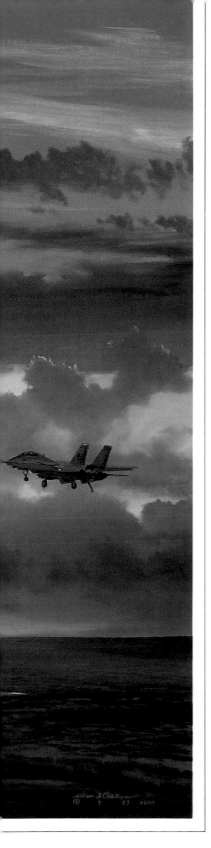

CATCHING SOME RAYS

"In the USAF you get in deep trouble for napping like this," says Bill. "But these navy guys work 24 hours a day and grab sleep when and where they can." This time it's on the folded wing of an Intruder, during flight operations on the USS *Midway* while the carrier was taking part in the guarding of oil tankers in the Gulf of Aman. Bill Phillips says, "The inspiration for this painting came while I was being deployed as a navy combat artist in the Persian Gulf." He saw this crewman, Mickey Mouse ears blocking some sound, getting a well-deserved doze.

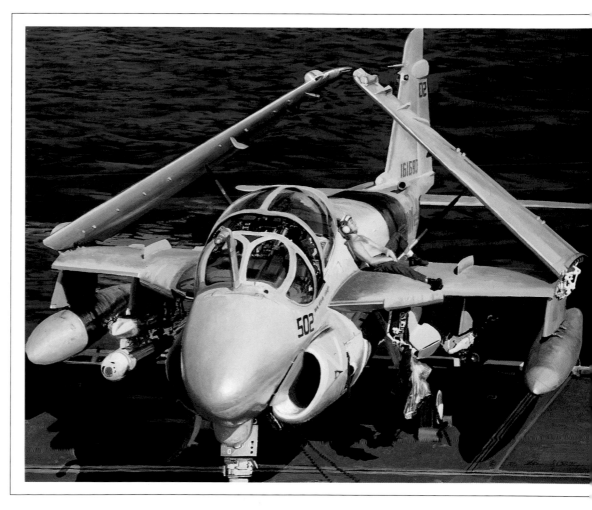

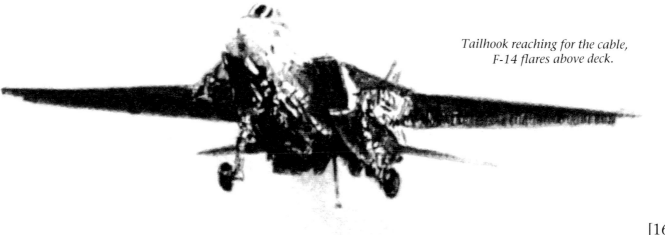

Tailhook reaching for the cable, F-14 flares above deck.

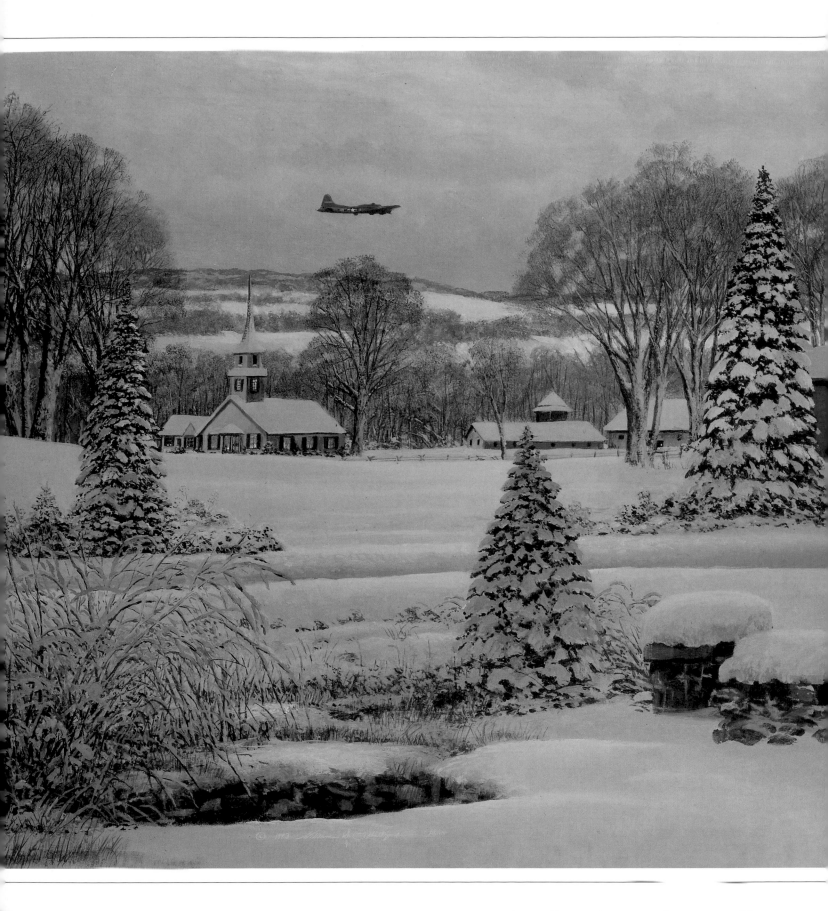

IF ONLY IN MY DREAMS

Is this really a William S. Phillips painting? Bet on it. Bill paints subjects that move him. Most have to do with the air and the sleekly beautiful machines that have conquered it. Here he has ventured into the thoughts of any military flyer of World War II at Christmastime. This is the sort of thing men saw in their minds as the Decembers of '42, '43, and '44 rolled around.

At this time families came together, clung together, united by fears and hopes. A sedan bringing relatives has pulled in behind the coupe that's been parked since before the snow fell—saving gas. The home is well lit, a wreath to mark Christmas, a star to honor the one who's away. Another reminder is the distant mutter of a plane. The church is lit, too, and much used.

Around the world, these sights haunt young Americans. That fresh, unblown snow—especially moving to men in the tropics. That sense of brightness and joy and peace. Upstairs there'd surely be a room with college banners and model planes, and a bed, long unused.

It's cold, but the collie won't come in yet. He seems always to be waiting for someone else.

To contemporary artist William S. Phillips, power, speed, and beauty are synonymous with flight. Aircraft in flight—soaring over the Rub' al Khali or thundering through the Grand Canyon—are what Bill paints best. He has participated in the Air Force, NASA, and Navy Art Programs and is constantly receiving requests for private commissions of his work.

Bill has devoted himself to a wide spectrum of aviation subjects, from the Wright brothers at the turn of the century to the exhilaration of the space age. While some scenes are carefully researched studies of historical events, others are taken directly from his own experiences. Bill has flown in numerous aircraft, including the F-16 Fighting Falcon and the F-4E Phantom. From the jungles of Vietnam to the white cliffs of Dover, his paintings capture both the energy and elegance of the aircraft and provide a pilot's view of the landscape below. His renderings can possess an almost abstract simplicity or a touch of the sublime: mountain ranges lit by the cool, clear light of dawn, glimpses of white mist hanging on the air, skyscapes beyond a crescent moon and evening star. But whether they exist in a windless, silent domain, or roar by with breathtaking speed, the aircraft of William Phillips all have the unmistakable hallmark of his unique vision.

William S. Phillips was born on May 25, 1945, in Los Angeles, California. His father was an actor who appeared on Broadway and in movies, such as *High Noon* and *Thirty Seconds Over Tokyo*. William S. Phillips Sr. was also, in his spare time, a cartoonist.

The artist recalls his first memory as a child: "I was lying back on a warm summer day looking up at a beautiful blue sky, and along with white puffy cumulus clouds there was a little airplane, bright yellow. It had two wings and made a lot of noise (I think now that it was a Stearman). I was fascinated by the contrast of the yellow against the blue and the white of the clouds."

Bill's first masterpiece was a mural in his family's new home in San Fernando, when he was about five. He had been left to take a nap in a room with blank walls and a box of crayons. He says: "That was a big mistake—the airplane took up the length of the entire wall—a fairly comprehensive aviation piece." The parental critique was not positive.

The artist with the countersigners of the limited edition fine art print The Hunter Becomes the Hunted *(see pp. 52-53). Left to right: Harold Stearns, Hub Zemke, Wolfgang Kretschmer, Phillips, and Robert Schoens.*

Nevertheless, Bill continued to draw throughout his school years, often on any piece of paper that was available. At age 12 he would go down to Van Nuys airport with a friend and spend the day watching F-86 Sabres of the California Air National Guard; then he would attempt to sketch what he had seen. However, Bill did not take an art course until his senior year in high school, where he far surpassed the other students, despite his lack of training. He hoped, at that time, to pursue a career in art. Unfortunately, he was not able to obtain a college scholarship at that late date. This left Bill in a quandary: his father had died several years before, and the family had no funds for his further education. As college was out of the question, he decided to join the Air Force. The government would help him later with his education, and his love of aviation made this a logical choice. On September 6, 1963, Bill joined up. The

THE ARTIST

experience was not all that he hoped for, however. "Vietnam was just starting to heat up and personnel were needed. I went to Lackland Air Force Base, and most of my class was put into security police. I had wanted to be an air traffic controller and begin college in my off-duty time."

After tours of duty in Minot, North Dakota, and Portland, Oregon, Bill was stationed in Vietnam from 1965 to 1966, assigned to base perimeter patrol. At Tan Son Nhut, most of his duty was at night, so he could spend part of the day sketching. He recalls: "Vietnam is a beautiful place, especially down on the delta during the rainy season—everything is green, and towering cumulus buildups reach 65,000 feet near the equator." Unfortunately, all his sketchbooks were lost in transit to the United States, so his paintings of Vietnam represent images supplied from memory.

Bill entered college when he was discharged from the service in 1967, majoring in criminology with the intention of attending law school. Although he had been drawing and painting aircraft throughout his life, he did not feel that art was a practical career pursuit. This decision was reversed in April 1971 when he sold four aviation paintings at the Red Baron Restaurant at the Medford Airport.

Bill realized that he needed to learn more about art. His job as a firefighter with the Ashland, Oregon, fire department allowed him sufficient free time to study art history, method, and composition at the library. Bill also worked on his painting and drawing, and remembers: "I began developing a style of my own and integrating aviation into that style." He had been particularly influenced by the work of American Luminist landscape painters, such as Albert Bierstadt, Thomas Moran, and Frederick Church.

When Bill began taking his work to art galleries in the 1970s, he found no market for aviation-related art. Knowing that he must show his work in galleries to develop his career, Bill turned to wildlife scenes for inspiration, specifically to ducks. The artist recalls thinking: "A duck has no motors on it, but it does fly in formation, and has aerodynamic properties." The popularity of these paintings in turn led to an audience for his aviation paintings.

Bill was thrilled by his first visit to the U.S. Air Force Academy in 1973, and subsequently went to Luke Air Force Base, Arizona, to paint the F-15 as a special commission for the Academy collection. He was invited to join the Air Force Art Program in 1976, an event he feels was a turning point in his creative development. In 1981 Bill left the fire department to pursue his aviation art career full time. A testimony of his skill was his selection by the Navy to serve as a combat artist during the 1987-88 Persian Gulf crisis. He works in his home in Ashland, Oregon, and travels widely in the pursuit of aviation research needed for his artwork, visiting Japan, Hawaii, England, Germany, Jordan, and Saudi Arabia.

Each time Bill finds a fresh approach, he provides a new way of seeing a point in time, whether it is an historic moment or a bit of his personal experience. Although combat scenes are sometimes the focus of these paintings, Bill says that "the original purpose of the airplane was to allow us to experience the sky, and I want to focus on the exhilaration of flight. I enjoy meeting the people who were involved in aviation history, an opportunity many history painters do not have." He finds that one-time mortal enemies now meet cordially to co-sign paintings and prints. While Bill passes on their experiences through his paintings, he hopes that his artwork will also express "the insanity of all war."

There is, in these paintings, an underlying relationship between what the artist gives to the work, and what the viewer finds there. In the quest for new directions, Bill explores the panorama of flight in the 20th century.

—Mary S. Henderson

LIST OF PLATES

Advantage Eagle, 4-5
Alone No More, 58-60
Alpine Defender, 121
America on the Move, 24-25
Among the Thunderstorm's Savage Furies, 42
And Now the Trap, 36-37

Bandit Goes Down, A, 70-71
Baron Scores, The, 106
Beaver Country, 160
Black Cat on the Prowl, 163

Cannibal Queen, 12
Chasing the Daylight, 126-127
Catching Some Rays, 167
Climbing Out, 34-35
Coasting to Monterey, 115
Confrontation at Beachy Head, 94-95

Dauntless Against a Rising Sun, 18-19
Dawn, the World Forever Changed, 64-65
Desert Resupply, 144
Dusting the Ridgeline, 118-119

Eagles of the Columbia, 120

Fighting Their Way Out, 50-51

Gee Bee, 136
Giant Begins to Stir, The, 76-77
Going In Hot, 85

Heading for the Mine Danger Zone, 79
Heading for Trouble, 22-23
Hellfire Corner, 96-97
Hot in the Canyon, 73
Hunter Becomes the Hunted, The, 52-53
Hunting for Bear, 38-39

I Could Never Be So Lucky Again, 2-3
If Only in My Dreams, 168-169
Into the Teeth of the Tiger, 92-93
Into the Throne Room of God, 164-165
Intruder Outbound, 20-21

Last Chance, 161
Last Chance Before Nightfall, 152
Last of the Bush Pilots, 112-113
Lethal Encounter, 101

Lightning in the Sky, 145
Long Green Line, The, 80-82
Long Ride Home, The, 148-149
Low Pass for the Home Folks, 116-117

Mission Complete, 153
Mr. Thomas Tries the Canyon, 114

Nanette, 40-41
Next Time Get 'Em All, 57
No Empty Bunks Tonight, 150-151
No Flying Today, 28-29

Over the Napali Coast, 158-159
Over the Top, 62

Pebble Beach Blues, 130
Pedal to the Metal Over Smith Ranch, 43
Phantoms and the Wizard, 44-45
Ploesti: Into the Fire and Fury, 74-75

Rainbow Chaser, 6-7
Range Wars, 72
Riding the Thunder, 63
Riverine Support, 78

Shore Birds at Point Lobos, 128-129
Sierra Hotel, 86-87
Sunlit Angels, 131
Sunset Serenade, 56

Those Clouds Won't Help You Now, 102-103
Those Last Critical Moments, 166
Thunder in the Canyon, 132-133
Time of Eagles, A, 26-27
Time to Head Home, 84
Top Cover for the Straggler, 54-55
Top Gun, 100
Two Down, One to Go, 104-105
Two Down to Glory, 107

"Welcome Home, Yank," 146-147
When a Sure Grip Means Survival, 134-135
When Prayers Are Answered, 142-143
When You See Zeros, Fight 'Em, 98-99
Wright to Liberty, A, 136-137

Yellow Peril, The, 162